Emperors of Dreams

ONE WEEK LOAN

Mike Jay

Emperors of Dreams

Drugs in the Nineteenth Century

Dedalus

Published in the UK by Dedalus Ltd, Langford Lodge,
Judith's Lane, Sawtry, Cambs, PE28 5XE
email: info@dedalusbooks.com
www.dedalusbooks.com

ISBN 1 873982 48 8

Dedalus is distributed in the United States by SCB Distributors,
15608 South New Century Drive, Gardena, California 90248
email: info@scbdistributors.com web site: www.scbdistributors.com

Dedalus is distributed in Australia & New Zealand by Peribo Pty Ltd,
58 Beaumont Road, Mount Kuring-gai N.S.W. 2080
email: peribo@bigpond.com

Dedalus is distributed in Canada by Marginal Distribution,
695, Westney Road South, Suite 14 Ajax, Ontario, LI6 6M9
web site: www.marginalbook.com

First published in by Dedalus in 2000, reprinted 2005

Printed in Finland by WS Bookwell
Typeset by RefineCatch Limited, Bungay, Suffolk

THE AUTHOR

Mike Jay is the author of *Blue Tide: The Search for Soma* (1999), an investigation into the use of sacred plant drugs in Indo-European prehistory.

He is the editor of *Artificial Paradises* (1999), an illustrated anthology of drug literature, and the co-editor of *1900* (1999), a collection of *fin-de-siècle* writings on evolution, decadence, atheism, the unconscious, feminism, sexology and futurism. He has also edited, with an introduction, James S. Lee's classic *fin-de-siècle* drug and travel memoirs, *Underworld of the East* (2000).

He has written on the social history of drugs for various publications including *The Guardian, The Independent, Arena, Fortean Times* and the *International Journal of Drug Policy*.

CONTENTS

Introduction 9

1. "Oh! Excellent Air Bag": NITROUS OXIDE 14

2. The Black Drop: OPIUM 51

3. The Seraphim Theatre: CANNABIS 88

4. Attack of the Vapours: ETHER 124

5. "Watson – The Needle!": COCAINE 147

6. A New Artificial Paradise: MESCALINE 185

7. Ardent Spirits: TEMPERANCE AND PROHIBITION 221

 Appendix: Selected Texts 246

Bibliography 266

Index 273

Introduction

Like most people, I grew up believing that drugs were a subject without a history. Almost everything I was taught, or read, or saw on television, implied that they were something new, a plague introduced into society by hippies in the 1960s. Occasionally the curtain was pulled a little further back to reveal glimpses of Victorian opium dens, or perhaps the stupefying effects of toxic plants on primitive people. But the implication was still that drugs, even if they'd been around for a while, had always been illegal – at least as soon as societies had evolved far enough to make sensible laws. These substances had only ever existed in the shadows of civilisation, and no respectable person had ever been interested in them, with the exception of the doctors and police whose job it was to stamp them out.

Since the sixties, to be sure, this orthodoxy has been challenged by a revisionist view, and with it a revisionist history; but this history has tended to focus on the distant past, assigning the exclusion of drugs from Western societies to the Catholic Church or even to the alcohol-fuelled warrior culture of the Roman Empire. Yet there is another history far closer to hand which shows us that the very idea of drugs being illegal is an extremely recent one, dating back less than a century. In 1900, any respectable person could walk into a chemist in Britain, Europe or America and choose from a range of cannabis tinctures or hashish pastes, either pure or premixed with cocaine or opium extracts; they could buy cocaine either pure or in a bewildering variety of pastilles, lozenges, wines or teas; they could order exotic psychedelics

like mescaline or buy morphine or heroin over the counter, complete with hand-tooled syringes and injection kits.

Within the span of history this was only yesterday, and yet we hear surprisingly little of this recent story from either side of the highly polarised drug debate. For the sixties counterculture – or at least their evangelical spokesmen – it was important to stress that theirs was the first generation to discover drugs, and that this discovery marked an unprecedented, even evolutionary shift in human consciousness. Their opponents across the barricades were more than happy to collude with this rhetoric of novelty: it enabled them to stress the importance of counter-revolution, the unknown potential of drugs to aid and abet the breakdown of society, and the urgency of diverting unprecedented levels of government funding to combat the 'new drug menace'.

And yet, throughout the reign of Queen Victoria and the height of Empire – an era regarded by many as the golden age of our civilisation – the West was awash with these substances; in fact, it was only when the dream of Empire began to fail that the movement to question their legitimacy began. In 1800, Humphry Davy's experiments with nitrous oxide marked the beginning of the modern understanding of the drug experience, and by 1821 Thomas de Quincey's *Confessions of an English Opium Eater* had brought this understanding into mass popular culture. Yet it was not until 1900 that efforts to prohibit drugs began to take hold at an international level, and not until 1921 that these efforts were fully enshrined in law. The century in between, typically regarded as an era of repression, moral probity and social control, could also be billed as 'Drug Legalisation: The First Hundred Years'.

This is the century on which this book focuses, and its aim is to trace the origins of the drugs which emerged in the West in the nineteeth century. How did these substances, now an all-pervasive multi-billion-dollar black market phenomenon, first arrive in the modern world? Who were the first people to experience their effects, how were these effects originally interpreted, and how did they spread into the broader culture? My primary motive for this enquiry is simply amazement that

these pioneer stories are so rarely told: this is the first volume in English to relate them all together in any detail. Not only are these first encounters crucial to our understanding of what these drugs are and how and why people use them, but they also plumb a fabulously rich vein of explorers' tales, secret histories and weird scenes which combine to assemble a hallucinatory alternate narrative of the nineteenth century itself.

I've traced these stories with the drugs in question as the protagonists, following their arrival and picaresque progress through a world which was as new to them as they were to us. Drugs – like art, or science, or philosophy – only take hold within a culture once a sea-change is under way which transforms them from their previous irrelevant or inconceivable selves into a focus for a new sensibility. In the period from 1800 to 1900, the discovery of drugs continually mirrored other transformations rich and strange, and vigorously encouraged strangeness with new and mind-expanding experiences. These whether farcical or profound, courageous or deranged demonstrated repeatedly that human consciousness might include dimensions, even universes, previously undreamed of. Most previous historical work on drugs in the nineteenth century has shown little interest in the ideas and visions they generated, concentrating instead on more familiar and measurable processes like their supply, commoditisation, public perception or statutory control; these are all important elements of the story, but my aim here also includes building up a picture of the subjective world opened up by each drug and its personal effect on those who took it. Without this dimension, the responses of the drugtakers of the nineteenth century are too easily dismissed as reckless self-indulgence, juvenile aberration or deviant pathology. With it, we begin to sense the courage – or hubris – which was required not to dismiss or condemn these extraordinary and novel states of consciousness but to explore them further, to attempt the quixotic task of explaining them to the sober world, even to seek new roles for them – scientific or poetic, medical or social – within it.

Drugs, both in their external form as exotic commodities and in their inner guise as agents of altered consciousness, attached themselves to many of the nineteenth century's great themes. As science evolved, they offered new tools to tease open the mysteries of the mind, and new dangers as medicine struggled with sinister new paradigms of mental illness, repression and degeneration. Drugs discovered in the process of colonial expansion became global economic forces, devastating weapons in the free trade wars and, increasingly, symbols for the fear that the cultures subjugated by the West might find ways of turning the tables and enslaving their captors. Within the worlds of art and thought, drugs emerged from an Enlightenment quest to understand the workings of the mind into a Romantic or Transcendentalist search for subjective meaning beyond the measurable, and eventually into a *fin-de-siècle* celebration of the irrational and the forces of the unconscious. Consequently this is not exactly a history of science, nor a work of literary reference, nor a social history, but a combination of these and other investigations swimming within a broader current of evolving ideas.

The eventual prohibition of drugs gives many (though not all) of the stories in this book a classical three-act dramatic structure. In the first act, the drug is discovered and its novelties and benefits celebrated; in the second act, it escapes from the laboratory and begins to make its own journey through the strange byways of nineteenth-century society; in the third act, the powers that be unite in their attempt to extinguish it. It is, of course, the narrative of *Frankenstein*. But the terminal destination is by no means the whole journey, and in itself this conclusion tells us little about the extraordinary story of the century before. During the nineteenth century drugs were hailed by scientists as the crowning glories of the modern age, and praised by artists and philosophers as the keys to transcendental realms beyond religion; promoted by doctors as the solution to the crises of modern life, and demonised by politicians as the agents of sinister conspiracies against civilisation itself. Above all, then as now, they were increasingly passed around among ordinary people, along with a

12

gradually evolving lore of their pleasures and pains, their uses and abuses, and with an ever watchful eye on the State which, as its powers grew, sought to control and prohibit them.

℘ ℘ ℘

I'd like to thank many people for their time, encouragement and help with obscure notes and queries, including: Miranda Bennion, David Bird, John Birtwhistle, Mike Blackburn, Louise Burton, Bal Croce, Edward Featherstone, Juri Gabriel, Ben Goldacre, Nicholas Goodrick-Clarke, Anthony Henman, Robert Irwin, Danny Kushlick, Gary Lachman, Eric Lane, Howard Marks, Antonio Melechi, Barry Milligan, Michael Neve, Russell Newcombe, Charles Peltz, Steve Rolles, Richard Rudgley and Sophie Stewart.

1

"Oh, Excellent Air Bag!"

Nitrous Oxide

On the 17th April 1799 the young chemist Humphry Davy –
later, of course, to become Sir Humphry, the famous inventor
of the miners' lamp and distinguished President of the Royal
Society – inhaled four quarts of nitrous oxide from an oiled
silk bag in order to study the effects of the gas on his mind and
body. These turned out to be considerable.

Davy was twenty-one, the junior partner in an ambitious
and controversial medical project called the Pneumatic
Institution which had opened the previous month in Hot-
wells, a declining suburb of Bristol. Bristol itself was in
decline, with newly-independent America stealing much of
the trade which had made it England's second city; Hotwells,
a spa district originally set up to rival nearby Bath, had
become home to a downmarket cluster of cheap clinics and
miracle cure outfits offering hydrotherapy or mesmerism to
the hopeful or desperate.

Davy was seated in the Institution's lamp-lit laboratory, in
the centre of which he had set up a chemical reaction. Nitrate
of ammoniac bubbled in a heated retort; the escaping gas was
collected in a hydraulic bellows before seeping through water
into a reservoir tank, from which the silk bag could be filled.
Also present were the Institution's founder and head, the rad-
ical doctor Thomas Beddoes, and another medical colleague,
Dr. Kinglake.

Davy emptied his lungs and began to inhale the gas. The
first thing he noticed was its curiously benign sweet taste,
followed by a gentle pressure in the head as he continued to
breathe deeply. Within thirty seconds the sensation of soft,

probing pressure had extended to his chest, and the tips of his fingers and toes. This was accompanied by "a highly pleasurable thrilling", and a gradual change in the world around him. Objects became brighter and clearer, their perspectives quietly shifting, the sense of space in the room expanding and taking on strange, cosmic dimensions.

It became rapidly clear that Davy's only analogy for this type of chemical intoxication – alcohol – would be no help at all in understanding what was happening to him. Far from dulling his senses, the gas was elevating them to levels which he had never imagined possible. His hearing became fantastically acute: he could hear every sound in the room and, as he concentrated on the echoing babble, he began to sense that he was hearing sounds from far beyond the room – a vast and distant cosmic hum, the vibration of the universe itself. In his field of vision, the objects around him seemed to be teasing themselves apart into vibrant packets of light and energy. He felt the gas diffusing inside him, inflating him to something far beyond the man he had been a minute before. He was rising effortlessly into new worlds, worlds which had perhaps – until this moment – been the provenance of the gods. Somehow, the whole experience was irresistibly funny. He had "a great disposition to laugh" as everything became suddenly clear, his eye-in-the-sky perspective revealing the answers to questions which he had never had the wit even to ask. He might, like Archimedes, have shouted "Eureka!", but he was too immersed in the moment to shout anything at all.

He continued breathing the sweet gas slowly, deeply, forgetting the presence of the bag in his mouth as the tingling sensations flattened out to a warm, ecstatic numbness which enveloped him entirely, a breathless submersion in an all-consuming intensity beyond words. As new realms of experience opened up before him, he "lost all connection with external things", the stimulus from within his brain itself eclipsing the two-dimensional shadowplay of the laboratory and his companions. Here, thoughts and ideas played across his consciousness at lightning speed: "vivid visible images" presented themselves to him in rapid succession, illuminating

patterns and connections previously unimagined. Flashes of insight broke like thunder and lightning around him, ideas crackling across spark-gaps of former ignorance to illuminate an understanding of the universe vaster than any that science or poetry or religion, separately or combined, had ever offered. To breathe the gas was, simply and literally, inspiration.

Davy was far beyond the point where he could choose to end this experience, but after an eternal moment he felt the bag being removed from his lips and Dr. Kinglake leaning over him with a solicitous manner. The sight of his erstwhile colleague, coming as it did at the end of his unprecedented cosmic journey, struck him forcefully with a combination of emotions. First, indignation that this mere mortal had made the decision to remove the air-bag – a decision taken in complete ignorance of the uncharted landscape through which Davy was travelling. Next, an irresistible superiority to these poor functionaries fiddling with their gas-bags, their tubes and their medical apparatus without the faintest idea of the brave new world at whose portals they were officiating. Next, as the air of the room chased the gas from his system, diffusing its effect out through his fingers and toes, a nervous flash of doubt. What had they seen? Presumably nothing more than a man stupefied, near unconscious, mumbling, giggling, perhaps drooling a little . . . a lunatic? Was the name of this new world – madness? And since his colleagues couldn't begin to understand where he had been, how on earth could he convince them that he had been there?

As his situation impressed itself upon him, he cast around for a sentence which would encapsulate everything he had seen, done and learnt in the impossibly short time he had been away. It was like trying to cram an ocean into a teacup: the more he tried to formulate what he had seen, the more he felt it ebbing away, back into the dimension from which he was returning. He got up and walked unsteadily round the room. Kinglake and Beddoes were both firing questions at him, asking for descriptions of what had happened, assurances of his wellbeing. Davy paced, ignoring everything, trying to

turn his mind into a vice, to grip the essence of what had happened to him before it slipped away entirely. After a minute or so he turned to them and addressed them with "the most intense belief and prophetic manner" he could muster, in order to sear his revelation into their brains as it had been seared into his.

"Nothing exists but thoughts!", he told them. "The Universe is composed of impressions, ideas, pleasures and pains!".

℘ ℘ ℘

For many pioneers of science, it's a cliché that they couldn't have imagined that their discoveries would change the world. This cannot be true of Humphry Davy. His nitrous oxide experiment, right at the dawn of the nineteenth century, must have seemed to him to have changed the world entirely.

Mind-altering drugs were not new. The ability of some substances to open the doors of perception and take their subjects to an entirely other reality was understood long before history: the evidence of drug-seeking behaviour in animals suggests that this knowledge probably predates humanity altogether. At the time when Davy performed his experiment, people had been taking drugs for this purpose from time immemorial. In Mexico, the Huichol were making their annual migrations to gather the peyote cactus; in Africa, the Bwiti cult were initiating their young men with the ibogaine root; across the Arctic north, from Lapland to Siberia, shamans were employing the fly agaric mushroom in their ecstatic spirit-journeys.

But Davy's experiment represents a coming-of-age in the understanding of the nature of drugs and their effect on the human mind. Pure nitrous oxide, a substance not found in nature, had only existed for a few years. To experiment with it was not to enter a sacred world of tradition and divine revelation, but to catch a glimpse of a human future which only a few people had even begun to imagine. It was to take up the tools of science to expand the mind, to whisk the subject not into the world where the gods walked among men, but one where the only gods who walked were the new men

17

themselves. In the same way that the outside world was being transformed by scientific progress, it proclaimed that this same progress could also transform the parameters of human possibility from the inside out.

To attain these ends, it was clear that the same precepts needed to be followed as those of any other scientific project. The empirical method must be followed: observation, repetition, the careful whittling away of extraneous factors until the skeleton of cause and effect is rendered clearly visible. The study of mind-altering drugs, until this point, had been a miasma of facts and fancies, tales of dreams and visions, illusions and madness, secrets and potions, compendia of poisons and herbal lore, morality plays of the devilish and the divine. But, from the beginning, Davy's exploration of nitrous oxide was a model of the new method. He had synthesised the gas, and submitted it to rigorous tests of its properties and nature. He had tested it on dead and living tissue, on animals, and finally on himself. As he inhaled it from his silk bag, he shifted the arena of his research from the chemical apparatus in front of him to the inner laboratory of his own mind.

This emergence of the effects of mind-expanding drugs into the clear light of science was both a cause and an effect of the birth of a new aspect of humanity – one which today we take for granted as part of our modern inheritance, but which in Davy's time was still emerging. To allow drugs into the mind in this way demands modern ideas of human agency, personality and responsibility; it both requires and generates an entirely new language for describing what goes on inside our heads; it holds up a mirror of self-consciousness which strips away the protective cladding of symbol, mystery and belief, leaving us naked in the keen air of the future, our inner workings visible as never before. We are at the dawn of a new creation, a modern Adam and Eve once again eating the fruit of the knowledge of good and evil – but this time we are deceived by no serpent. We have made the choice consciously, and with eager anticipation of the result.

The roots of this modernity are too many and complex ever to fully unravel, but Davy serves as an illuminating

case study for some of its constituent parts. Within his first twenty-one years he had placed himself in the front line of the new science, and had held the mirror of the new consciousness up to his own mind in a way that few, if any, had done before him.

Davy could never have achieved this by following one discipline alone. It was his instinct for meshing knowledge from across the known spectrum which raised him to the point where he could receive the revelation of the gas. At least three different disciplines were essential for him to reach this point: chemistry, medicine and poetry.

℘ ℘ ℘

It is as a chemist that Humphry Davy is best known, and it is as a chemist that he enters the frame of this story.

He grew up in the provincial backwater of Penzance, at the tip of Cornwall and about as remote from the mainstream of British public and scientific life as it was possible to be. His local mentors were the conservative stalwarts of the community, for whom a medical career was the proper and realistic way of entering the professional classes; Davy probably envisaged medicine as his ultimate calling, but his early aptitude lay in the fast-moving modern discipline of chemistry. Here, the isolation of gases was one of the recent discoveries which was reshaping the modern understanding of the world. The French chemist Lavoisier had isolated oxygen for the first time in the 1770s, around the time of Davy's birth. Subsequent demonstrations had produced the claim that it was oxygen which caused substances to burn in air, and indeed to nurture and make possible all the dynamic processes of life.

This claim ran head to head with the orthodoxy of the previous generation of chemists that fire was not merely an energetic process but a physical substance, known as phlogiston. For those who maintained this theory, such as the luminary of British gas chemistry Joseph Priestley, Lavoisier's so-called 'oxygen' was not the substance which enabled things to burn, but was in fact phlogiston, fire itself in a latent state.

The isolation of oxygen developed in tandem with the discovery of various other gases – among them nitrogen, nitric oxide and nitrous oxide. All of these accreted explanations analogous to those of oxygen, assigning each a different role in the processes of life and matter. Nitrous oxide had attracted the particular attention of an American chemist, Samuel Latham Mitchill, who saw in it a dark counterpart to oxygen, a sinister substance which brought death where oxygen brought life. His claim was that it was nitrous oxide which was responsible for the processes of disease and decay: an invisible miasma, present everywhere in small concentrations, which disintegrated living tissue and fed the process of putrefaction. He christened it 'septon', the "Great Disorganiser" – and, in the common custom of the time, described its effects in verse:

"Grim Septon, arm'd with power to intervene
And disconnect the animal machine"

Davy, still in his teens, was sceptical of this pronouncement and set out to disprove it. He synthesised nitrous oxide, and ran tests on animals and tissue samples. He established quickly that, although nitrous oxide could not support life without oxygen, it was no more putrefying than air itself, and that air without nitrous oxide was still a sufficient medium for tissue decay.

With the eye for the main chance which would always be his hallmark, Davy cast around for interested parties who might be prepared to engage his services on the basis of this discovery. He set his sights high and, perhaps more in hope than expectation, wrote directly to Dr. Thomas Beddoes, the founder and director of the recently-established Pneumatic Institution in Bristol.

It's with Beddoes that the second plank of the nitrous oxide story is established: medicine. Had Davy remained simply a chemist, he would never have entertained the idea of taking the gas himself, and shifting the focus of his experiments to his own body. But while the chemists had been synthesising, the doctors – one doctor in particular – had been applying the

recently discovered gases to the human body in the search for new medical treatments.

For Beddoes, the new gases were as radical a discovery for medicine as they were for chemistry. Just as Davy was a chemist with a strong interest in medicine, Beddoes was, for a doctor, no mean chemist. He had held a readership in chemistry at Oxford, from which he had been forced to resign as a result of his political radicalism. A strong supporter of the French Revolution and of the Republican movement in Britain, he had written a series of pamphlets which marked him, in the eyes of the establishment, as a political firebrand and revolutionary.

Beddoes' radicalism was not limited to politics: in fact, the main focus of his reforming zeal was the medical profession. Eighteenth-century medicine had largely progressed by discovering, naming and classifying new diseases, leading to a profusion of different schools with competing nomenclatures, taxonomies and diagnoses. For Beddoes, most of these were as meaningful as medieval disputations about how many angels could fit on the head of a pin. All they had succeeded in doing was to elevate the pretensions of the medical profession, and at the same time distance them from the proper focus of their enquiries: how to cure patients. For him, "the sick and drooping poor" were a constant reproach to the claims of modern medicine, and approaches which alleviated their suffering were the only ones which deserved the name of progress.

But there was one school of medicine for which Beddoes had great enthusiasm: the 'Brunonian' system developed by the Scottish doctor John Brown a generation before. Brown had turned medicine on its head by pointing out that, no matter how many hairsplitting definitions and diagnoses the medical profession could come up with, they were still effectively limited by the number of effective medical treatments, which were very few. How much more sensible, Brown had insisted, to reconstruct disease classification from the bottom up: start with the cures, and then classify diseases according to how they could best be treated.

This led Brown to propose a system of the greatest possible

simplicity. All illnesses, he claimed, were characterised either by overstimulation or understimulation of the basic nervous, or 'tonic' system. Consequently the core principle of medical treatment should be either to stimulate the depressed system, or depress the overstimulated one. The classic stimulant was alcohol; the classic depressant, opium.

The Brunonian system threatened a root-and-branch overhaul of the emerging medical science. First, all its categories and theoretical structures would be torn down; second, and even more disastrously, it would put medical treatment back in the hands of the people. Diagnosis and prescription would become little more than common sense, and slim Brunonian manuals would take the place of the swelling ranks of doctors.

As such, the Brunonian system was regarded by the profession as a virtual heresy; but for Beddoes, despite his criticisms of its oversimplifications, it was the only system which offered a solid enough bedrock to be worth building on. And the most effective way of building on it would be to extend the range of treatments: to discover more Brunonian stimulants and depressants, observe their effects and develop their applications. Thus it was that Beddoes had been eagerly researching the new gases like oxygen; thus, too, that when Davy's letter arrived, the offer of a sympathetic, eager and gifted young chemist fell on fertile soil.

Beddoes' new venture, the Pneumatic Institution, was hardly a pillar of the establishment. The use of gases was from the first a radical idea – the concept of an invisible, intangible substance was still generally considered bizarre and exotic, and their differences from ordinary air were still obscure to many (the new gases were commonly referred to as "factitious", or artificial, "airs"). Within medicine, the barely-hidden Brunonian agenda behind their application was hardly designed to ingratiate the pneumatic project with the establishment. Beddoes had applied to the Royal Institution, recently established to offer capital for scientific ventures, but the president, Sir Joseph Banks, had refused to lend funds, professional support or even the Institution's name to Beddoes' scheme. Eventually Beddoes had found funding, but

not from the professional establishment or the movers and shakers of metropolitan London: his backers were provincial *nouveau riche* industrialists from the Midlands, families like the Boultons and the famous potter Thomas Wedgwood.

The Pneumatic Institution was a combination of laboratory, lecture theatre and hospital, serving Beddoes' primary *raison d'être* of treating the poor while also researching and developing new medicines and spreading the word of the revolution in treatment which it hoped to offer. Davy's account of his work on nitrous oxide, accompanied with a modest demand for a "genteel maintenance" in exchange for his services, was enough to bring him into the fold. He was appointed 'superintendent' of the Institution, responsible for administering the 'airs' to its patients.

Thus Davy's talent for chemistry brought him into a world of medicine where the central focus was the effect of substances on the human constitution. After continuing his series of animal tests, he eventually decided to try nitrous oxide himself.

This required no little confidence and bravery, since nitrous oxide was still widely believed to be a deadly poison (both as a result of Mitchill's septon theory and of an ongoing confusion with the genuinely toxic nitric oxide). Davy's initial experiment, on the 11th April 1799, was consequently modest: a brief whiff of the gas, from which he noticed no ill effects. He followed this up with a second attempt five days later, this time with Dr. Kinglake in attendance. Breathing more of the gas, he began to feel the first presentiments of the intoxication to come – a "slight degree of giddiness" and an "uncommon sense of fullness in the head". These passed quickly, and one might have thought that the safety of nitrous oxide as a treatment had been tested satisfactorily. But these fleeting effects had awakened a curiosity in Davy that was more than medical, and he asked for both Dr. Kinglake and Beddoes himself to attend a further, more intensive trial the very next evening.

Davy's curiosity in the psychoactive effects of the gas relates to the third plank of what would become the most

systematic exploration of altered states of consciousness which had ever been attempted: poetry. He notes in his own account that the reason for the experiment of the 17th April was to determine more clearly whether the effect of nitrous oxide was, in Brunonian terms, stimulating or depressing; but the sensation he had experienced had clearly awakened an interest which lay not so much in the treatment of illness as in the exploration of the artistic temperament and the imagination.

The Pneumatic Institution was already the nexus of a remarkable cross-fertilisation between science and poetry. Beddoes himself wrote poetry, something which his son Thomas Lovell Beddoes would become famous for. He was also Samuel Taylor Coleridge's doctor, and contributor of radical political columns to Coleridge's journal *The Watchman*. Coleridge's fellow poets William Wordsworth and, particularly, Robert Southey were no strangers to the Institution and the 'Bristol circle' of scientists and poets, artists and radicals which had developed over the previous decade. For the poets, science was a subject of fascination, offering a new language for the description of Nature in a parallel project to that which the poets themselves were attempting. Coleridge, in particular, was fond of scientific coinings: he would describe someone in a fiery rage as "filled with phlogiston". He also, more enduringly, coined the term 'psychosomatic', a fine description of his own tendencies.

From early in their acquaintance, Davy, Coleridge and Southey had become deeply involved in subjecting the essence of nature to the twin probings of science and poetry. All had been enraptured by the *Arabian Nights* as children, and all maintained their fascination with dreams and visions to the end of their lives. The poets looked to science to provide a new language for thoughts previously inexpressible; Davy looked to poetry to express the sublime and complex ideas which were lost when science – quite properly – turned its microscope onto the minutiae of nature's constituent parts. The same turn of mind which led Davy to shift his attention from one discipline to another made poetic inspiration uniquely satisfying to him; it also led Coleridge and Southey

to recognise the poetic sensibility in Davy and his approach to science. Davy, Coleridge would later say, was "the father and founder of philosophical alchemy, the man who *born* a poet first converted poetry into science". One of the leitmotifs of the Romantic movement was that the natural world can't be fully understood by dry-as-dust dissection without considering the extent to which it's coloured, even constructed by the human mind and imagination, and Davy's nitrous oxide project must have been immediately recognised as a crucial scientific incursion into the new territory.

In truth, though, Davy's generosity to poetry was a little less than the poets' generosity to science. While he loved both, he insisted that in the final analysis it was science, not poetry, which enabled man "on Newtonian wings sublime to soar". Nevertheless, especially as a young man, he was an ardent composer of poetry – and his search for poetic inspiration was one of the first tasks to which he would turn the new intoxicant gas. But his poetry was generally regarded as less than inspired. Southey observed sadly that Davy "had all the elements of the poet; he only wanted the art": though a pioneer, even a genius with the tools of science, their poetic equivalents remained beyond his grasp.

The subsequent progress of the nitrous oxide project after Davy's initial experiment makes little sense in the context of a clinical medical trial, but a great deal in the context of an ambition to weld the languages of science and poetry together to describe the indescribable, and allow access to the nebulous realms of 'genius'. Armed with the gas, with an intense interest in medical treatment and a burning desire to explore and describe the world of the imagination, Davy emerged from his first psychedelic foray with his mind perhaps temporarily blown, but with both the means and the motive to embark on the first systematic drug exploration of its kind.

℘ ℘ ℘

Within a year of this first experiment, Davy and the Bristol circle had produced a massive tome on the new gas and its effects. Its equally massive title, *Researches, Chemical and*

Philosophical; chiefly concerning Nitrous Oxide, or dephlogisticated nitrous air, and its Respiration, introduces over five hundred pages of meticulous accounts of the synthesis of the gas, its effect on animals and animal tissue and, most ambitiously, detailed descriptions of the subjective effects of nitrous oxide intoxication on Davy, Beddoes and another twenty or so subjects, including Coleridge and Southey. Organised and presented with striking clarity, it reflects the remarkable nature of the project which it describes, and is still unsurpassed as a template for the reporting of psychedelic science. When set against, for example, the equally doorstopping contemporary volumes of Alexander and Ann Shulgin, with their similar combination of experimental chemistry and subjective reportage, it's clear that there has been little formal advance in the presentation of such material in two centuries, and that *Researches . . .* is likely to remain the classic of the genre.

As the title suggests, the thrust of the research which followed Davy's first journey was more philosophical than medical, and the book focuses less on the medical treatments with the gas than on the quest to unravel its effects on the mind, the emotions, the senses and the subjects' perception of the world around them. (Davy's original dedication of the book to Beddoes was removed just before publication, which may suggest a last-minute realisation that the finished work had strayed further from the medical ambit than originally planned.) One of the first subjects, probably within days of Davy's own session, was Robert Southey, whose ecstatic letter to his brother after trying the gas for the first time sets the tone for the explorations which were to follow:

> "Oh Tom! Such a gas has Davy discovered, the gasoeus oxyd! Oh, Tom! I have had some; it made me laugh and tingle in every toe and fingertip. Davy has actually invented a new pleasure for which language has no name. Oh, Tom! I am going for more this evening; it makes one strong and so happy, so gloriously happy! Oh, excellent air-bag! Tom, I am sure the air in heaven must be this wonder-working air of delight!"

Only a few days before, nitrous oxide had been "grim Septon", the universal toxin, agent of all pestilence and decay; now it was, in Davy's words, the "pleasure-producing gas", and as such began to make its chaotic and ecstatic inroads through the Bristol circle. Scientific self-experimentation had demonstrated, for the first but not the last time, that the theories of a substance's likely effect, even those of its discoverer, are no match for the direct experience of the substance from within.

And so the nitrous oxide trials began. The nitrate of ammoniac reaction must have been bubbling almost constantly as the circle made repeated trials on themselves and each other, on doctors and patients, men and women, scientists and men of letters. Davy himself, by his own account, was inhaling the gas three or four times a day. The laboratory became a jumping-off point for an experience without precedent or limits, the inner sanctum of an ever-expanding brotherhood of initiates into a new universe.

Even the supposedly medical trials of the gas persisted in producing results which were more philosophical than physical. Davy was constantly impressed by the poverty of the 'language of feeling', the feebleness of the patients' attempts to put their inner revelations into words. Having experienced the same on his own maiden voyage, he was aware that this was not because the patients were mentally numbed, but because they were being overstimulated beyond the reach of words themselves: he confessed in the *Researches* . . . that "I have sometimes experienced from nitrous oxide, sensations similar to no others, and they have consequently been indescribable". The standard medical question, "how do you feel?", was almost always answered with confusion, puzzlement, a sense of the inadequacy of language to map these new reaches of the mind. Davy was struck by the poverty of one patient's answer to this question: "I do not know, but very queer". As James Thompson, one of the experimental subjects, put it: "We must either invent new terms to express these new and peculiar sensations, or attach new ideas to old ones, before we can communicate intelligibly with each other on the operation of this extraordinary gas."

Some subjects, however, produced metaphorical answers which were both vivid and oblique. Another patient's answer to "how do you feel?" was "I feel like the sound of a harp". Musical analogies emerged unexpectedly again and again, attempting to catch the aural effect of ringing harmonics and gradually ascending tones which often accompanies the rising nitrous intoxication. Beddoes, emerging from a deep immersion, once shouted out the single word "Tones!" All this seemed to connect to the poetic images familiar from the works of Coleridge and the Romantics: the Aeolian wind-harp, for example, which is played by no man but draws its harmonies directly from Nature herself.

One frequent – though not universal – response to the gas was the sensation of exquisite pleasure. Felt powerfully by both Davy and Southey during their initial highs, this must have been strongly suggested to the subsequent subjects in advance. But, although this pre-programming may have minimised the anxiety which can be produced by the disorientation, there is no doubt that the pleasure experienced by most of the subjects was not only real but intensely powerful. One account by a Mr. Hammick records that, "I had not breathed half a minute when, from the extreme pleasure I felt, I unconsciously removed the bag from my mouth; but when Mr. Davy offered to take it from me, I refused to let him have it, and said eagerly, 'Let me breathe it again, it is highly pleasant, it is the strongest stimulant I ever felt!'" Coleridge himself adds: "Towards the last I could not avoid, nor felt any wish to avoid, beating the ground with my feet; and after the mouthpiece was removed, I remained for a few seconds motionless, in great ecstacy."

But although the experiments demonstrated a high degree of consensus about the effects of the gas, they also revealed ambiguities at almost every turn. The powerful pleasure effect was contradicted by, of all unlikely sources, Southey himself. Returning to the gas after a period of illness, he found that, "the nitrous oxide produces an effect on me totally different . . . the sensation is not painful, neither is it in the slightest degree pleasurable".

Coleridge's account of his compulsive foot-stamping points to another effect which emerged frequently (though by no means invariably) from the trials: "antic" behaviour, the acting out of strange and unconscious impulses. A Mr. J.W.Tobin recalled that, "When the bags were exhausted and taken from me . . . suddenly starting from the chair, and vociferating with pleasure, I made towards those that were present, as I wished they should participate in my feelings. I struck gently at Mr. Davy and a stranger entering the room at that moment . . . I then ran through different rooms in the house, and at last returned to the laboratory somewhat more composed." There are several such accounts of impulsive physical action, which seem surprising from a substance which is essentially a dissociative anaesthetic whose effects include the loss of motor coordination; but the "antic" effects of nitrous oxide would reappear decades later, and even more dramatically, in a quite different context.

But alongside the distractions and laughter, the gas also consistently delivered genuinely sublime experiences and moments of profound insight. These seemed to be oddly inseparable from the ecstasy and hilarity: it is one of the perennial paradoxes of nitrous oxide that its effects seem to mix the juvenile and trivial with the philosophical and profound, and that any attempt to separate them out appears somehow artificial.

One of the most interesting accounts was offered by Dr. Roget, best remembered as the compiler of *Roget's Thesaurus*. "My ideas succeeded one another", he wrote, "with extreme rapidity, thoughts rushed like a torrent through my mind, as if their velocity had been suddenly accelerated by the bursting of a barrier which had before retained them in their natural and equable course". This metaphor of the ability of drugs to flood the brain with perceptions which are usually 'edited' is familiar to us from Aldous Huxley's *Doors of Perception*; as a metaphor it is not only an enduring one but one which seems quite close to our current understanding of the brain's neurochemical action. The Bristol circle's search for a 'language of feeling' was not without its quiet successes.

℘ ℘ ℘

It's hard to imagine just how strange the scene in the Pneumatic Institution's laboratory must have become as these bizarre experiments continued through the days, weeks and months. Day or night, visitors would be more likely than not to find some subject in the grip of a temporary lunacy, groaning, giggling, babbling, uncontrollably acting out inscrutable fantasies. It's hardly surprising that the experiment seemed to take on ceremonial, almost sacred dimensions. The rules of outer society were replaced by a code whereby those in the thrall of the gas were left undisturbed in their reveries, excused almost any antisocial behaviour, allowed the freedom to express themselves and listened to attentively as they channelled the revelations of the gas. Despite Davy's rigorously maintained empirical procedures and committment to the modern disciplines of 'sceptical chemistry', it's hard to avoid parallels with religious rites of spirit possession, trance, oracles or speaking in tongues. The laboratory must have become more than simply the source of the gas: it must, on some levels, have taken on the qualities of a sacred shrine, a sublime place of power, the inner sanctum of the mysteries.

This ceremonial aspect of the nitrous experiments has not been lost on historians of science, some of whom have tended to dismiss the *Researches* . . . – and, by extension, the entire pneumatic project – as a drug-addled wallow in self-indulgence, bad science and worse poetry. There are various reasons for this. One, of course, is the moral and quasi-medical disapproval of drug intoxication which has grown up in the interim. Another is simply embarrassment at having to accept that Sir Humphry Davy, one of the great heroes of science, should have been so clearly and genuinely interested in the type of chemical mind-expansion which has since been so thoroughly marginalised. Another is that the Pneumatic Institution ultimately failed in its quest to introduce "factitious airs" into medical treatment, and has thus been dismissed with hindsight as at best a dead end, at worst a deluded aberration.

These tendencies can, to a greater or lesser extent, be put

down to a combination of prejudice and hindsight; but there are other common objections which make scientific claims which are susceptible to more detailed examination. Chief among these is that what was experienced by the Bristol circle, and is described in the *Researches* . . . , has much less to do with nitrous oxide than with some form of group hysteria. The over-enthused, highly-strung members of the experiment were fired up by Davy's claims and took the gas-breathing as an excuse to work themselves up into lyrical and antic frenzies. But this interpretation was forseen by Davy himself, and guarded against with proper blind procedures. On several occasions he told his subjects that he was giving them the gas, but substituted ordinary air: in these cases, he found, they reported that the gas had no effect.

A related interpretation is that what the subjects were experiencing was not the action of the gas, but simply the oxygen starvation to the brain produced by their favoured method of breathing it from the silk bag. 'Anoxia' is indeed one of the side effects of nitrous inhalation, and can be responsible for some of the effects described – dizziness, for example, or ringing in the ears. But the frequent reports of ecstatic pleasure, acceleration of mental processes, physical warmth and "thrilling" sensations are hard to square with the well-known effects of oxygen starvation or dropping blood pressure. Under these quasi-scientific objections, too, runs a thread of prejudice: the reluctance to admit that there are indeed mind-altering drugs which can offer access to the realms of insight and ecstacy which the Bristol circle describe.

The chief irony of the 'scientific' objections to the nitrous experiments is that they have all been put forward in ignorance of what nitrous oxide actually does and how it works. Its mechanism of action, even throughout its extensive subsequent career as a surgical and dental anaesthetic, has been poorly understood: it's only within the last few years that it's been convincingly explained in neurochemical terms. It now appears that it works on two separate neurotransmitters, glutamate and endorphin, and among the endorphin complex on both the mu and kappa opioid receptors. The effects of

glutamate antagonism are still largely obscure, and best understood from the action of the other psychoactive drugs which have similar mechanisms of action – ketamine and phencycladine (PCP). These drugs have demonstrated that glutamate suppression has the power to produce powerful and chaotic effects on sense-perception which go far beyond simple anoxia. And the action of nitrous oxide on, particularly, the mu opioid receptors (named after morphine) offers for the first time a convincing rationale for its powerfully euphoric effect, as well as the tingling and "thrilling" physical sensations associated with it.

So it's only now that science has genuinely begun to develop the tools to assess the effect of nitrous oxide from the outside, and these effects (to the degree with which such tools can render them) provide remarkable corroboration for the Bristol circle's observations – and, one would imagine, insuperable problems for historians of science who continue to insist that the effect was 'all in their minds'. It's hard to imagine how such claims could ever have been sustained if the self-experimentation which Davy pioneered had remained an acceptable tool of scientific enquiry.

Another and, perhaps, the most common dismissal of the Bristol circle's work is that the group were too confused and impaired by their drug-induced voyages to notice the one medical application of nitrous oxide which subsequently turned out to be of enormous and enduring value: its use as a short-term anaesthetic. Some medical historians attribute this to a chemical process which produced nitrous mixed with too much air to produce the loss of consciousness which is now regarded as the effect of a 'proper' anaesthetic dose: this, though, ignores the evidence that the subjects were deliberately inhaling quantities of the gas which would allow them to retain consciousness. It also ignores the fact that Davy specifically notes his observation of the anaesthetic effect. "As nitrous oxide", he writes, "in its extensive operation seems capable of destroying physical pain, it may probably be used with advantage during surgical operations".

But there were reasons why this didn't seem an obvious

avenue to pursue at the time. For one thing, the gas didn't seem to relieve pain in all cases: sometimes quite the opposite. Particularly in the cases of the (anonymous) female subjects, inhalation often led to "hysterical affectations" or panic attacks, followed by severe headaches and weakness. There's no biological reason why the gas should have an adverse effect on women – we may suspect a bias in the small sample of subjects, the social roles inhabited by eighteenth-century women, or an ingrained chauvinism in the scientific culture – but Davy's findings gave him good reason to doubt the wider anaesthetic application. Many of his subjects, too, described feelings of drowsiness, but others acted their experience out physically or reported "irrepressible muscular strength". All this sat uncomfortably within the Enlightenment view of Reason, whereby the mind could not contain contradictory ideas at the same time; it also caused both Davy and Beddoes to question the Brunonian system itself, since the gas demonstrated both its polar opposites of depression and excitability. With hindsight, however, it has become almost a truism of psychedelic science that a substance can present both a strong effect and its complete opposite: cannabis, for example, has been abundantly demonstrated to produce both relaxed wellbeing and paranoid anxiety. Such paradoxical observations point not to a failure of the scientific method, but to a general tendency of psychoactive drugs to intensify either the positive or the negative aspects of the experience – or, indeed, both simultaneously.

But all this isn't to assert that Davy's prodigious explorations of the nitrous oxide experience were without their dangers. More than the other subjects, his trials progressed from moderate inhalation to extreme and even reckless doses and combinations. He inhaled the gas in different quantities, at different times of day, on a full and an empty stomach. He took his silk bag down to the river Avon, making a spectacle of himself by passing out and, on recovery, having to "make a bystander acquainted with the pleasure I experienced by laughing and stomping". He tried the gas in combination with different stimulants: he drank a bottle of wine

methodically in eight minutes flat, and then inhaled so much that he passed out for two hours. He also experimented with oxygen, nitrogen and 'hydrocarbonate', frequently inducing giddiness and a plummeting pulse: on one occasion, he recalls, "On recollecting myself, I faintly articulated: 'I do not think I shall die'". He developed difficulty sleeping, and felt in retrospect that his health had been "somewhat injured". His colleagues may have been concerned; acquaintances were frequently judgmental. Joseph Cottle, who wrote biographical material about his recollections of Coleridge during this time, was one of many who speculated that Davy's self-experimentation led to chest problems which ultimately shortened his life. Again, this is a view which has obtained broader currency than the medical evidence really allows. Even prolonged nitrous oxide use, in subjects with normal blood pressure, causes little damage apart from a rapid depletion of Vitamin B12 – although in Davy's case it's plausible that either the anoxia associated with the delivery method or the other less benign gases may have done him more harm than good. But it's notable that Coleridge, thirty years later and after a lifetime of debilitating struggle with his opium habit, still felt that their nitrous experiments had been uncommonly positive. "It is said", he comments, "that every excitation is followed by a commensurate exhaustion. The excitation caused by nitrous oxide is an exception at least; it leaves no exhaustion on the bursting of the bubble."

Also raised, not for the last time in the exploration of drugs in the nineteenth century, was the spectre of addiction. In the *Researches* . . . , Davy admits that he noted a level of compulsion in his nitrous use, confessing that "the desire to breathe the gas is awakened in me by the sight of a person breathing, or even by that of an air-bag or air-holder". Cases of nitrous oxide addiction are not unheard of even today, but they remain rare, and in the absence of the classic addiction markers of physical tolerance or withdrawal symptoms are usually regarded as, at most, psychological. The description of Davy as a "nitrous oxide addict" is a commonplace of the subsequent literature – but it would clearly be unnatural for anyone not to

desire, or even crave, something which produced such intense levels of pleasure. We must, as always, beware of those who use the term 'addiction' in a pseudo-medical sense to explain away the repeated use of a substance in preference to other motives whose reality they are reluctant to credit.

℘ ℘ ℘

The *Researches* ... may subsequently have come to be regarded as Davy's juvenile aberration, but there's no doubt that, at the time, they were regarded as evidence of his prodigious scientific talents. After their publication, he was invited to the Royal Institution in London where he delivered lectures to the metropolitan scientific community, followed by a trial of the "joy-inspiring gas" the next day with a "party of philosophers". Both the lectures and the self-experimental session were greeted with enough enthusiam to win Davy a research post at the Royal Institution – but they would also mark the end of his association with the gas.

It is still unclear why Davy abandoned his nitrous experiments. Some people, then and since, saw it as a sign of his ambition: the gas had carried him from distant Cornwall to provincial Bristol and now to the hub of science, London itself – and as such its job was done. Others suggest that he was concerned about his own health, either physical or mental, but there's little evidence of this from his own hand. Others point, probably pertinently, to the image which the gas had developed among the more traditionalist ranks of the scientific establishment. Although Davy's Royal Institution lectures were favourably reviewed in various magazines and journals, they were also savagely criticised and lampooned. James Gillray's satirical engraving of the event remains perhaps the best known image of the entire nitrous oxide programme: Davy working the hydraulic bellows while the gas is administered to a bewigged, frock-coated Sir John Hippisley, who farts it out prodigiously through his coat-tails. An anonymous columnist in the *Sceptic* magazine lambasted the "quacks-pneumatic" and their theories as "mere vapour, which involves all objects in obscurity". Nitrous oxide

quickly came to symbolise the folly and vanity of the 'gassy', chattering radicals, intoxicated with cloud-cuckoo-land fantasies of abolishing the monarchy and clipping the wings of the medical profession. Like mesmerism before it, the gas implied a mechanistic natural philosophy within which the role of religion became more open to question: to conservatives who blamed such Enlightenment ideas for the French Revolution, it represented the spectre of radical, even atheist reform. The self-experimenters claimed that they knew things which those who had not taken the gas did not: but how could these claims be more than self-important, extravagant delusions?

It was not as if Davy had no ideas to his name but nitrous oxide. Already in Bristol he had begun the work on electrolysis and the voltaic pile which would shortly make him famous, and in time carry him to the very summit of his profession. Nitrous oxide, extraordinary as it was, had no immediate application. The Pneumatic Institution was doing badly: the patients were already complaining that they were being used as guinea-pigs, and within a year Beddoes would have to begin paying them to receive gas treatments. Davy's dereliction of the cause may not have been admirable, but it was understandable. As for Beddoes, his rueful but prophetic verdict was that "we might even prepare a happier era for mankind, and yet earn from the mass of our contemporaries nothing better than the title of enthusiasts".

But it seems that, even if Davy gave up on nitrous oxide, the gas did not give up on Davy. Throughout his glittering career in the scientific mainstream, he never abandoned his quest for inspiration from other realms, and continued to resort to poetry to give his ideas a grandeur and fullness which the language of science lacked. His lectures at the Royal Institution remained "figurative and poetical", and his themes still seemed to carry irresistibly into philosophy and the imagination. His last, posthumously published work, *Consolations in Travel: Or, the Last Days of a Philosopher*, is an imaginative voyage in the course of which he is carried through space, lectured by the spirit of Genius and meets the Unknown. The

36

doors which nitrous oxide opened for him seem never to have fully closed.

℘ ℘ ℘

For Davy and the Bristol circle, 1800 may have marked the end of the nitrous oxide experiments; but the diffusion of the gas into the atmosphere of the nineteenth century was only just beginning. Over the next fifty years it escaped its medical origins entirely, becoming a recreational toy in a series of increasingly bizarre contexts, and spontaneously generating its enduring nickname of 'laughing gas'.

Although this new twist owed little to either Davy or Beddoes (except that they foreshadowed it by noting the 'antic' effects of the gas in company), it highlights one of the differences between them which might well have widened into a rift had the nitrous experiments progressed far enough. For Beddoes, arch-democrat, there was no doubt that the gas was for all: he foresaw a preventative public health programme where the entire population would not merely be offered the gas as a corrective to disease-ridden environments but perhaps even forced to use it for their own good. For Davy, soon to be acclaimed as the Romantic 'genius' of science *par excellence*, its primary interest was as a stimulant for the elite who were able to approach the sublime – like Coleridge and, indeed, himself. He doubtless wanted its use to become more widespread, but saw its future milieu as the 'parties of philosophers' to whom he introduced it at the Royal Institution.

The Pneumatic Institution project did develop far enough to make it clear that transferring the experiment from the Bristol inner sanctum to the broader world was surprisingly problematic. In 1799 Davy attempted to franchise the gas, passing the details both chemical and philosophical to the Watt brothers in Birmingham. But their reports were disappointing. They found the preparation difficult, and were never quite sure that the substance they were producing was the same as Davy's; but, more than this, they were unable to capture the same spirit which pervaded the Bristol laboratory so irresistibly. The effect of the gas seemed to vary from

person to person; no-one was quite sure what they should be experiencing; where the Bristol circle all leapt spontaneously to the same truths, the Birmingham trials failed to manifest the revolution in consciousness which seemed so palpable and universal a hundred miles to the south west.

Once the *Researches* had been published, however, the experimental chemistry of nitrous production was in the public domain – and, given the extravagant and public claims which had been made for it, it was no surprise that the curiosity of many, chemists included, was piqued. In a manner which would be repeated throughout the nineteenth century – and remains equally familiar today – the new substance began a process of osmosis into society at large, a diffusion which, within a few years, led both to the ready availability of nitrous oxide in the public arena and also to a new public understanding of its effect which owed little to the terms in which science had first presented it.

This process of diffusion is impossible to recontruct in its entirety, but the fragmentary records demonstrate the manner in which the revelations of nitrous oxide made their way out into the broader world. By 1814, for example, the *Philadelphia Gazette* was carrying small ads for weekly "lectures" by a Dr. Jones on the gas and its effects. These took place in a small public hall, which was prepared with some theatricality, with the raked seats separated by bars from the lecture-pit to protect the ladies in the audience from any dangerous effects of the intoxications. Dr. Jones would begin with a dry lecture on the history and chemistry of the gas, over the audible shuffling and boredom of the audience, until it was judged that lip-service to science had been properly paid and the "supernatural experiments" could safely begin.

The account we have is by Moses Thomas, a vigorous pamphlet subtitled "*A Physico-Politico-Theological Lucubration on the Wonderful Properties of Nitrous Oxide*" which veers precipitately halfway through into a state-of-the-nation diatribe on the patriotic necessity of invading Canada. Before this, though, it includes a thorough blow-by-blow account of Dr. Jones' session. After the introduction, young men are

invited one at a time from the audience to make their own experiments with the gas. The first is a fifteen-year-old youth who, upon inhaling the gas, marches up to the barred audience. A gentleman holds up his cane to bar him from coming any closer; at this, the youth becomes furious. "That tyrant siezed my cane!" he exclaims, before attempting to leap into the audience and reclaim it, and having to be restrained by five men. As the effect of the gas passes, he turns round to the company "with an air of good-humoured hilarity".

After this, every red-blooded male in the house is clamouring for a taste of the "delicious poison". One bears down on the doctor, forcing him to scuttle off, before turning to the audience and declaiming: "By Heavens! – 'Twere nobly done! – To snatch the bridal honours – From the blazing Sun!" Another, returning from the gaseous realm, turns to the doctor, shakes his hand and announces: "Well, doctor, here I am at last!"

Behind these seemingly chaotic outbursts of spontaneity, we can see that a complex interaction of the innate effects of the gas, the contrived setting and the expectations of the audience has produced a new paradigm for the intoxication. Superficially clothed in the language of science, it has become a space not for launching into the sublime, but for public demonstrations of disinhibition. The caged audience sets up the suggestion that the 'antic' effects of the gas are those which are expected; the one-at-a-time audience selection turns the expression of these effects into a performance. Anyone who, like Coleridge, "remained motionless, in great extasy", would probably be booed off stage. Not unlike today's stage hypnotism shows, the entertainment is provided by an audience who already have a preconceived idea of how such entertainment is constituted.

It's hardly to be wondered at that the nitrous oxide shows took off, and rapidly became a new staple of public entertainment. The gas could be got at 2d a dose, but the apparatus required a substantial initial outlay: thus the experience became something that was prohibitively expensive to indulge in private, but virtually a licence to print money for

anyone who set up to offer it in public. Unsurprisingly, too, the 'professionals' never tired of stressing the dangers of either synthesising or inhaling the gas without 'expert' supervision.

By 1824, nitrous oxide shows were part of the variety show at London's Adelphi Theatre: "Uncommon Illusions, Wonderful Metamorphoses, Experimental Chemistry, Animated Paintings etc.". Humphry Davy's name was prominent on the poster as, at other shows, were the ecstatic soundbites of Robert Southey – the scientific veneer remained important to selling the show as a 'genuine' marvel of science, although the scientific method associated with it had long been forgotten. Also, by 1824, its chemical nomenclature had been largely succeeded by a universally recognised and enduring common coinage: "The Laughing Gas".

A German naturalist called Schoenbein was one of the many thousands to witness these shows, though one of the few to write about it. In the Adelphi, the scientific preamble is interrupted by a heckler (a plant?) from the audience who shouts that the wonders of the gas are "all nonsense and humbug"; of course, he is the first to be invited up on stage, where after receiving his dose he "beat around him like a madman and assaulted the 'Experimentator'". Schoenbein is under no doubt that what he has seen is new, undoubtedly marvellous and destined to become still more popular: "Maybe it will become the custom for us to inhale laughing gas at the end of a dinner party, instead of drinking champagne".

Nitrous shows remained a staple of the variety circuit in Britain, but it was on the much larger travelling 'carny show' circuit in America where they truly came into their own. As a 'novelty', their repeat value in British cities was as nothing compared to the vast tracts of the States where the novelty could be repeated in a different town night after night for years. One of the first itinerants to make a success of this was an eighteen-year-old Samuel Colt, later to design the first mass-produced revolver, who toured a nitrous show around the East Coast from Canada to Maryland.

But the American 'laughing gas shows' were to produce an entirely unrehearsed surprise, a spontaneous revelation of the

properties of the gas which would once more transform the public perception of its effects and propel it into an entirely new arena.

<p align="center">℘ ℘ ℘</p>

During the 1840s, a travelling temperance campaigner called Dr. Gardiner Quincy Colton was plying carnivals and show-grounds with an exhibit known as *Court of Death*. This was simply a huge painting, a crowded canvas depicting the evils of drink and the pits of hell, complete with a fire-and-brimstone lecture on the subject. At 25 cents a showing, the same as a magic lantern show or fairground ride, he found himself struggling for business, until he had the idea of adding nitrous oxide to the mix.

With the gas, he also added the now-familiar trappings: twelve strong men to protect the performers from the unpredictable effects of the intoxication, 'safe' dress seats for the ladies, and a gentlemen-only rule for the volunteers. He proved to be an expert and popular master of ceremonies, not only adept at holding forth on the science but also at reinterpreting its effects to reinforce the moral of his show. The gas, he pronounced, had the uncanny effect of materialising original sin. Safely, temporarily and reversibly, it would expose the inner natures of the audience, showing how bestial they would all become unless they made temperance their guiding light. Part of the appeal of Colton's show proved to be his expertise at 'guessing' what the true inner nature of each audience member would prove to be – in the act of doing so, presumably, presenting them with the idea of what he expected them to do and effectively challenging them to do it. He was doubtless helped by the popularity of his shows which allowed him, in the manner of the modern stage hyp-notist, to select only the "most interesting subjects" to experiment with the gas. The whole routine worked so well that local newspapers began to claim that his method of guessing inner natures was even "more accurate than phren-ology". His temperance lecture, too, gained enormous power from the demonstration that preceded it: audiences now,

instead of a prologue of science, received an epilogue of religion.

In 1844, Colton took his gas-fuelled *Court of Death* show to Hartford, Connecticut, where a young dentist called Horace Wells happened to be in the audience. One of the volunteer performers, a man called Cooley variously identified as a carpenter or a drugstore clerk, was gripped by the typical 'antic' mania under the influence; untypically, though, he was allowed to rush into one of the front benches, smashing his shin against it quite badly. He carried on entirely unaware of his injury until the gas wore off, at which point he began to complain of severe pain. Wells, the doctor in the house, examined him and, finding the injury to be quite severe, was seized by the idea that nitrous oxide might make an effective dental anaesthetic.

This idea was probably motivated by some level of self-interest, since Wells himself had a wisdom tooth in need of extraction and had not yet volunteered himself to any of his colleagues. At this point, he asked Colton if he would be prepared to administer the gas to him during the operation.

Colton agreed, and Wells' tooth was extracted without difficulty and, as far as anyone could observe, painlessly. This observation was confirmed by Wells himself, who appears to have undergone some sort of revelation, both professional and personal, under the influence. He emerged, not unlike Davy, proclaiming in prophetic manner the existence of a new dispensation: "A new era in tooth-pulling!" are his reported words. When his colleagues tried to persuade him to patent this technique of dental anaesthesia, he more closely echoed Beddoes: "No! Let it be free as the air we breathe!"

Unfortunately for Wells, this pinnacle of revelation was followed by a vicious succession of professional and personal disasters. As the fame of his new dental treatment spread – locally, at first – a former partner named William Morton came after him for a share of the action. But the value of the entire project was thrown into doubt in December 1844 when Wells persuaded a leading surgeon, John Collis Warren, to carry out a public demonstration of the new anaesthesia in

surgery at the main hospital in Boston. It was a disaster: the patient, a young boy, cried out during the operation and Wells was booed from the theatre. It was later established that the boy had not in fact felt any pain, nor been aware of the moment when the tooth was extracted; but the medical men had already lost interest.

In the face of these setbacks Wells seems to have retreated, partly under the cover of scientific experiment, into habitual use of nitrous, chloroform, ether and other anodyne inhalants. During this stressful period, a friend came to visit him, asking a semi-professional favour. This friend had recently had acid thrown on his clothes by a New York prostitute, and asked Wells to help him obtain his own supply for revenge. He did so, and the friend was soon back at his door asking for more: it had been a great success, and he was fired up with the notion of starting a concerted acid-throwing campaign to drive the entire trade off the streets. Wells was shocked by the idea but must have brooded on it: a few days later, walking the streets on a melancholy chloroform binge, he himself threw acid over a streetwalker's shawl. He was arrested, imprisoned and, under the combined influences of guilt and chloroform, committed suicide in his cell by carefully opening his femoral artery.

℘ ℘ ℘

It's with Horace Wells, the pioneer and father of dental anaesthesia, that the medical history of nitrous oxide truly begins. In the half-century since Davy's *Researches* it had sporadically been tried as a medical treatment for asthma, cholera and rabies, but with little success. It had become a novelty without application, sold by the public to each other with the gloss of science but of no use to science itself. Today, it has been taken under the wing of medicine to the extent that most people, doctors and the public at large, believe that it has never been anything but an anaesthetic – indeed, that it was synthesised specifically for that purpose. Most clinical textbooks give the date of its 'discovery' as 1844. The first fifty years of its life present a deviation from this retrospective view which is far easier to edit out than to explain.

Hard to explain with hindsight, too, is how slow the medical establishment were to accept the use of what is still regarded as one of the most durable and indispensable of surgical anaesthetic agents. Morton, Wells' former partner, abandoned his interest in nitrous anaesthesia after Wells' death, concentrating instead on ether which was in the process of being developed for the same purpose – and, indeed, from the same starting point of a medical man witnessing "ether frolics". As the brief interest in nitrous subsided, the only person who remained in the frame was the man with whom the flurry of interest had begun, Gardiner Quincy Colton. Abandoning *Court of Death*, he reinvented himself as the Colton Dental Association and began offering nitrous anaesthesia to dental patients himself. The 'painless method' was spread by word of mouth for nearly twenty years before the medical establishment was prepared to give it another try, and its efficacy was finally demonstrated to the satisfaction of the profession in New York in 1863. By the time it was adopted by their official bodies, Colton had already franchised his operation across several large American cities and assisted in at least 75,000 surgical extractions.

But although the gas had finally completed its diffusion into the medical mainstream, it resolutely refused to be contained within it. No sooner had it received the label of surgical anaesthetic than it began to be vigorously re-proposed as something else entirely: a source of mystical or even religious illumination.

℘ ℘ ℘

One of the thousands who passed through the Colton Dental Association in the 1860s was Benjamin Paul Blood, a farmer, bodybuilder, calculating prodigy and relentless pamphleteer who first experienced the effects of the gas during dental surgery in upstate New York. Not uncommonly, he had the powerful sensation that the secret of life had been briefly and tantalisingly laid bare under the influence; less commonly, he was driven to synthesise the gas himself and persist with his experiments. After ten years of self-experimentation, he

produced an intense and idiosyncratic pamphlet on the subject, entitled *The Anesthetic Revelation and the Gist of Philosophy*.

Blood's claim was dramatic, a burst of vision from a perspective which he claimed was not merely important but fundamental and undeniable. He claimed that the 'Anesthetic Revelation' was nothing less than the initiation of mankind into "the Open Secret of Being . . . the primordial, Adamic surprise of Life", for which the only analogy could be the eating of the apple of knowledge in the Garden of Eden. Nitrous oxide demonstrated that "the Kingdom is within": the entire history of metaphysics and philosophy is made redundant by the direct experience which the gas makes possible. This experience is incommunicable, not because it is vague but simply because it is beyond words, a fundamental level of truth which we can only approximate with ubiquitous terms like 'God' or the presiding Supreme Genius of the Universe, a "thick net of space containing all worlds". Further levels of description are unnecessary, as nitrous oxide provides us with direct access to a truth which is "inevitable" and "ever the same".

Blood was a well-known character in his small town, famous for heckling lecturers and exposing touring spiritualists, always good for a broadside letter in the local paper but ill-placed to foist an entirely new understanding of the nature of existence upon the world. *The Anesthetic Revelation*, self-published and sent unannounced to everyone Blood could think of, must have raised a few eyebrows but failed to make any public impact. As his flurry of self-publicity subsided, however, it became clear that a handful of people had been sufficiently intrigued to try the gas themselves, and Blood's initiative led gradually to the formation of a loose correspondence circle.

Its greatest success was among the ranks of the recently-formed Society for Psychical Research in England, a network of spiritualist scientists (and scientifically-minded spiritualists) who were making a concerted effort to validate spiritualism's claims in terms which the scientific community would be forced to accept. The SPR had a strong appetite for

experiment and the search for replicable phenomena which could be produced under test conditions to demonstrate effects beyond the explanation of science as it was then constituted. Thus nitrous was highly appealing to them, promising as it did an explanation of previously metaphysical speculations in terms of a knowable and repeatable physical mechanism. The spritualist Edmund Gurney, the Nobel-prizewinning physicist Prof. William Ramsay, the leading British psychiatrist Sir James Crichton-Browne and the art historian John Addington Symonds were among the self-experimenters who contributed their observations of nitrous oxide phenomena to the SPR journals.

Once again the gas had escaped from the lab, but this time it had found itself in a milieu almost diametrically opposed to the "antic" performances of the century's beginning. In terms of the notional schism between Davy and Beddoes, it had passed from a democratic model of "the gas for all" into the hands of an elite "party of philosophers" who felt that its stimulation of the 'higher' faculties was only of interest to those in whom such faculties were already developed, and who were interested in extending them still further. This agenda was specifically formulated by, for example, the psych-iatrist Sir James Crichton-Browne, who wrote in *The Lancet* that nitrous oxide's effects "in persons of average mental cali-bre . . . are pleasant and stimulating but in no way remarkable; but in persons of superior mental power, they become thrill-ing and apocalyptic. A working man who inhales the gas intimates on his recovery that he felt very happy, as if he had had a little too much beer, and a philosopher announces that the secret of the universe had been, for one rapt moment, made plain to him". In the climate of the late nineteenth century, where the immoderate habits of the working classes were an acute cause of anxiety, it was important for 'serious' researchers to stress that the activity in which they were engaged differed from the public intoxications of an earlier era not merely in degree but in kind.

℘ ℘ ℘

The outside world – even the broader world of letters and academia – might still have heard little of this minority activity had it not been for the man frequently cited as the greatest philosopher America has ever produced – William James. James, a doctor turned Harvard professor (and brother of the novelist Henry), encountered Blood's theory in the only form in which it was publicly reproduced, an anonymous digest in *The Atlantic Monthly*, and recognised immediately that it might prove relevant to what he had increasingly come to regard as the central dilemma in modern thought.

James' problem was this. As a doctor and psychologist, he had great faith in the programme of scientific materialism, which he felt undoubtedly provided the answers to many questions which, before its development, could not even be properly asked. But he also felt that its method was intrinsically loaded in favour of certain classes of phenomena and states of mind which it explained well, and against others which it did not. Of prime interest to him among these were those states and experiences usually referred to as 'mystical' or 'religious', which were increasingly becoming damning terms within the scientific community, carrying with them implications like 'unverifiable', 'subjective', even 'meaningless'. This marginalisation, to James, was a failing not of religion but of science: for science to justify its claim as the ultimate language of truth, it would need to find a way of making sense of them.

The philosophical language which seemed to James to offer the most promising exit from this confusion was the idealism of Hegel, which insisted that truth could – indeed, must – be arrived at by accepting both a proposition and its opposite – the thesis and antithesis which could be united to form a synthesis. But Hegel's view ultimately stuck in James' craw: he was unable to digest the possibility of holding two opposites to be true simultaneously without the conclusion degenerating into meaninglessness. He was consequently struck by Blood's insistence that this is exactly what the 'Anesthetic Revelation' of nitrous oxide regularly and reliably demonstrates: Blood deliberately contradicts himself throughout his pamphlet, referring to the nitrous-induced state, for example,

47

as a "condition (or uncondition)". Setting up the now-familiar reaction of ammonium nitrate with tubes and cloth bags, James set himself to reach this state.

No less than for Blood, James' experience was a fundamental revelation. Like Davy before him, he found through its portals an unsuspected new universe of ideas, a protean state of unity from which all the complex and contradictory perceptions of normal life emerge. It was euphoric, an intellectual climax in which the profound pleasure arose from reaching the fundamental state of being where everything made sense. Most revelatory for James was his newfound ability to sense the superficiality of contradiction, indeed the necessity for contradiction to exist for everything to make sense. His stream-of-consciousness jottings under the influence show how his mind danced around this apotheosis: "Agreement–disagreement!! – Emotion–motion!!! – Reconciliation of opposites; sober, drunk, all the same!"

Behind these philosophical pirouettes, it is clear that James also found in nitrous a reconciliation of many of the incompatible perspectives which he had throughout his previous life been unable to resolve. His father was a Swedenborgian mystic, and James' scientific career had involved taking up an entirely different philosophy, one which explicitly rejected his father's beliefs; nevertheless, his early exposure to the mystical world view had made a deep and often positive impression on him, and he had always been uncomfortable with the conclusion of science that it should simply be dismissed. He had in this respect also been puzzled by his own character, which seemed to gravitate inexorably towards the logical and material, and had been unable to shake the idea that the mystical state was not an illusion but something on which he had been missing out, an important piece of the jigsaw of consciousness which his mind, by some quirk, refused to reveal to him. For him, nitrous oxide resolved this nagging internal dialogue: a solidly material cause which could produce the sublime effects which he had always hankered after but never experienced.

James wrote a couple of specific essays on his nitrous oxide experiences, particularly engaging with their implications for

the philosophy of Hegel, while broadening his revelations into what would become his greatest work and a landmark text in psychology, *The Varieties of Religious Experience*. The core of the *Varieties* is precisely the synthesis with which nitrous presented him: that the phenomena of 'extraordinary consciousness', whatever the truth or otherwise of their revelations, are 'psychologically real'. This psychological reality is, or will be, or should become, part of the domain of science, but its content is not susceptible to empirical validation – as he puts it, "one cannot criticise the vision of a mystic" merely because it refuses to subject itself to the tools of empirical enquiry. He attributes this realisation explicitly to his inhalation of nitrous oxide in what has become one of the book's most frequently quoted passages:

"One conclusion was forced upon my mind at that time, and my impression of its truth has ever since remained unshaken. It is that our normal waking consciousness, rational consciousness as we call it, is but one special type of consciousness, whilst all about it, parted from it by the filmiest of screens, there lie potential forms of consciousness entirely different."

After the *Varieties*, James engaged himself with spelling out the practical implications of this view of religion, particularly in his subsequent book *The Will to Believe*. He rejected the idea that faith or dogma could provide an indisputable basis for religion, just as he had concurred with Blood in viewing the nitrous experience not as 'proof' of any particular doctrine but simply as an undeniable and irreducible experience. But he also rejected the idea that religious or mystical beliefs were simply false, since their psychological reality was palpable and they were just as capable of determining behaviour as scientific materialism. He conceived religion as existing in the space between the opposite claims of 'true' and 'false' – a space where religious belief can be understood in positive, even Darwinian terms as something which is capable of producing health, happiness, even a will to prevail which can make it superior to the 'rational balance' offered in its absence.

In these terms, he saw it as beneficial, even necessary, and his conclusion that mystical experience "adds to life an enchantment which is not rationally or logically deducible from anything else" gathered a consensus among those who, like James himself, searched (and continue to search) for a language capable of shedding light on both aspects of the human condition without being forced to choose between them. As such it became a founding text of modern humanistic psychology, and for a dialogue which still continues both inside and outside academia, between both scientists and transcendentalists – and both with and without the use of drugs.

<p align="center">℘ ℘ ℘</p>

And what happened to nitrous oxide? Why is the most celebrated, studied and frequently experienced psychedelic drug of the nineteenth century so little in evidence in the modern drug revival? Unlike most other mind-expanding drugs, its recreational use has never been controlled by law, probably for the same reason which limited it to public performances in the years following its discovery – as a gas, its delivery systems of cannisters, compressed bulbs, siphons and respirators are too elaborate and clunky for widespread recreational use. It was also the archetypal psychedelic drug of the nineteenth century because it was virtually the only psychedelic which was available – LSD and ecstacy were decades away from being synthesised, and plant psychedelics like psilocybin and mescaline – as we shall see – only emerged into limited circles towards the century's end.

But nitrous oxide has continued to find its uses to this day in medicine, in industrial processes, in consciousness research and in the interstices between all these fields. It remains the standard analgesic and anaesthetic agent in emergency and obstetric medical practice; it's added to drag racing cars to provide extra fuel injection; it's used by deep-sea divers as part of their high-pressure gas mix, and by caterers as the propellant for whipped cream. And, less publicly, it continues to be used to alter the consciousness of hedonists, mystics and sceptical truth-seekers alike.

2

The Black Drop

Opium

In today's popular imagination, opium was the archetypal drug of the nineteenth century – and, overall, it was probably the most prevalent. But our image of it – dark, visionary, romantic, the crucible of agony and esctasy for poets and painters – is only a small part of the story. Opium entered the nineteenth century as a widely used medicine, and left it in broadly the same role. But over this period the ways it was perceived altered almost unrecognisably – from homespun folk remedy to Oriental plague, from avatar of the sublime to agent of corruption and degeneration. To trace the transformation of opium through the nineteenth century is to follow some of the darkest, most turbulent and contradictory currents of the century itself.

Consider the contradictions which still revolve around this substance today. Chemically, it's almost identical to heroin, which is merely its refined clinical cousin. Yet opium for us conjures images of the sensual, the exotic and the forbidden, its name borrowed as such for products like mass-market perfumes. It's hard to imagine Yves Saint Laurent marketing 'Heroin', with its entirely different associations of inner-city misery, addiction and lowlife squalor.

But a hundred years ago this polarity was largely reversed. Heroin, newly launched as an over-the-counter cough medicine, was specifically marketed as the pure, medically-approved, wonder-drug successor to opium, which had by then accreted the image of a primitive, atavistic, filthy substance peddled by Chinese gangsters.

What remains true, then as now, is that our view of the

opiate drugs is defined by contradictory assertions. Opium is romantic, but heroin is sordid. The use of these drugs for pain is a regrettable necessity, for pleasure a self-destructive vice. Under medical supervision they're safe, without it they're a plague. Then as now, these distinctions are vigorously promoted despite – or perhaps because of – the fact that opiate use is far more complex and ambiguous than they allow.

Although heroin, opium and morphine are chemically slightly different from one another, much becomes clearer if we regard them as broadly the same substance – a substance which we repeatedly invest with a dual identity, and whose history is blurred by a vocabulary designed to create distinctions which aren't merely chemical but which reflect a broader social and moral frame. The drug has one name when it is the servant of progressive clinical practice, used by medical authorities for the treatment of pain – and another when it is being used by degenerate pleasure-seekers who wantonly cast themselves into abysses of vice, addiction and crime. 'Heroin', for example, was a name expressly coined by clinicians to express its membership of the first category; now that it's slid to the second category of illicit street drug, its medical use takes place under its original clinical name, diamorphine. Opium made the same journey during the nineteenth century, beginning it as a medicine and ending it as a menace.

Because of these shifts in cultural perception, the popular image of the nineteenth century use of opium stands in need of some correction. The vast majority of its users didn't partake of the romantic and visionary qualities with which today's perfume sellers (and buyers) associate it. In its everyday use it should perhaps be viewed more prosaically as the aspirin of the nineteenth century: aspirin itself only made its debut in 1899, courtesy of Bayer Pharmaceuticals who were looking for a follow-up to their big-selling brand medicine of the previous year – heroin. Throughout the nineteenth century, opium was the most effective painkiller around, and had been since long before the century began. It was the 'queen of plant medicines', the one item in the pharmacopoeia which

no doctor would be without. In a world of bloodletting and phrenology, blistering and mercury treatments, it worked.

But the way in which opium works leads us straight into the true and central dichotomy which lies behind all opiate use – its effect is quite different on different people, depending on how it's used. Taken occasionally, whether in response to pain or in pursuit of pleasure, it is wonderfully effective. When eaten, drunk or smoked, its effects seep into the consciousness slowly: a relaxation and physical heaviness, a falling away of anxiety, a sense of timeless and profound contentment. During the hours that the dose builds and fades, it insulates you from the outside world, lending you an inner warmth and languorous euphoria which is more than sensory illusion: in situations of extreme cold or trauma, or conditions such as severe dysentery, it's saved countless lives. As you drift into sleep you're swallowed up by a world of beneficent dreams, vivid and exquisite, and sleep is deep and restorative. Some of the most pleasurable effects may be felt on waking the next day to find yourself blissfully cocooned in a silken web of warmth and pleasure, with the prospect of a further excursion into dreams no more than a nod away.

These euphoric and visionary effects – produced by opium, heroin and morphine alike – may be had again the next day, and the day after. Many users find that the euphoria and vivid dreams actually increase over this short period, only reaching a peak of intensity after three days or so. But after a few days in succession, these realms of bliss begin to recede. As the drug wears off, a feeling of malaise develops which is the physical and mental counterpoint of the initial euphoria. With persistent use, you begin to find yourself somehow uncomfortable in your own skin: itchy, overstimulated, insomniac, flushing hot and cold, sleep interrupted by clammy nightmares, and the aftermath of every dose a sense of frustrated craving which can only be satisfied with a return to the drug and an intensification of the cycle.

Contrary to the view which evolved over the course of the nineteenth century, this process does not automatically transform the user into a helpless addict, shrunk to an insect core of

pure need and powerless to resist the drug's spell. Then as now, the majority of people who spent a few days or weeks medicated with opiates found that, on recovering their health, they could easily shake off these side effects and return to their previous life within days. Now as then, too, the majority of those who use the drug for pleasure are well aware of the diminishing returns of constant use, and indulge periodically without coming to any great harm. But this majority use, then as now, is an excluded middle within the dichotomies of the opium debate. The extremes of opium's benefits and dangers have increasingly encouraged expert professionals to insist on a clean dualistic split between its 'good' and 'bad' uses, and to regard any attempts to investigate it for oneself – and to discover the obvious truth that the supposedly stark black and white picture is actually a grey scale – as a form of heresy.

So the true dichotomy is between opium users who take it occasionally and those who have, for whatever reason, developed a metabolic dependency on it: compared to this, the questions of whether it's prescribed by a doctor or whether its use is prompted by pleasure ('feeling good') or pain ('feeling better') are largely irrelevant. This dependency can be clearly measured in terms of dosage, which needs to increase steeply to maintain the original effect on a habituated subject. But the rigid distinction which emerged during the course of the nineteenth century was not so scientifically observable: rather, it was between those who used it to treat pain and those who used it to pursue pleasure. The first, of course, remained legitimate, and became a defining issue for the evolving medical profession; the second became a source of increasing anxiety and social crisis as the century progressed.

The simplistic distinction between 'medical' and 'recreational' use of opiates is endlessly problematic, especially when (then as now) definitions and diagnoses of mental illness, vice and heredity were constantly shifting and being reconceived just as the calls for moral certainty grew loudest. The question becomes clouded with value judgements imposed over complex, subjective and impenetrable questions

of motive and need which can only be cleanly resolved with the imposition of a strident and brittle pseudoscience. The course of the nineteenth century saw the evolution of this dualist fundamentalism, and of the *folie-à-deux* which has been danced ever since by the respectable opium of medical science and its evil scapegoat twin. The direct legacy of this dance is today's war on drugs.

℘ ℘ ℘

Over the last thirty years, the drug culture revival has produced a revisionist image of the early inhabitants of Britain and Europe: druids, Celtic shamans, ancient megalith builders, all using our indigenous psychedelic plants – mushrooms, ergot, belladonna – to visit shared otherworlds and quest for visions, bringing back the telltale images of swirling spirals and daubed handprints, encounters with the little people and the gods of earth and sky.

All this is possible, but the hard evidence which we have suggests that the true and time-honoured plant drug of Western Europe is not a psychedelic mushroom or a deliriant nightshade but the opium poppy. Despite the poppy's image as a product of the decadent Orient, the earliest prehistoric evidence of its culture is from Germany and Switzerland: it presumably moved east along with the human traffic of the Neolithic period. The use of opium forms a continuous thread in the fabric of Western society from prehistory to the present. Were it not for the prejudice of the psychedelic counterculture against the ignoble opiates, it would be far more credible to recast our ancestors as narcotic poppy cultivators, and opium as our national drug.

The opium with which the nineteenth century began was a largely uncontroversial and highly respected medicine, which had been a staple of doctors ever since the birth of the medical profession. Thomas Sydenham's laudanum preparation – opium diluted in wine fortified with cloves and other spices – had been prescribed by the gallon to Oliver Cromwell and Charles II, and doctors ever since had concurred with Sydenham's sentiment that "among the remedies

which the Almighty saw fit to reveal to man to lighten his sufferings, none other is as useful and effective". Thomas Beddoes was by no means the only doctor at the beginning of the nineteenth century convinced by the Brunonian claim that, if opium and alcohol were removed from the doctor's bag, precious little would be left but arcane classifications and large bills.

So, whereas nitrous oxide emerged at the beginning of the nineteenth century as a product of Enlightenment science, a brand new substance unknown in nature, its characteristics and uses a *tabula rasa*, opium emerged by contrast as an old friend, already loaded with associations, epithets and folklore. In areas like the Fens in the east of England, damp, cold and windswept, most families had since time immemorial grown a stand of white poppies in the corner of their gardens, harvesting them to make a 'poppy-head tea' which was supped as a traditional remedy against the chills, aches, agues and fevers which were a common backdrop of rural life. But the same modern curiosity, both scientific and poetic, which had led to the nitrous experiments would also lead opium to be reconceived as a tool for exploring and developing modern notions of the mind. In the process, the drug would take on imaginative dimensions beyond that of the numbing warmth of a folk remedy, and the descriptions of its effects would no longer be limited to observations of the drowsy behaviour of its subjects but would move under the hood, as it were, in an attempt to dissect the internal workings of thought and feeling which it was capable of affecting so profoundly.

This project, too, would be most notably developed among the same circles as the pneumatic researches, and the discovery of opium as an agent of consciousness and the imagination can best be traced through two men: one of our previous Bristol protagonists, Samuel Taylor Coleridge, and his protégé Thomas de Quincey.

℘ ℘ ℘

The effect of opium on Coleridge's work has long been a bone of contention among Coleridge scholars and enthusiasts,

who are many and passionate. Questions like "was *Xanadu* written under the influence of opium?" or "does the albatross in *The Rime of the Ancient Mariner* represent the monkey on his back?" have generated thousands of pages of often intense and bitter wrangling (the sober academic consensus being, in these two cases, no and no). But Coleridge's own voluminous letters and diaries contain more than enough detail for us to reconstruct his pattern of opium use throughout his life, and to get a strong sense of the spectrum of beliefs which this complex and self-contradictory man held, at various different stages and in various different moods, about the effect which the drug had on his exceptionally vivid inner life.

The external facts of his opium use can be swiftly sketched, and fall into a still familiar pattern of chronic dependency – although their significance to him went far beyond any such dry pathology. He may, like many of his contemporaries, have been given it a few times for childhood ailments, but his first major exposure to it was as a treatment for the rheumatism which he began to suffer as a student at Cambridge in 1791. He continued to use it sporadically for many years, but his period of physical dependence on it is unlikely to have started until the winter he spent in Keswick in 1800-1801 – after the Bristol nitrous oxide sessions – where he began to have constant recourse to the preparation marketed as Kendal's Black Drop, an opium solution in vegetable acids which was reputed to be several times more potent than the laudanum which he had previously used. His first attempt to withdraw took place in 1808, under medical supervision; and his life from that point onwards was a seesaw of heavy use interspered with periods of more or less – usually less – successful reduction.

But although this pattern is outwardly familiar, its relationship with the rest of his life is tangled and frequently obscure. To ask, for example, whether he used opium for pleasure or pain is to seek to impose a modern distinction which only complicates the picture, and leads immediately into the profound and metaphysical questions with which he himself was engaged for most of his life. More than most other drugs, the opiates are intimately connected with the balances and

contradictions between pleasure and pain: they offer a chemical slider which enables the subject to transmute one into the other in the short term while often simultaneously having the opposite effect at the other end of the scale. The nature of experience, the questions of temptation and redemption, the power of the imagination were all strings in the cat's cradle which created Coleridge's turbulent and tragic relationship with the Black Drop.

But if we expect to find all this explicated in his writings, we are disappointed. He refers to his use of opium frequently, but almost always in the broader context of the trials and tribulations of his physical and nervous health, and as a burden which he's forced to bear – or, as we might say today, an albatross around his neck. His dependence on opium is a symptom rather than a cause of the malaise with which he is struggling, but one which is frequently blamed for exacerbating his condition. It takes the blame, particularly, for much of the moral weakness for which he curses himself: "What crime is there", he writes in 1814, "which has not been included in or followed from the one guilt of taking opium? . . . I have in this one dirty business of laudanum a hundred times deceived, tricked, nay actually and consciously *lied*." But, despite his insistence that "all these vices are so opposite to my nature", it's not hard to notice that his tendencies to avoid conflict, put off difficult decisions and rationalise his weaknesses predate his use of opium, nor that he seeks time and again to lay the blame for his opiate use elsewhere – on Beddoes, on his wife, on society itself for his having been "ignorantly deluded into the seeming magic effects of opium".

And yet, particularly in the early stages of his opium use, there are clear indications that its effects came as a powerful revelation to him, and a stimulant to his imagination. In 1798, after taking it for toothache, he writes to his brother George: "Laudanum gave me repose, not sleep: but YOU, I believe, know how divine that repose is – what a spot of enchantment, a green spot of fountains, & flowers & trees, in the very heart of a waste of Sands". Here, and in much of his correspondence with the similarly opiated Tom Wedgwood, we find a sense of

a new 'secret brotherhood' of enlightened opium users, those who unlike the merely sedated masses have the refinement to distinguish its peculiar mental effects and to draw on them in their search for the sublime. We can feel the esoteric appeal of recognising and describing the chemical triggers of sensation, of taking control of the means of production of mystery, depravity, visions, heightened perceptions and forbidden entertainments. Other letters refer slyly to the clichés which were already developing around opium use in the gothic pot-boilers of German romanticism, with mock-gothic jokes about poisons and funereal sleep. Although this sense of the mental and imaginative effects of opium is more common in the early stages of his career, it persists for longer with partners-in-crime like Wedgwood, with whom he could agree that the effects of opium were "far less pernicious even than tea"; while with those who stood outside his habit, notably Wordsworth, the same effects were described with floods of histrionics, prostration and self-disgust.

While it remains moot how much of the world of opium found its way into Coleridge's work, the effect which finds the closest parallels in his poetry is the sudden, claustrophobic nightmares which are characteristic of the withdrawal period and which precipitate the user into clammy, heart-pounding waking with obscure but vivid images burnt into the mind. Coleridge records several of these: himself and his wife, both dead, looking for their children; being "followed up and down by a frightful pale woman who, I thought, wanted to kiss me, & had the property of giving me a shameful disease by breath-ing in my face". He woke once with an image of Humphry Davy, disfigured by his attempts to enlighten humanity, reduced to a dwarf in a hospital bed. In poems like *The Pains of Sleep*, perhaps, we find these grotesque residues of the opium effect percolating most clearly into his imaginative world.

The later stages of Coleridge's life, and some of his heaviest periods of opium use, were attended by the young Thomas de Quincey, an adolescent worshipper of Wordsworth and Coleridge who had sought them out in the Lake District and subsequently became Coleridge's secretary in 1808. Already

secretly using opium himself, de Quincey found Coleridge in the chaotic, self-loathing thrall of chronic use: bedridden, nerves shattered, weeping, self-pitying, borrowing money from de Quincey yet managing with extraordinary cunning to keep getting hold of opium despite having pleaded with those close to him to keep him from it at all costs – and leaving de Quincey with the impossible task of attempting to organise his shreds and tatters of half-finished writing for publication. Coleridge "pleaded with flowing tears, and with an agony of forewarning" for de Quincey not to take opium, but the spectacle of Coleridge's disintegration told his young protégé a different story: that this was the result of a self-deception about opium which had caused its subject to become its slave, and that the way to escape the drug's clutches was not to curse and berate its effects but to understand and address them, and to forge from them the central narrative of one's life.

<center>℘ ℘ ℘</center>

In this de Quincey succeeded admirably. His *Confessions of an English Opium-Eater* caused a sensation when first published in *London Magazine* in 1821, and sold out several editions when it appeared in book form the next year. It was to be his only huge hit in a career which combined reams of short-order hack journalism with nuggets of brilliance, and 'The Opium Eater' remained his instantly recognisable epithet not only throughout his life but for many decades afterwards. In a century which was awash with opium use, his book made him its prime exemplar – in his words, "the true church on the subject of opium – of which church I acknowledge myself to be the only member". He wrote this defining text at the age of thirty-six; at the age of seventy he was still revising it and working on its perpetually imminent but somehow never quite completed sequel.

Thanks in part to its sensational title, *Confessions* . . . did more than any other work in the nineteenth century to define the image of opium which we've inherited, and to which products like Yves Saint Laurent's perfume still appeal. But,

read as a general or typical description of opium use at the time, it's misleading in the extreme. First, de Quincey is not typical but exceptional in the clarity of focus and psychological rigour which he brings to his subject: for the vast majority of users before and after him, opium remained a simple anodyne, a standard ingredient in any patent remedy one might take 'for the nerves', invested with no more poetry than valium or antihistamines today. Second, the sensational title is a more cunning gambit than it appears, admitting surreptitiously as it does that the true subject of the book is not the obvious buzzword – opium – but the author himself. *Confessions* . . . takes opium not as its subject, but as a dark prism through which to refract de Quincey's own mind. Thus the many landmarks and templates which the book set are an often inseparable mixture of impeccable clinical observations about drugs and highly personal reflections of the author's own quirks, obsessions and tribulations.

De Quincey's main observations of the effects of opium might be described merely as common sense – but if so, this is a common sense which sets him at odds not only with the expert medical opinion of his time but also with ours. In these passages he dismisses the idea that opium – or any drug – is an agent which imposes the same effects on every subject regardless of their will. The drug does indeed have an innate spectrum of effects, but these interact with the personality of the user and are always to some degree subject to the user's control. Thus anyone who says that "the drug made me do it" is being less than honest with themselves (shades of Coleridge here); by the same token, anyone who takes opium hoping for imagination or inspiration won't find it magically granted. "If a man whose talk is of oxen should become an opium-eater, the probability is, that (if he is not too dull to dream at all) – he will dream about oxen." Thus the visions which de Quincey paints throughout the book were, in his view, aided and abetted by opium's power, but their true origin must be sought not in the rusty depths of the laudanum tincture but in the author's own childhood and subsequent adventures. In his case, these were highly unusual – running away from school,

spending his adolescence on the road in Wales, squatting with prostitutes in Soho and, with opiated detachment and pinprick pupils, wandering aimlessly among the London theatre crowds – and he spends much of the book unpicking the cavalcade of images, tender and grotesque, from these years.

By separating out the effects of the drug from the personality of the user, de Quincey creates a space where the subjective effects of opium can be observed in a detached manner by the subject, and its raw spectrum of tendencies outlined. But even to begin this process is to set himself at odds with almost all received medical wisdom about what opium does. "Upon all that has hitherto been written on the subject of opium", he declares, "I have but one emphatic criticism to pronounce: Lies! lies! lies!" Yes, it's brown; yes, it's rather expensive; and yes, if you eat too much you die – "but in these three theorems, I believe we have exhausted the stock of knowledge as yet accumulated by man upon the subject of opium". Most doctors progress from these theorems to the observation that people who take opium become 'intoxicated': for de Quincey, even a cursory experience with opium is enough to demonstrate that its effects are, if anything, the opposite of alcohol. Having departed from medical opinion within a few sentences, he proceeds to elaborate his careful account of how it affects the workings of the mind, the tyranny of moods, the broader sense of fullness or emptiness of the spirit.

This level of observation is the most conspicuously modern aspect of de Quincey's thinking: an empirical and detached voyage into hitherto unmapped reaches of the mind, its Enlightenment credentials signalled by the borrowing of its 'confessions' motif from Rousseau. But it's only one strand of the way he characterises the effects of opium in the book, and was by no means the most influential. Far more enduring was his framework of the 'Pleasures and Pains' of opium, which has remained the hallmark of the vast majority of drug literature right up to the present; and also his association of opium with the Orient, and all the amoral bliss and ecstatic cruelty

this entailed – an association which would redefine the image of the drug as the century progressed.

℘ ℘ ℘

There can be no doubt that, even more than Coleridge, de Quincey experienced both pleasure and pain from opium; but the thrust of his work is to yoke them into an ineluctable causal relationship where one can't be separated from the other. As much as he revels in opium's pleasures, he insists on the necessity of its pains. The first edition of *Confessions* . . . contains a couple of veiled references to Coleridge, as a man who was unable or unwilling to admit to his dependency on opium, or to fully explicate its effects. These references were made more explicit in subsequent editions, and are largely responsible – together with his article on *Coleridge and Opium-Eating* – for the enduring image of Coleridge as an opium addict: as such they scandalised Coleridge's friends and led to the severing of relations between de Quincey and most of the Lake Poets circle. But, throughout *Confessions . . .*, de Quincey displays a similar fatalistic self-pity to that of which he accuses Coleridge. Sometimes he tells us that he only began using opium for pain (like Coleridge, as a student – in his case to treat an earache acquired by sleeping in a draughty room); sometimes he insists that his early years of occasional use were deliberate and entirely pleasurable. Sometimes he contradicts himself in the same sentence. "At the time I began to use opium daily", he begins, "I could not have done otherwise . . . " – and then continues, in Coleridgian tones, "I am too much of a Eudaimonist . . . I hanker too much after happiness . . . I cannot face misery". Despite the bold division of *Confessions* . . . into 'The Pleasures of Opium' and 'The Pains of Opium', the distinctions between the two are constantly melting: opium is a dreadful medicine to which his ailments force him to take recourse; opium opened up the channels of his imagination; it has ruined his life; considering how long he's been taking it, he is doing "pretty well"; he suffers unimaginable tortures daily; until he started taking it regularly it did him no harm at all.

As far as we can pick our way between the contradictions, de Quincey's relationship with opium, like Coleridge's, follows a familiar pattern: occasional experimentation as a young man, sliding into regular use in response to illnesses and mounting to a massive dependency, leading to decades of maintenance and sporadic reductions. But his empirical observation of the drug doesn't extend as far as attempting to separate his pleasures from his pains: both are wrapped up together in the tragic drama of his fate. Nevertheless, we can unpick them to some extent for ourselves, and look a little more closely than the author himself at the various strands which contributed to his pains.

Clearly, some of the pains of opium which he suffered were caused by his dependence on the drug: dozens, sometimes hundreds of grains a day producing an achy lassitude which made it impossible for him to work or sleep, and all-consuming withdrawal symptoms whenever he failed to keep up with his body's habit. Set against this cycle, too, was the increasing need to earn money and support a family, demanding ever steeper commitments to tight-deadline journalism and dashed-off, second-rate plagiarism and recycling. The texture of his life, as revealed in his letters, is dominated by the petty chiselling for advances against future work, begging and borrowing, a constant and stressful juggling and parlaying to keep afloat.

But there are other elements of the 'pains' which are by no means such a direct consequence of his habit. His hypochondriac tendencies, which advanced with age, seem to have co-opted opium into the role of both tyrant and scapegoat: as his life progressed, the eponymous Opium-Eater took to blaming opium for all his ailments, even those which he took opium to cure. The pains became, in a sense, a necessary corollary of the pleasures: having defined himself by elaborating the visions and ecstacies of opium, he felt it necessary to insist that such exquisite pleasures were only available to those who were willing to put up with the unimaginable tortures which must necessarily follow. The rubric of Pleasures and Pains into which his text is so boldly divided were not so easily pigeon-

holed in his life: the Pleasures were shot through with nostalgia, longing and guilt, and the Pains, if truth be told, were the source of at least a little pleasure.

There are also more prosaic reasons for his insistence on the Pains – not least, the stipulations of his publishers. Despite his own conviction that "no man is likely to adopt opium or lay it aside in consequence of anything he may read in a book", his editors were concerned that the Pains should be stressed. Although they run to twice the length of the Pleasures, the book was still criticised for dwelling immodestly on the positive aspects of the drug – unsurprising, since it was here that much of its originality lay – and de Quincey's defence was to insist that there were further instalments of the Pains still to come. (These, in the form of a sequel volume called *Suspiria de Profundis*, were constantly promised throughout his life but only appeared in a fragmentary posthumous form.)

Once de Quincey's *Confessions* . . . had been forced into this mould, it became *de rigueur* for almost every subsequent subjective account of drugs throughout the century and, indeed, up to the present. Countless books and magazine articles in Britain, Europe and America reiterated the format of counterbalancing lurid and prurient tales of drug-inspired depravity with an inevitable comeuppance and the sombre moral that the pains of such indulgence would always outweigh the pleasures. Then as now, the "my drug hell" confessional is a genre with which publishers are more than comfortable, offering as it does both edgy thrills and an expression of social concern. By contrast, "how I took drugs for many years without any terrible consequences", though a far more common story, is one which few people are moved to write and few publishers are courageous in promoting. However, there are enough examples of this second genre to make it clear that Pains are by no means a necessary concomitant of Pleasures, and it's perfectly possible to separate one from the other; and, given that this is the case, it would be surprising if this were not the more common practice among the non-writing public. Still, from the

emergence of *Confessions . . .* onwards, the template for the drug script had been written, and the vast majority of subsequent public expressions about drugs have followed it faithfully ever since.

<p style="text-align:center">℘ ℘ ℘</p>

But perhaps de Quincey's most enduring contribution to the perception of opium was to shift its imaginal *mise-en-scène* to the East. Despite its continued popularity as a homegrown folk remedy in forms such as poppy-head tea, opium had begun to be imported into the country in ever greater quantities from Turkey, where the climate produced a higher yield than in Britain, and to a lesser extent by the East India Company, for whom it was among a number of commodities (like tea and cotton) which could be obtained for a pittance in the colonies and sold at a massive profit abroad. This influx led to a burgeoning range of patent opium products sold not just by chemists and apothecaries but in general stores: Hemmings Syrup of Poppies, Battley's Sedative Solution, and dozens of similar preparations, often combining opium with paregoric or recently-synthesised derivatives like morphine, joined established brands like Kendal's Black Drop on shelves across the country, generally offering their sedative effects for less than the price of alcohol.

For de Quincey, focusing as he was on the 'personality' of the drug and on drawing out the resonances of its characteristic effects, the fact that the substance he was consuming daily had come all the way from Turkey or India gave it a particular mystique and fascination. The East, in the romantic tradition – which took in, with little distinction, a span from Cairo to Tokyo – had already accreted a powerful charge of exoticism: most of the poets of his and Coleridge's generation had been brought up on bowdlerised children's versions of the *Arabian Nights*, which had become woven into their memories and the texture of their dreams from an early age and which they recorded, sifted and recycled into their work. Coleridge, in one of his most opiate-resonant passages, declared that, "I should much wish, like the Indian Vishnu, to float along an

infinite ocean cradled in the flower of the Lotus, and wake once in a million years for a few minutes": the idolatry of Oriental religion and the abandonment to the sublime of drugs or poetry were already comfortable bedfellows. Thus it was entirely in character that de Quincey should allow himself to be borne on the tide of Oriental opium to gauzy worlds of chinoiserie and arabesque. But this is a strand in the *Confessions* . . . which, in combination with the ambiguous but insistent narrative of opium's pains, conjured up a particular brand of nightmare – one which would impress itself indelibly not only on the popular image of opium but on the increasingly urgent and bitter political debate which developed around its use in the second half of the century.

The Orient of de Quincey's mind was simultaneously a pleasure-dome of exquisite sensory delights and the repository of his deepest nightmares. He seems to have had an aversion to China which predates his opium use, and in his opiated dreams and reveries it reveals itself repeatedly as a place of ancient and unspeakable evil. In one of his most famous passages, this role is filled by an imaginal Egypt, "I have been transported into Asiatic scenery . . . I suddenly came upon Isis and Osiris; I had done a deed, they said, which the ibis and crocodile trembled at". By the end of this vision, his claustrophobic opium nightmares are transposed to the chambers beneath the pyramids, where he is "kissed, with cancerous kisses, by crocodiles, and was laid, confounded with all unutterable abortions, amongst reeds and Nilotic mud". His snake-fascination with the Orient even had a physical avatar: a Malay who he claims he met in the unlikely surroundings of the Lake District, where they silently recognised each other as opium-eaters. After this perhaps imaginary encounter, "the Malay" became a frequent and baneful influence in his reveries, haunting his dreams and intruding on his waking visions, an evil *djinn* who seems to stand for the innumerable generations of Orientals destroyed by opium but still watching and waiting in some netherworld, spying on those who were about to join them in the drug's funereal clutches.

It was not that de Quincey caused the paranoid anxieties about Oriental influence and the 'Yellow Peril' which came to dominate the image of opium in the following decades: these were formed by larger economic and imperial forces which were to coalesce around opium as the century progressed. But the combination of his personal horrors with his definitive description of opium's effects lent it, in the popular imagination, an Oriental cast which was to become ever more influential.

\wp \wp \wp

But these charges which were planted by de Quincey's *Confessions* . . .were not to detonate for several decades. On its publication, it received little moral condemnation, being seen more as the work of an impressive oddball scholar than a degenerate addict. It led neither to a noticeable increase in experiment or addiction, and the problems of opium use remained of sporadic interest to the medical profession, never more than the side effects of a powerful and versatile remedy. Imports of raw opium, mainly from Turkey and Persia, grew slowly but steadily, and the range of patent medicines, tinctures and preparations in the shops gradually expanded as niche marketing created and filled ever more tailored demands: preparations for children, nursing mothers, coughs, insomnia, the elderly. During the peak of Empire, Britain was saturated with more of what we would now call 'hard drugs' than at any time before or since. Many public figures used it constantly. Clive of India was dependent on it for decades, eventually dying of an accidental overdose. William Wilberforce took a four-grain opium pill for his ulcers three times a day for thirty years without ever increasing his dose. Florence Nightingale, similarly, used it regularly for decades. Gladstone frequently laced his coffee with laudanum before addressing the House of Commons. Many thousands of members of the armed forces and civil service began to take it habitually on postings in India and the Far East, where it was the most reliable treatment for dysentery, malaria and tropical fevers, and often continued using it back home.

At this point – in, say, 1840 – it would have seemed entirely incredible that, by the end of the century, opium would be the focus of an increasing international hysteria, its use regarded as a contagious plague which was reaching epidemic proportions, its regular users reclassified as diseased, mentally ill or constitutionally feeble-minded. It would have seemed not merely incredible but incomprehensible that the right to buy and sell opium would be taken away from ordinary people and held exclusively by doctors and chemists. Furthermore, this unprecedented *volte-face* in attitudes towards opium wasn't a response to a drastic increase in habits or prevalence. Although the end-of-the-century newspapers carried a daily diet of scare stories about opium addiction and death – and particularly about the substance being used by malign Orientals to enslave young white women – there was little alteration in the levels of opium use between its mid-century role as home medicine and its later recasting as scourge of *fin-de-siècle* society. Between 1850 and 1900, the price of laudanum dropped slightly – from 8d to 6d an ounce; the sales of the major opium patent medicine, J. Collis Browne's chlorodyne, also fell slightly (from £28,000 to £25,000). The number of deaths from opium – classified as 'accidental poisonings' and 'suicides' – increased slowly from around 100 per year without ever reaching 200, a level which today's doctors would gladly trade for the thousands associated with modern prescription drugs.

We can scour the statistical markers of nineteenth-century opium use looking for anything which might indicate a reason for the transformation in attitudes towards it, but the truth is that it was not opium which changed, nor the way it was being used, but the world around it. Several sea-changes, only tangentially related, combined to recast opium in its new role. It became a scapegoat in a grand imperial struggle, a motor for stark new racial anxieties, a bone of contention in a professional struggle to reconceive the role of medicine in society. In some of these arenas, the recasting of opium was merely a side effect, in others it was tenaciously fixed on as the means to leverage some greater

end. The new role of opium was the outcome of a long succession of coincidences and contrivances, and its new role became integral to the underpinning of the new order which emerged at the end of all these dramas – so much so that it remains ingrained in our modern social and political structures to this day.

℘ ℘ ℘

The two Opium Wars, which took place in the 1840s and 1850s, were the first manifestation of the sea-changes which were to transform opium in the second half of the century. The wars followed the British discovery that the opium they were producing in vast quantities in India could be lucratively sold on in China, where opium use had been well-established for centuries but imports were prohibited by the Emperor. When the Chinese authorities attempted to seize the British imports, the British enforced the traffic with gunboats, burned down the Summer Palace in Peking and forced the Emperor to sign treaties opening up 'free trade' enclaves (such as Hong Kong) where the British opium supply could be protected.

The Opium Wars were a high watermark of imperial aggression, a trigger for the novel idea that business expansion in the colonies might in some circumstances be morally reprehensible. Lord Palmerston, the, Prime Minister, insisted that it was the principle of free trade which was at stake, although it was clear that opium was the only commodity involved; in the subsequent debates the imperial hawks lost significant ground to the voices – such as Gladstone and Lord Shaftesbury – who maintained, in the press and even in Parliament, that the opium trade was an imposition on the sovereign rights of China which was knowingly doing harm to the Chinese population. In these first Wars on Drugs, the roles were the reverse of today's: Britain was in effect the Medellin cartel, ruthlessly enforcing their prohibited trade with violence, while China was cast in the role of the modern West, powerless to prevent illicit substances from being smuggled across their borders by gangsters. Only the most dogmatic supporters of free trade and empire continued to insist that

there was nothing wrong with Britain's aggressive enforcement, and it came to be seen over succeeding decades as the most shameful of its imperial adventures.

It was during these succeeding decades that the Opium Wars, which at the time had little direct influence on Britain's opium supply or pattern of use, came to colour the image of opium itself. Much of the rhetoric against the campaigns had stressed, with a far greater vehemence than most previous opinion, the evil and degenerative influence of opium; the picture which had been painted, largely by missionaries and campaigning journalists, was of a China reduced to misery and collapse by its opium slavery, a nation of cadaverous addicts smoking themselves to death while their fields remained unplanted. Combined with this was the ever increasing fear of a China resurgent, its millions of souls organising and arming themselves for conflict with the West, a phoenix reborn from the bitter ashes of its opium slavery and consumed with fantasies of revenge. Specifically, the idea began to form that the Chinese, still burning with hate from the wrongs they had suffered at Western hands, were laying plans to reduce the populations of America and Europe to opium slavery in reprisal.

The image at the core of this belief – that of a China reduced to chaos and misery by being flooded with opium – was one which was rarely questioned or examined, either at the time or during the decades that followed. It was in the interests of the Chinese to stress the catastrophic effects of the British policy; it was in the interests of the groundswell of right-thinking opinion, encouraged by on-the-spot missionary reports of sensational horror, to do the same; and it was only the increasingly discredited voices of gunboat diplomacy who openly queried how much damage was actually being done to China by the trade. And yet it has subsequently become clear that reports of the destruction of China by its opium habit were much exaggerated. Prevalence of opium use was high, but the vast majority of it was light or moderate levels of social smoking, and actual addicts were recognised in China itself as a relatively rare phenomenon. By contrast, in

the Western rhetoric, the distinction between casual opium use and 'addiction' was gradually eroded, leading to hugely erroneous figures about the numbers of 'addicts'. Many of the sensational reports were from areas of famine, where many people smoked opium to dull the pains of hunger, but their "drawn and leathery . . . glazed and dull" expressions were attributed exclusively to the drug. More dispassionate contemporary reports stressed both the polite social context of opium use and the absence of conspicuous signs of its effects in society at large, and recent statistical analyses estimate the number of genuinely dependent 'addicts' as perhaps two or three per cent of total users. This is a similar figure to the percentage of dependent users among the widespread drug cultures of the West today – and, indeed, to the percentage of alcohol drinkers who become 'alcoholics'.

This revision is highly significant because of the extent to which the 'opium plague' of nineteenth-century China has become the *locus classicus* of the modern drug menace, and the foundation stone of the subsequent moves to control and prohibit not merely opiate but all illicit drug use. The Fate of China was the rationale for the increasingly draconian measures taken against drugs in America and Europe: another reason why there was little interest in following up the sporadic contemporary suggestions that the most remarkable fact about China's 'Fate' was not that there were so many opium addicts, but so few.

℘ ℘ ℘

But while the Fate of China was mobilising political and religious opinion against the dangers of opium, even more significant changes in its image were being forged within the medical professions. The second half of the century saw the medical establishment form itself into a body of increasing authority and power, moving from a loose confederation of orthodox opinion to a powerful lobby which extended its influence into the statutory and legal arenas, to the point where it became enshrined to an unprecedented extent in the fabric of Western government. There were many dimensions

to this increase in medical power and influence, but none were more ambitious – or successful – than its gradual transformation of opium from a popular folk remedy into a controlled substance and, eventually, a professional monopoly.

Until the 1860s, there was not and never had been such a thing as a 'controlled substance'. Broadly speaking, anyone could sell anything to anyone else and make whatever claims for it they wished. Opium was marketed directly at children ("Atkinson's Infants' Preservative", or "Street's Infant Quietness"); some preparations claimed to contain opium but used cheap, inactive but bitter-tasting substitutes; others contained uncredited shots of opium to ensure a sensation of potency. But the notion was developing that, as public health policies around hygiene and disease began to take effect, the supply of some substances – such as poisons – should be brought under a tighter rein. Various suggestions as to how this should be done were presented by different interested parties. The recently formed associations of doctors – the British Medical Association and the General Medical Council – made the case that the supply of poisons was a medical matter, and one which should be brought under their aegis. But they faced competition from the ambitious and newly formed association of chemists, the Pharmaceutical Society, keen to impress on government and public alike that pharmacy was a skilled and responsible profession which could effectively control and regulate the supply of opium by taking it out of the hands of barbers, confectioners, ironmongers, stationers, tobacconists, wine merchants and all its other occasional suppliers, and turning it over to the new breed of retail specialists.

The 1868 Pharmacy Act marked both the success of the pharmaceutical lobby and the first legal step towards controlling the supply of opium. It stipulated that anyone buying any of a list of poisons such as arsenic, cyanide or prussic acid – a list to which opium was promptly appended – was obliged to do so from a registered chemist, who in turn was obliged to record their name, the date and the quantity purchased. The effect of this was slight, although it increased public confidence in the safeguards around opium use, and led to a

73

modest reduction in the numbers of deaths by poisoning. But, within a few years, it would no longer be enough: the medical profession, having lost their initial skirmish, refused to concede the war. Doctors throughout the 1870s and 1880s were not only better organised but on the crest of a wave of scientific advances which were transforming medicine as a whole. The most significant were perhaps in bacteriology, where the agents of common diseases like cholera, typhus and diphtheria were being made visible by microscopy and effectively treated for the first time with vaccines. All manner of plagues and contagions were being shown to have organic and treatable causes, and the time was right for a medical campaign which claimed that opiates were substances of unique medical importance and potential danger which no-one less than a doctor was capable of administering.

Medical concerns about opium had been sporadically voiced since the eighteenth century, and de Quincey had meticulously explained the opiates' physical mechanisms of addiction: the tolerance brought about by repeated use, the escalation of dosage required to achieve the same effect, and the physical and psychological cravings produced by withdrawal. But a growing body of medical literature had begun to insist that the questions of whether opium could be used safely were more complicated than this. In 1857, the French psychiatrist Benedict Augustin Morel had brought opium use into a broader arena of concern by implicating it in what he saw as the main danger facing the human race: hereditary degeneration. In his *Treatise on Degenerations*, he conjured the spectre of a sector of the population, far from progressing onwards and upwards towards an ever greater fitness, becoming progressively feebler and more retrograde as a result of the 'environmental poisons' to which industrial labourers and city-dwellers were increasingly exposed. High on the list of such poisons was opium which, in his view, not only caused a creeping paralysis of the moral sense and an inevitable decline into physical weakness, but passed these traits on to the user's offspring. Thus opium was, to the trained medical eye, far more insidious than it seemed: its

visible effects were only the tip of a submerged iceberg of transgenerational decline.

The notion of degeneration came to develop an ever stronger hold on medical science as the century progressed, meshing with Darwinism to introduce fears of extinction as a nightmarish flipside to the possibilities of evolution. But for the next twenty years or so the idea that opium might be an agent of chronic deterioration of the human race remained on the margins, in part because of increasing concerns of this nature about the dangers of alcohol. It was a matter of clear observation to any doctor that, while excessive drinkers suffered rapid and severe systemic damage, opium seemed by contrast almost to preserve the organism and to lead to fewer, if any, long-term health risks.

But there were various aspects of opiate use which, within the newly regulated system, led to increasing medical intervention. One was the question of dosage, which became more relevant once the quantities which were being sold were accurately recorded and the contents of the patent medicine preparations became less inscrutable. Unlike most drugs of choice, the window of dosage with opiates is rather small. Cannabis or cocaine users can take many times the active dose without serious ill-effects, but only about four times the active dose of an opiate can be dangerous, causing potentially fatal repiratory depression. Regular users, of course, need to increase their standard dosage to achieve the same effect, often ending up with a dose which would kill a dozen naive subjects. Thus opiate users need to be well-informed about their appropriate dose, and there's no round figure which can be safely recommended as a dose for everyone.

The question of dosage, which is the aspect of opiate administration which calls most plausibly for medical expertise, was made more pressing by the 1880s through the diffusion of two hi-tech developments in opiate administration: morphine and the hypodermic syringe. Morphine, the most powerful active ingredient in the poppy-head, had been isolated early in the century, but its medical use took off with the use of the newly invented hypodermic. Here was a delivery

method which produced a more concentrated and powerful effect than opium, but also one which required a degree of specialist knowledge to administer. It was also, to the untutored user, far more dangerous. Not only could poor injection technique transmit disease and cause septicemia, but it was far easier to inject many times too much of the drug by accident. With raw opium, and gentle methods like Chinese-style pipe smoking or sipping at relatively weak tinctures, it's hard to make mistakes of this magnitude since the dose is titrated in small amounts, allowing the user to take a little at a time until the right level is reached. But the purity of morphine, and the one-shot method of injection, gave birth to an opiate form which was both far more dangerous and far more pleasurable than anything which had previously existed. This gave urgency to the medical claim that opiates were becoming something else, something more dangerous and with a greater potential for self-destructive use – and something which only doctors were fully qualified to supervise.

The first influential account of the new dangers in Europe was produced by a Berlin doctor, Eduard Levinstein, who had been supervising a clinic for morphine users in Berlin. His *Die Morphiumsucht*, or *Morbid Craving for Morphia*, emerged in 1877 and began a wave of coinages and Latinate neologisms which would become a flood over the next twenty years. 'Morphinists' were people who, usually through long-term medical treatment, had acquired an opiate habit, but were cooperating in getting rid of it. 'Morphinomaniacs' were people who took opiates for pleasure and had no interest in being cured. More general names began to appear for this latter type: 'narcomaniacs', 'drug habitués' or, in America, 'dope fiends'. But what was it that characterised this type? Again, technical terms proliferated: 'neurasthenics', or people suffering from nervous, or constitutional, or hereditary 'diathesis'. These terms demarcated a new borderland in psychiatry for people who weren't clinically mad, but whose lives were tainted by the risk of madness: the highly-strung or neurotic, a category which typically included women, 'brain-workers', homosexuals, heavy drinkers, criminal types and the heredi-

tarily feeble-minded. The (with hindsight) obvious attempt to intertwine scientific-sounding terms with less-than-scientific moral judgements is perhaps most conspicuous in the catch-all diagnosis which emerged to describe anyone who wanted to take drugs contrary to the advice of doctors: 'moral insanity'.

This medical literature of the period is almost impossible to read today: by turns preposterous, tedious and offensive but chiefly, even to the casual layperson, plain wrong. Some of it is predicated on a discredited racial science: we learn that black people are less likely to become addicts because they lack the "delicate nervous organisation" of whites. Most of it stresses the degenerational aspects of opiate use, insisting that habits acquired by taking drugs during one's lifetime can be passed on biologically to one's offspring. But most of all, it stresses repeatedly that taking opiates against the recommendation of a doctor is a disease, and one which only a medical professional can cure.

The urgency of this literature, then as now, was justified by claims that opiate addiction, especially hypodermic morphine use, was a plague which was spreading virulently through the general population. But there was one demographic group which was falling victim to the syringe to a far greater degree than any other: doctors themselves. Just as opium had been by far the most effective medication in the doctor's cabinet in the first half of the century, so the morphine syringe came, from the 1870s onwards, to provide miraculous relief from common illnesses like cholera and neuralgia: by the 1880s a standard British medical textbook would comment that "the hypodermic syringe and morphia solution are now almost as indispensible accompaniments of the physician as the stethoscope and thermometer". The German doctor von Niemeyer observed as early as 1870 that it was becoming common for doctors to go out on their rounds with a syringe and a bottle of morphine in their pocket, and more often than not to bring the morphine bottle home empty. This occasionally raised cynical suspicions that doctors were spreading the plague of addiction for

the benefit of their own business, but it also became tacitly recognised that they were not merely carriers of the plague but its frequent victims. Some surveys concluded, in fact, that the majority of 'morphinists' were doctors, nurses and their families; perhaps the most reliable, conducted by the toxicologist Louis Lewin, estimated that doctors constituted over forty per cent of addicts, and doctor's wives a further ten per cent. This largely undiscussed problem makes much sense of the disjunction between medical claims of an opiate 'plague' on the one hand and the broad stability of opiate consumption by the general public on the other: in evolving their notions of the disease of morphinism from which the public needed to be saved, doctors were to a significant extent diagnosing their own condition.

The 'disease model of addiction' is the lasting legacy of this otherwise largely ignored episode in medical science: the insistence that opiate use is a 'deviant' pleasure survives unscathed in today's official circumlocutions like 'drug abusers' and 'drug misuse', which still have the hybrid qualities of clinical diagnosis and moral judgement. Within the disease model there were various shifts of emphasis, but the salient features were broadly agreed. Although the distinguishing features of morphinism or narcomania are physical, and the condition clearly has a physical component, it is in fact a mental disease with an organic origin. This disease is common in certain 'classes' or 'types' of people, and so rare in others as to be negligible. The reason for this is that the 'disease' is in large part communicated by heredity – it is, as we would say today, all in the genes. In terms of treatment, whatever system is favoured (at this time anything from dose reduction to cold baths to substitution with the far more addictive heroin) must be imposed on the patient coercively – what's the point, after all, of seeking the consent of the mentally ill? Opiate addiction is a medical business, and opiate management is the job not of the subject but of medical professionals.

Anyone with a working knowledge of modern clinical psychiatry or drug treatment will recognise the survival of all

these elements in modern medical orthodoxy, despite the persistence of troubling and persistent facts. If opiate-addicted subjects are unable to give up without medical supervision, how is it that the Nation of Islam, for example, which simply locks junkie recruits in a room until they're 'clean' and ready to join the brotherhood, have a far higher success rate than a medical profession armed with an arsenal of synthetic substitute opiates, elaborate detox techniques and *Clockwork Orange*-style aversion therapies? Every day, postoperative patients give up substantial opiate habits on their own initiative without showing the slightest craving to return to them in normal life; every day, too, chronic opiate users relapse after spending weeks and months withdrawing under medical supervision. Nevertheless, the irreducible core of the disease theory of addiction is still as strong as ever – the significant distinction between good and bad opiate use is whether it's medically supervised.

The progress of the controls against opium went far in enshrining the opinions of the medical profession in law: someone caught with controlled opiate drugs was either a criminal or a patient, depending largely on expert medical opinion. This type of power developed in other areas at around the same time: for example, the institution of a criminal insanity plea between 'guilty' and 'not guilty', again at the discretion of medical opinion. It was an extrordinary *coup d'état* for a professional body which had barely existed fifty years before to become a significant constitutional authority in areas of judgement which were, then as now, by no means easy to distinguish from matters of opinion and intellectual fashion.

It wasn't as if the entire notion of medical controls around opium, and especially the newer and stronger opiates, was the product of a medical conspiracy. There were, then as now, good arguments for the regulation of potentially dangerous substances, and for manufacturers' guarantees of strength and purity. There a widespread need for the medical profession to act in an advisory capacity around questions of dosage and administration, especially with the introduction of

morphine and hypodermics, and to assist people who voluntarily decided that they wished to withdraw or reduce their use under medical supervision. But these commonsense roles would not have been enough for the nascent medical professions to gain any substantial statutory power. To achieve this it needed a monopoly on the opiate supply; it needed powerful laws to punish any attempts to circumvent this monopoly; it needed the power to coerce unwilling individuals into treatment. And, with the disease model of addiction, this was the prescription which it wrote itself.

℘ ℘ ℘

The progress of the laws controlling opium and its chemical cousins drew both on their developing associations with Chinese politics and on this new medical science – two discourses which, though in theory entirely unconnected, turned out to be natural bedfellows. The first places where the new laws bit were in the Chinese immigrant communities in the West, and the anxieties about these alien enclaves were translated into medico-moral terms by a legion of eager and willing professionals. The synthesis of the Chinese threat and the new medical dangers brought the new Oriental poison – as opposed to the old traditional remedy – into the broader culture far more forcefully than before. The newspapers, novels and penny dreadfuls of the 1880s and 1890s evidence an unquenchable public fascination with the 'new' vice and its juicy subtexts of forbidden pleasures, exotic threats, illicit liaisons, dens of iniquity and the unmentionable pathologies of deviance. From the medical perspective, too, the role of opium was changing. New sedatives like bromides and chloral were being more widely prescribed; when opiates were required, synthetics like morphine and codeine, with their more controllable dosage, were increasingly preferred. Thus, for doctors, lobbying for laws to prohibit opium became increasingly effective in consolidating the profession's control.

The first of these laws was the Opium Exclusion Act introduced in 1875 in San Francisco, which since the use of Chinese coolies in building the railroads across the West had

developed the largest Chinatown outside Asia. It's unclear whether the social opium-smoking in this community extended far into the Caucasian world around it, but there's no such uncertainty about the spirit in which the law was enacted, or the anxieties it was brought in to prevent. Winslow Anderson, a San Francisco doctor, attested to the "sickening sight of young white girls . . . lying half-undressed on the floor on couches, smoking with their 'lovers' . . . men and women, Chinese and white people, mix in Chinatown smoking-houses". In Britain, at the same time, an Anglo-Oriental Society for the Suppression of the Opium Trade, in its speciously-titled journal the *Friend of China*, produced a steady stream of pen-pictures of the opium menace and the Fate of China, typically concluding that the Chinatowns of Britain's port cities were the potential seeding-ground for the victims of the Opium Wars to return to haunt and infiltrate their persecutors. In the words of one of its stalwarts, the Reverend George Piercy, "Those who have been claiming justice for China relative of the opium traffic at the hands of our government have not been silent upon this point – the reflex action and retributive consequences of our own doings . . . What could all this grow to but the plague spreading and attacking our vitals? . . . It begins with the Chinese, but does not end with them!"

The prospect of this type of cultural and sexual invasion, reinforced as it was by 'scientific' notions of hereditary degeneration and more abstract fears of Chinese contamination and revenge on the West, was enough to carry anti-opium measures almost unanimously in the public debate, and to build a lurid and largely baseless image of the role of opium in Chinatowns and the perils they presented to their neighbours. Central to this image was the notion of the 'opium den', a concept which, like the 'drug fiend', was largely a creation of the 1870s and 1880s. The vast majority of Chinese opium smoking, in China and in Western Chinatowns, took place in people's homes as part of a social evening; but the opium den suggested not merely that opium consumption might be a commercial operation, but that it might be the sort

of activity which depraved people would gather together to enjoy communally. Despite the abundance of opium use in mid-Victorian Britain, it was rarely if ever practised – or imagined – in a social or recreational context. This shift in perception had a striking effect on reconfiguring the nature of the opium 'menace', and turning opiates from a medicine into a recreational or, in the phrase of the time, "luxurious" drug. Consider valium today, for example: used by millions, more addictive than opiates, and the cause of more deaths by overdose than heroin, and yet essentially a "solitary vice" without an organised subculture. If we began to hear that there were 'valium dens' where 'valium habitués' were congregating, selling the drug to naive subjects and paying for their fix with burglary or prostitution, the drug's image would change rapidly from medicine to menace.

There's scant evidence of the existence of bona fide opium dens in Britain at the point when they became familiar to the general public. The largest Chinatown was in the Poplar and Limehouse areas of London's East End, a community of a couple of hundred people which grew steadily towards the century's end. Doubtless there were British people – sailors, for example – who'd acquired the habit of smoking opium while abroad and who continued to do so in local company. But any such actual 'contamination' was far too low-key and unsubstantiated to cause by itself the sharp and vicious turn in the popular perception of the Chinese which began abruptly in the 1870s with movements like the Anglo-Oriental Society. One of the clearest examples of this is Charles Dickens' last, unfinished novel, *Edwin Drood*, which opens with the protagonist John Jasper in an East End opium den. Dickens' fictional opium den was based on his visit to the house of a Chinaman named Chi Ki, who lived with his English wife in Bluegate Fields, where opium was smoked in the evenings in the company of friends and curious visitors, the most famous being the Prince of Wales who had stopped there on his tour of the East End some years before. In the novel, though, John Jasper awakes from a vision of "an ancient English Cathedral town" transformed into a writhing

Oriental horror show; he finds himself lying on a squalid bed in the company of sinister, dribbling Orientals, and is offered more opium by a raddled East End woman beside him who has, in an image drawn from the degeneration theories of Morel and his successors, "opium-smoked herself into the strange likeness of the Chinaman".

This notion of the opium den, with its quasi-medical associations of plague and contamination, was replicated hundreds of times over the next two decades – most famously, perhaps, in Oscar Wilde's *Picture of Dorian Gray* and the late Sherlock Holmes story *The Man With the Twisted Lip*, both working the now familiar theme of the double life of the opium addict, his respectable gentleman exterior in bourgeois central London shadowed by a degenerate, secret existence in the East End. But by the end of the century, in one of the first instances of the self-fulfilling prophecies created by drug prohibitions, opium dens had genuinely begun to proliferate. As more exclusions against the Chinese use of opium were enacted in Chinatowns around the world, so an illicit supply chain developed, and the couple of opium bunks in the average family home were gradually superceded by clandestine operations where the distribution and consumption of opium were increasingly concentrated.

But the criminalisation of opium outside Chinese communities took longer to orchestrate. Pressure from the medical and anti-opium lobbies led to a Royal Commission in Britain in 1895 which was set up to examine the use of opium in India and to assess the damage it was causing. The gist of the Commission's report was that opium was widely used but caused little harm, especially in comparison with the rise in alcohol use which would be likely to follow any opium prohibition. But this report carried little weight with the opposition: the British government's official view was still tainted by the Opium Wars, and the report was seen as a whitewash intended to resist any change in the law which might affect the substantial revenues generated by the trade. There were plenty of grounds for these accusations of bias: as Joseph Rowntree damningly demonstrated, the Commission

received fifty-two reports from missionaries, of which forty-nine insisted on the negative consequences of opium use – but the final report included only two extracts from this batch of testimony, both of which were drawn from the three exceptions. Thus the voices which rallied against the opium trade were legitimately protesting against elements of government cover-up and conspiracy in much the same way as today's radical voices in favour of drug legalisation – though, of course, to the opposite effect. Perhaps the closest parallel from our era would be the spectacle of the executives of the multinational tobacco companies queueing up to deny under oath that nicotine is addictive.

In the end the first national, as opposed to racial, prohibition of opium came not from Britain or Europe but from America, in one of its few ventures into colonial control: the Philippines. When these islands were annexed from Spain in 1898, the new administration inherited a situation broadly in line with that of most other South-East Asian colonies: opium was forbidden to the Chinese community, but still sold (by the government) to the native and Spanish population. Under pressure from the Episcopalian Bishop Brent, the new Governor Howard Taft extended the law to prohibit opium entirely. This initiative won the support of public health movements around the world and became a powerful and distinctive feature of American policy, and one of its most effective tools in America's transformation into a major diplomatic player on the world stage – which perhaps partially explains why anti-drug initiatives have remained so tenaciously in the vanguard of US foreign policy ever since. By the turn of the century, the States was taking the lead in toughening global policies for opium control, and mounted the Hague Conference whose conclusions set the stage for the prohibition of opium worldwide. As this project developed, and the moral and medical dangers of opium use were painted in increasingly stark terms, it became ever more indefensible that the drug remained available, even under licence, to the citizens of America and Europe, and the West began the task of attempting to put its own house in order

by outlawing raw opium entirely – except for approved governmental and medical sources. This project was finally completed after the First World War, when emergency wartime acts – like the Defence of the Realm Act in Britain – were commuted into the drug laws still in force today.

<p align="center">℘ ℘ ℘</p>

An ironic coda to the story of opium in the nineteenth century is the discovery and mainstream marketing of heroin, its most powerful and addictive synthetic derivative, and of course the common currency of today's illicit opiate trade. During the period of its high-street availability, concurrent with the final stages of opium's demonisation and prohibition, heroin was hailed both by the medical profession and consumer culture as the modern, hi-tech solution to all the problems associated with opium, and it became increasingly widely available in almost exact proportion to opium's disappearance.

Heroin was originally synthesised in London in 1874, but its first commercial exploitation came in 1898 – the same year as the first universal prohibition of opium in the Philippines. The German chemical giant Bayer Pharmaceuticals, who'd been engaged for many years in investigating opium derivatives and analogues, dusted it off while searching for a new opiate untainted with the associations of opium which could be marketed to treat respiratory ailments, and found it particularly effective. In fact all opiates, including opium itself, are respiratory depressants and thus effective in treating a range of symptoms from colds to tuberculosis, and heroin itself has far more dramatic properties – for example, greater analgesia at lower doses than anything available at the time – but it was a respiratory sedative which Bayer were looking for and the new compound fitted the bill, testing well in dogs and subsequently in humans. Its brand-name, "heroin", clearly associated both in German and English with heroism, seems to have been part sales pitch ('a hero among cough remedies'), and part medical reference to the tradition of 'heroic' medicines – powerful doses of pure, concentrated drugs – which

was a pharmaceutical buzzword at the time. It emerged in 1898 as a patent cough medicine, sold without prescription at chemists' counters with vivid endorsements of its power, and prefigured Bayer's other novel medication, aspirin, in the top range of pharmacy bestsellers. It remained available in this form until the clampdown on opium and morphine sent non-medical users on a search for substitutes, for which – then as now – heroin offered the biggest bang for the buck on the market.

Thus heroin's rise during the period of opium's decline was more than just coincidence, as was its subsequent demonisation after the shutdown of the opium supply. More than coincidence, too, is its continued prevalence, given that its strength and low dosage make it the most profitable opiate to smuggle in a criminal black market. Today opium is rarely found in the illicit markets of the West: as far as can be gathered from Home Office figures, opium deaths in Britain are now nonexistent. It's still smoked by many millions of people across central and southern Asia, from Iran to Laos, but the raw opium which is grown for illegal export is almost all converted into the more compact and valuable heroin before smuggling – typically, these days, in eastern Turkey and Afghanistan. Since the early 1990s, too, opium has been introduced as an illicit cash crop in Colombia, where it's grown exclusively to provide heroin for the vast black market in the United States.

℘ ℘ ℘

It's hard to tell the story of opium in the second half of the nineteenth century without it sounding like a polemical and revisionist history constructed to call our contemporary drug laws into question. But it's only because of our contemporary drug laws that the story is so rarely told, and that it still seems revisionist at all. It's not controversial to point out, in other contexts, that the racial and hereditarian science of the late nineteenth century is long discredited: indeed, organisations like UNESCO are specifically committed to doing so. Nor is it controversial to claim that the fallout of the colonial

programme produced a culture of intense xenophobia in late nineteenth-century Britain, Europe and America: in fact, it's been one of the mainstays of academic cultural studies for decades. Nor is the idea unfamiliar that the medical profession, through a century of public health initiatives, has constructed its modern role in ways not entirely unrelated to its own self-interest. History is no friend of drug prohibition, which is why the question of why we have the laws which we do is almost never addressed in the stream of government-sponsored anti-drug messages which has permeated public culture for two generations.

But it's one thing to cast a critical eye over the cultural and scientific context in which opiates were criminalised, and another thing entirely to argue that history proves that these substances should simply be legalised. This is a conclusion which puts a greater weight on the story than it can necessarily bear. It's not as if we can rewind history and play an alternative version: the century in between has changed our older, traditional relationship with opiates into something else. To be an opium 'addict' in the Fen country of Victorian England, or in rural nineteenth-century China, meant little more than to drink or smoke a mild narcotic on a regular basis with family and friends; to be a dependent opiate user in modern London, Bangkok or Los Angeles means, more often than not, to be bound into a cycle of petty crime or gang violence, coercive health treatment or prison. To contemplate an alternative dispensation is to contemplate reconceiving international politics, the global economy, our entire notion of public health: in many ways to contemplate a different type of modern society entirely, which is why such initiatives are so thoroughly marginalised despite their obvious benefits. But at the very least we should remember, when we hear calls to return to traditional moralities and Victorian values, that those Victorian values included a regime of mass-market, legally available opium and its fellow 'hard drugs' very different from the one which we've inherited.

3

The Seraphim Theatre

Cannabis

At a public meeting of the Institute of France in Paris, on July 7th 1809, the distinguished Orientalist Baron Antoine Isaac Silvestre de Sacy announced a momentous discovery. He had spent several years researching the shadowy medieval Islamic sect known as the Assassins, and had finally discovered the meaning of their name which, since the time of the Crusades, had come to denote cold-blooded murderers. Assassin, he revealed, derived from *hashashin*, or *hashashyun*, and meant 'hashish-eaters' – and the comparatively unknown Oriental drug hashish was the key to the mystery which had accreted around the heretical Assassins from the Crusades onwards.

De Sacy was the greatest of the first generation of French scholars of the Orient who had begun systematically to explore and study the Middle East since Napoleon's invasion of Egypt in 1798 – and, just as India made opium a uniquely British story, so France's colonisation of Egypt would make the history of hashish in the nineteenth century predomin-antly French. De Sacy spoke and wrote many ancient and modern languages of the East – Arabic, Persian, Hebrew, Syriac, Chaldaean – and had unearthed the tangled origins of some of the most anomalous sects and communities of the Levant, including the Druzes, who he demonstrated had ori-ginated in a schismatic movement among the Shi'ites before becoming a separate community based around the divine worship of Caliph al-Hakim. But the true story of the Assassins remained the great prize. The sect had come into existence during the Crusades, and had rapidly become a terrifying threat to Crusaders and Saracens alike. They had

no country of their own, only an impregnable mountain top in the remote north of Persia where their leader Hassan-i-Sabbah – the Old Man of the Mountain – ruled with seemingly magical power. He commanded an army of *fidayeen*, the Faithful, who travelled in disguise and earned their name by passing themselves off as soldiers or peasants, Arabs or Christians, and living undercover for weeks, months, even years before leaping out of the shadows and murdering kings and caliphs of both sides. They owed alliegance to no-one – even, it was said, to God, after a heretical ceremony in which Hassan had announced the End of Time and the dissolution of all rules and laws. Saladin once attempted to take their citadel but, according to legend, retreated in panic after finding an Assassin dagger in his pillow one morning, a final warning to retreat. The impregnable fortress was finally destroyed, along with the rest of Western Asia, by Ghengis Khan's grandson Hulagu and the Mongol hordes, at which point the Assassins vanished – or, according to some, retreated into deep cover from which they were yet to emerge.

The most influential telling of the legend of the Assassins was by Marco Polo, and it was here that the idea of a brainwashing drug took centre stage in the story. According to Marco's Chinese-whispers account, the Old Man of the Mountain recruited his *fidayeen* by inviting them up to his mountain fortress and drugging them, after which they fell into a deep sleep. They awoke to find themselves in a garden enclosed within the fortress walls, with streams of milk and honey produced by concealed mechanical devices, an endless supply of forbidden wine, and *houris* and courtesans to while away the hours of pleasure. After a few days they were drugged once more, and woke again in the castle believing that the Old Man had used his magic to transport them to the Paradise of the Faithful. They were then initiated into the sect with the secret knowledge that, if and when they died in the act of assassination, they would be transported there once more, this time for eternity. The most famous motif of their ultimate obedience was that, at a snap of the Old Man's

fingers, they were prepared without question to plunge from the citadel walls to their deaths a thousand feet below.

De Sacy's presentation to the Institute of France added two crucial details to this legend which had fascinated and horrified the West since the Middle Ages. First, that the Assassins were Nizari Isma'ilis, a breakaway sect from the Shi'ite Fatimid Caliphate in Egypt. Second, that the origin of their name and the secret of their initiatic rites were both to be found in a drug called hashish.

℘ ℘ ℘

If the image of opium in the nineteenth century differed radically from that of today, the image of cannabis was unrecognisable as the same substance. Throughout the nineteenth century most educated people, if they'd heard of hashish at all, would know of it only from the story above. To the extent that it had an image, it was that of an Oriental potion used by murderers, or a tool used by shadowy secret societies to brainwash their members into committing dastardly acts.

But, like opium, this image depended on and was underpinned by a vocabulary of contradiction which allowed the same substance to assume two seemingly unrelated identities. The cannabis plant was widely known as hemp, an indigenous and widespread fibre crop, but one which in temperate Northern latitudes produces very little of its psychoactive alkaloids. In subtropical climates, the same plant exudes a gummy resin which has since time immemorial – at least the late Stone Age – been eaten or smoked, often in the East, from Morocco to India, in the form of extracts like the resinous hashish, the sweet fudge-like *majoun* or the soluble paste *dawamesc*. Thus the term hashish, introduced to the West as the source of the Assassin legends, had the effect of severing the botanical connection with the familiar hemp plant and conjuring up an imaginal Orient of pleasure and vice similar to that which accreted around opium.

For this and other reasons, cannabis as an intoxicant never found the mass-market in the nineteenth century which characterises its use in the West today. It's strange that an era in

which the use of mind-altering drugs was so commonplace should fail to discover what has subsequently turned out to be the most popular of them all, but there were factors which marked it out from the beginning as a quintessentially foreign habit. First was the Assassin legend, which gave it a powerful association with frenzy and violence completely the reverse of its hazy, peacenik image of today. Second was its covert use by a small artistic elite who repeatedly stressed its exotic and frightening aspects. Third was its mode of ingestion: in Egypt and the Middle East, where its use was first discovered, it was typically eaten or drunk rather than smoked. Smoking produces a mild and almost instantaneous high, whereas eating produces a much more powerful, uncontrollable and long-lasting effect. The high-flown descriptions of hashish intoxication by writers like Charles Baudelaire and Fitz Hugh Ludlow can seem hilariously overblown to contemporary readers, but we must remember that the few hashish-eaters of the nineteenth century were eating mindblowing doses of three or four grammes, at which level cannabis is no gentle mood elevator but an intensely powerful hallucinogen, and its use in these quantities even today is probably no more common than it was then.

\wp \wp \wp

Thus it was that cannabis entered the modern West as two entirely different substances: one a fibre crop with some medicinal properties, the other a potent deliriant from the East with an obscure and sinister past.

The indigenous European hemp plant, though nowhere near as central to folk medicine as the opium poppy, was nevertheless well entrenched in traditional lore. Nicholas Culpepper's *Complete Herbal*, first published in the seventeenth century, lists it as a treatment for inflammations and a general analgesic, demonstrating that its current (though mostly illegal) use for rheumatoid arthritis and chemotherapy has a long pedigree. But there are few, if any, references to its mind-altering qualities, reflecting the low levels of psycho-activity of the northern strains. The most frequently cited

mention of these properties is in François Rabelais' sixteenth-century libertine fantasia *Gargantua and Pantagruel*, where a discourse about hemp sails leads into a panegyric to "the herb Pantagruelion", named after Pantagruel as "the exemplar and paragon of perfect jollity" because it has "so many admirable effects". Rabelais was certainly familiar with the hemp plant – his father cultivated it on a large scale at his farm in Chinon – but it's likely that this is one of the many cryptic references to classical literature which pepper his work. It relates most likely to the passage in Herodotus' *Histories* where he recounts the Scythians' habit of burning hemp stalks on red-hot stones inside tents and inhaling the smoke in a kind of intoxicating sweat-lodge ritual – a practice which Herodotus notes that the Scythians enjoy "so much they howl with pleasure". But this practice represents not an ancient European history so much as classical tourism into the lands where cannabis had long been known as an intoxicant – in fact, into the lands of its birth. Cannabis is a plant which was originally native to Central Asia and moved west, probably at the same time that opium was making the same journey in the opposite direction. Rabelais, who translated Herodotus before writing *Gargantua*, seems to have partially modelled his own chronicle on those of the man variously called 'The Father of History' and 'The Father of Lies': thus 'the herb Pantagruelion' is more likely to be a parody of Herodotus' *outré* reference to the sensual pleasures of cannabis, rather than a testimony to its actual use in early modern Europe.

Against this background, de Sacy's claim to the Institute of France was an incursion into virgin territory, and as a result his largely inaccurate explication of the effects of hashish was nevertheless influential and long-lived. He notes that it's derived from the hemp plant, but is unaware that its Middle Eastern varieties produce more resin, and thus assumes that the reason it's consumed as a drug in the Arab world is merely because alcohol is prohibited. So, in the absence of any pharmacological understanding of its effects, his assessment of its use becomes intertwined with European notions of the alien qualities of the Arab mind; these are aided and abbetted

by his reliance on clerical Muslim sources, among whom the prevailing view is that hashish-eating is a practice associated with the lower classes, peasants and tribal riffraff.

His view is that hashish "causes an ecstacy similar to that which the Orientals produce by the use of opium" – which, in turn, is presumed to be different from the effect which opium produces on Western minds. Echoing the clerical propaganda, he continues that "the too frequent enjoyment changes the animal economy, and produces, first marasmus and then death". He also notes that hashish-users in Egypt are still pejoratively referred to as *hashishin*, and that the image of hashish-eaters in folk tales including the *Arabian Nights* tends to be that of a poor buffoon who imagines himself a caliph, and his hovel a palace, under its influence.

But, even with the selective and disapproving literature from which he draws his facts, it's clear to de Sacy that there's a pertinent objection to his Assassin theory: the drug is usually described as producing "a kind of quiet ecstacy, rather than a vehemence apt to fire the courage and the imagination to undertake and carry out daring and dangerous acts" – in other words, how credible is a stoned undercover assassin? But he locates the answer to this paradox in the legend itself, specifically Marco Polo's version, which he quotes at length. The use of hashish was not by the Assassins in their criminal undertakings, but by the Old Man of the Mountain on the Assassins. By giving hashish to the initiates, and transporting them to his garden of "Asiatic luxury" filled with "young beauties", the Old Man made them "blind instruments of his will". Hashish was not used for the assassination but for the brainwashing – although de Sacy speculates that another drug may have been used at the point of action to "produce a state of phrenzy and violent madness" – rather, he somewhat implausibly claims, as amok Malays use "opium and citrus juice" to the same effect.

It would be well into the twentieth century before this scholarly pack of cards collapsed to the ground. Relying so heavily on Marco Polo's stories was a suspect practice even in in 1809, and de Sacy has to make his case that, even though Polo's veracity has frequently been called into question, he

seems to be reliable on this point. But de Sacy also relies exclusively on histories written by the Assassins' enemies. The Assassins, or Nizari Isma'ilis, were uniquely schismatic even within the schism-ridden world of medieval Islam, rejecting even their alliegance to the Fatimids, themselves a breakaway caliphate from the Shi'ite line. So the malevolent legends which accreted around them for centuries were asserted by all sides, Shi'a and Sunni alike, presenting de Sacy with an unambiguous version which he accepted as the truth. It was only when the Nizaris' own histories were unearthed that the picture changed dramatically. Specifically, it emerged that they had never called themselves Assassins, or *hashishin*, or anything similar: this was merely a derogatory epithet applied to them by their enemies, meaning outcast peasants unfit for decent society. Nor is there any evidence in the Nizaris' own writings that they used hashish at all – in fact, their doctrines seem strictly ascetic. De Sacy's entire edifice, and his construction of the role of hashish in their sect, had been based on mistaking propaganda for historical truth.

By the time this became clear, Orientalism and the world in general had long moved on from its obsession with the Assassins; but throughout the nineteenth century de Sacy's version continued not only to be believed, but to be woven into a far vaster historical and political tapestry. Ever since the first stirrings of the French Revolution, secret societies like the Freemasons and the Illuminati had been seen by many as puppet-masters behind the scenes of European politics, an invisible power-base which was constantly plotting either to overthrow monarchs or to subvert republican ideals. Especially in France and Italy, where societies like the Carbonari were the most visible agitators for national independence and against the Napoleonic kingdom, the world of the secret societies became a kind of shadow-politics which drifted from the phantasmic to the real and back again as history unfolded. Throughout a century of popular revolutions and royal restorations, communes and colonies, the role of secret societies encompassed a manifest *realpolitik* as well as the conspiracy paranoia with which we associate it today. The Vatican saw

the societies as "the greatest threat to Christendom"; in 1870 Benjamin Disraeli, in his bestselling novel *Lothair,* expressed what was close to his own view: "It is the Church against the secret societies. They are the only two strong things in Europe, and will survive kings, emperors or parliaments."

This climate generated an often obsessional interest in how secret societies worked, and how far their lineage and influence could be traced back into history – and, given that the nature of secret societies is that these things are secret, paranoid fantasy, self-glorification and cranky scholarship were free to develop unimpeded. The early Freemasons had certainly looked back into history for precedents to their transnational and elite enterprise, and had retrospectively incorporated Crusader orders like the Templars (and, in Germany, the Teutonic Knights) into their symbolism and corporate mythology. But where did the Templars' ritual secrecy and hierarchical structure come from? According to many, the Assassins were the original secret society, the Old Man's system of initiation was the fount of all conspiracy – and hashish was the forbidden fruit at the centre of the entire web of corruption and evil influence. The Secret of the Assassins had passed to the Templars, who had passed it to the Freemasons who, in unleashing it, had brought down the chaos and destruction of revolutionary Europe.

De Sacy's work was followed up by a *History of the Assassins* by Chevalier Joseph von Hammer-Purgstall, another respected Orientalist and author of a multi-volume history of the Ottoman Empire, but also a reactionary monarchist whose telling of the Assassin tale gives these paranoid assumptions full rein. For him, the sect of the Assassins was solely and consciously committed to spreading the poisons of revolution, libertinism and atheism throughout the world, and as such their mission was proceeding apace even as he wrote. In virtually every paragraph the Assassins are a "union of impostors and dupes" who "undermined all religions and morality", an "order of murderers", an "empire of conspirators" with a "doctrine of irreligion and immorality" who "published to the profane the mysteries of atheism", or revel in "the freest

infidelity and most daring libertinism". In the Assassin doctrine is to be found the roots of "the Jesuits, the Templars, the Illuminati", and in hashish we find a blasphemous substance which makes its subject "able to undertake anything or everything".

This view wasn't, of course, universally believed, but in the absence of any alternative history either of the Assassins or of hashish it gained a hold in public discourse which lasted throughout the century, aided perhaps by the sinister-sounding Oriental self-stylings of the Masonic movement with its 'Egyptian Rite','Grand Orient Lodge' and the rest. But this entire mythology had evolved without any of the Western scholars involved actually experiencing the effects of hashish. Once these effects became known and exploration of the inner world of hashish began, the drug escaped from its mythology and became something even stranger: first, the foundation of a radical new theory of mental illness and the mind itself, and then the focus of the first and one of the most legendary and enduring drug countercultures of the modern West.

℘ ℘ ℘

The crucial figure in this process – indeed, one of the most crucial figures in the understanding of drugs in the nineteenth century as a whole – was a French physician and psychiatrist named Jacques-Joseph Moreau de Tours.

As a young medical student in Paris, Moreau de Tours sought out a job at the Charenton Hospital where he could study under the early French pioneer of psychiatry, Jean Etienne Dominique Esquirol. Throughout the 1820s, Esquirol had been developing his notions and categories of 'mania' in an attempt to classify the various forms of mental illness which he was encountering, and the young Moreau de Tours wrote his thesis on the recently-developed category of monomania. For him, this type of objective and non-judgemental classification was the way forward to releasing psychiatry from the swathes of moral and religious thought in which it was blanketed. In the predominantly Catholic world

96

of French psychiatry, many of the profession's presumptions drew as heavily on Christian doctrine as on the emerging science: almost inevitably reason, or sanity, were viewed as God-given, and entirely separated from insanity, which carried strong resonances of the Fall and original sin. Thus insanity was a form of moral weakness, and psychiatrists a species of missionary whose job was to save souls for Reason. But this wasn't the way the picture looked to Moreau. Monomania – and, indeed, most of the manias – seemed to be present in most sane people, not least psychiatrists. What distinguished the insane was that these manias were magnified to an uncontrollable and debilitating degree. The way to understand and treat them, then, was not to regard them as the symptoms of some hidden physical lesion or disease visited on the unfortunate patient from outside, but as the uncontrolled growth of tendencies which were to be found in the most sane and 'normal'. Reason and madness were not black and white, but a grey scale with an infinite number of shades, gradations and contrasts between them.

One of Esquirol's treatments for mania was the 'rest cure': sending his patients off to an unfamiliar place where their compulsive routines and habits could be broken and they could have time to attempt to rebuild their lives away from the destructive patterns of behaviour which enslaved them; in cases involving wealthy patients, this often took the form of an extended tour of foreign parts, accompanied by one of his assistants. Thus it was that Moreau was assigned to accompany patients first to Switzerland and Italy, and then, in 1836, on a three-year trip to Egypt.

This extended posting allowed Moreau to investigate a phenomenon which was becoming increasingly puzzling to the nascent psychiatric profession: the relative paucity of cases of mental illness in the Arab world compared to Europe. While we might construe this with hindsight to be a function of the family and tribal networks of support in Arab culture – or, indeed, of the absence of mental health professionals – the search for a clinical and scientific basis for mental illness focused on a range of more concrete causes. Racial differences

were often suggested, along with religion or politics or climate – this last the view of the philosopher Baron de Montesquieu, who had suggested that "the heat of the climate can be so excessive that all strength leaves the body . . . the lack of strength passes on to the spirit no curiosity . . . laziness is happiness". But Moreau had not been long in Egypt before he noticed another glaring difference: the absence of alcohol, and the corresponding prevalence of hashish. On a hunch that this might provide a novel route to discovering the causes of mental illness and possibilities for their treatment, he used his time there to investigate its use: reading de Sacy and all the available literature, studying samples of the local preparation, a bitter greenish paste known as *dawamesc*, interviewing hashish users and adopting local dress and customs to infiltrate himself into the world of the *hashishin*. Eventually, back in Paris, he took the drug himself.

He came back from this interior journey with a multitude of things to say, but the primary revelation was that everything which had been written by Europeans about hashish up to this point lacked a crucial ingredient: self-experiment. In his major work on the subject, *Du Hachisch et l'Alienation Mentale (Hashish and Mental Illness)*, he begins, like de Quincey, with a broadside against the growing scientific notion that it's possible to assess the action of such drugs without having personally experienced it. "There is essentially only one valid approach to the study", he insists: "observation, in such cases, when not focused on the observer himself, touches only on appearances and can lead to grossly fallacious conclusions". To look at a supine, confused hashish user and to assume that the action of the drug is simply to produce drowsiness or delirium is to miss the point entirely: the reason that people intoxicated by hashish seem to be disconnected from the world is not that less is going on inside their heads than usual but far, far more. He accepts that for a psychiatrist to talk in this manner and to submit himself to the effects of foreign poisons seems superficially odd, but "at the outset I must make this point, the verity of which is unquestionable: personal experience is the criterion of truth here".

Moreau's first experiment with hashish – the first recorded cannabis experience of a Westerner – dramatically illustrates both the incredible potency of the traditional dose and a voyage into territories far from the Orientalist suppositions about assassins and addicts. He swallows the disgusting paste with difficulty, and notices its effects while eating oysters and suddenly finding the procedure unaccountably and irresistibly hilarious. Recovering from fits of laughter, he finds his companions insisting that there's a lion's head on the plate in front of them. When he finds himself grabbing a spoon and preparing to duel with a bowl of candied fruit, he decides it's time to leave the table, and is siezed with an urge to hear music. He sits at the piano and prepares to play an air from *Black Domino*, but is interrupted after a few bars by a vision of his brother standing on top of the piano and brandishing a forked, flashing and multicoloured tail. The sense descends on him that this is some kind of theatrical performance, and he finds himself imitating the voices of various actors, then picking up a stove and dancing the polka with it. Then, stumbling into a darkened room, events take a sinister turn: he feels himself falling into the well in the grounds of the Bicêtre mental hospital outside Paris. He runs his hands through his hair and discovers millions of insects, which causes him to send for an obstetrician to deliver a baby from one of the female insects which is going into labour on the third hair from the left of his forehead. Then he's back at dinner, but this time five years in the past, with an old friend, "General H.", serving a fish surrounded with flowers. Suddenly his spirits soar to intense delight, and he sees his young son sailing around in the sky with pink-trimmed white wings. "Surely there was never a nicer intoxication", he purrs, "an ecstacy that only the heart of a parent can understand". He drifts from here to a "country of lanterns", where all the people, houses and streets are lanterns. The flares of the lanterns seem to burn his eyes, until he opens them to discover that his servant has waxed them and is polishing them with a brush. He finds himself constantly on the verge of describing what's going on, but stops himself. However, he has been crying and singing and has, in real life,

woken his child who's sleeping in his mother's lap. This brings him immediately back to his senses, and he hugs the infant "as if I were in my natural state". He then goes out to a cafe and orders an ice, but finds the people out in the street stupid-looking or otherwise disturbing, and returns home, still rapt in "a thousand fantastic ideas".

℘ ℘ ℘

In a world where there were barely any familiar intoxicants apart from alcohol and opium, this must have been – especially for a psychiatrist – an experience which changed everything. But Moreau's primary instinct was to incorporate this new world within his evolving view of the mind. Subsequent to this exhilarating fantasia, his extensive descriptions of the effects of hashish in *Hashish and Mental Illness* are focused on the construction of a new scientific method. Although he insists that "it would be in vain to describe it to anybody who has not experienced it himself", there are nevertheless many crucial points which can be established. The most crucial of these from Moreau's perspective is that, however overwhelming and hallucinatory the effects become, the subject never forgets that they have taken a drug, and that what they are experiencing is being organically assembled within the mind. This provides vindication for his view of the grey scale between sanity and insanity: hashish proves conclusively that it's possible to travel into the realms of delusion, hallucination and insanity while still remaining entirely sane. He tested this conclusion under extreme conditions: one of his students, keen to find out if this effect held true at higher doses, swallowed a massive sixteen grams of *dawamesc* which kept him in a state of intense excitation and hallucination for three days, but on recovering his senses he affirmed that there was no point during the entire odyssey where he was unaware that what he was experiencing was the effects of the drug.

Moreau also brought back the news that, completely to the contrary of the received opinions of Orientalists and doctors, hashish was an extremely safe, even beneficial substance. It was very widely used in the East, and the vast majority of people

owe "undescribable delights" to it; in fact, combined with the absence of alcohol, it contributes greatly to overall mental health, as "wine and liquors are a thousand times more dangerous". If used to excess, especially by people with incipient mental illness, it can "violently disturb the organ of intellect", but "it is extremely seldom" that one encounters such cases despite its widespread use. The pioneering voyage which Moreau had taken to a manifest but still self-conscious and temporary madness can be made by anyone, with as much safety as the other voyage made regularly by the sane to the shores of insanity – dreams.

Beyond this, he gives a solid clinical outline of its basic effects. Physically, these are slight at low doses, comparable to "the sensation of wellbeing generated by a cup of coffee or tea taken on an empty stomach". At higher doses they include sensations of pressure, heaviness in the limbs, rushing waves of warmth, trembling of muscles and a pronounced and notice-able heartbeat. His view is that the action of hashish is primar-ily mental rather than physical and that these physical effects are the corollaries of mental excitement, a view which is supported by most current medical understanding.

He also includes a "feeling of happiness" as one of the core and presumably organic effects of its intoxication, a joy which is simultaneously mental and physical, spiritual and idealistic. Moreau is interested in the way in which this sensation is all-pervading, and persists without any attributable cause beyond the hashish itself. "The hashish user is happy", he maintains, "not in the manner of the glutton, the ravenous man who satisfies his appetite, or even of the hedonist who gratifies his desires, but in the manner, for example, of the man who hears news which compounds his joys, of the miser counting his treasures, of the gambler whom luck favours, or the ambitious man whom success intoxicates".

The way in which this euphoria manifests itself in the hashish user leads Moreau into his central claim about the ways in which hashish replicates the symptoms of mental illness, since this type of unattributable joy is, among other things, a common symptom of mania. Throughout most of

the rest of his book, he enumerates the symptoms of mania and mental disturbance and demonstrates how they can be summoned under hashish. All of these, in different ways, are symptoms of excitement leading to the dissociation of ideas, a syndrome of which either hashish or mental illness can be the cause. Hallucinations are an obvious example; so are "errors of time and space" (witness the way in which, under hashish, clock time seems to bear little relation to reality or a short walk can seem to last for hours). Exaggeration of the sense of hearing, and a powerful response to music, long recognised as an intense stimulus to the insane, are also characteristic of hashish; even hearing imaginary voices can be manifested under a large dose. Fixed ideas or delusions are another classic symptom of insanity which Moreau illustrates from his own experience: during one of his early sessions, after taking a somewhat larger dose than usual, he somehow formed the idea that he'd been poisoned. This idea refused to go away; indeed, it elaborated itself into the suspicion that one of his companions had deliberately slipped him a different dose to test him. When he voiced this suspicion his colleague burst into fits of laughter, and Moreau immediately recognised its absurdity; nevertheless, it kept irrationally nagging at him.

As a psychiatrist, the task which most clearly awaited Moreau as a result of his discoveries was to demonstrate how hashish might be useful in the treatment of mental illness. If he could demonstrate its effectiveness, it would be a powerful argument that mental illness was not caused by some invisible lesion in the brain but by, in his view, "a purely functional disturbance of the intellect". He began an informal pro-gramme of administering hashish to mental patients, with results which were intermittently striking: some insomniac patients were able to sleep soundly after their experience, and other depressives were seized by the profound joyfulness of the effects and found their blackest moods going into remis-sion as a result. But even Moreau himself didn't claim hashish as a panacea, or even a reliable treatment: its effects were too unpredictable, and more often than not short-lived.

However, Moreau had another and far more radical pro-

posal for the use of hashish in the treatment of mental illness: one which focused not on the patients, but on the doctors. Its greatest benefit, he claimed, was in allowing psychiatrists access to the mental worlds they were attempting to understand and treat. "We see only the surfaces of things", he points out. "Can we be certain we are in a condition to understand these sick people when they tell us of their observations? . . . To understand an ordinary depression, it is necessary to have experienced one; to comprehend the ravings of a madman, it is necessary to have raved oneself, but without having lost the awareness of one's madness". The inescapable conclusion was that it was the doctors, not the patients, who should be taking the drug, in order to recognise firsthand the conditions which they were attempting to treat.

Moreau was aware that it was outlandish enough to admit that he'd taken hashish himself, and to recommend that other doctors should take it – let alone to imply that they couldn't do their jobs properly unless they had – was a courageous conclusion to reach. And, initially, his courage seems to have been well rewarded. Reaction to *Hashish and Mental Illness* was somewhat bemused but generally favourable. Medical reviews noted that "it is certainly an audacity full of novelty which goes beyond the customary scope of current publications. Moreau has embarked upon an unknown path, and even though his contentions sometimes verge upon incongruities one should not forget that they have this in common with all works of essential originality."

It seems that Moreau's book also inspired a certain amount of self-experimentation among doctors and psychiatrists, especially in Italy. Within a year or two, the distinguished doctor Giovanni Polli had published reports of his own experiences on high doses of hashish, and Andrea Verga, director of the Ospitale Maggiore in Milan, had observed Polli's trials and compared them with Moreau's findings. A chemist called Carlo Erba, publishing in Polli's journal, began a methodical investigation of hashish's pharmacology and dosage levels, and another Milanese medic, Filippo Lusanna, reported taking hashish with his wife, who had a "cattivo

viaggio" – as we would now say, a bad trip. Nevertheless, it's unclear what happened to Moreau's project in the broader context of nineteenth-century psychiatry. Although he continued to command professional respect throughout his long life, few if any other psychiatrists came forward to admit that they'd followed his advice, and as the century progressed opinion hardened against self-experimentation with drugs as notions of hereditary degeneration gained ground. Morel, in his founding text of degeneration theory published ten years after Moreau, defers to Moreau's superior knowledge of the effects of hashish but nevertheless asserts that its use can lead to hereditary taint and even cretinism in successive generations. His reasoning for this is to point to the supposedly disastrous effects of opium on Arab populations, and to assert that hashish must be similar.

Many of Moreau's ideas, though, can be seen as having been reborn at the end of the century with the emergence of psychoanalysis. Moreau was the first psychiatrist to take an interest in drug effects and psychopharmacology, but Sigmund Freud was to become perhaps the most famous. Freud's work with cocaine is in many ways foreshadowed by Moreau, with his interest not merely in observing effects but in delving into the underlying worlds of abnormal mental states, and in seeing self-experimentation as a vital part of this process. Moreau, too, pioneered the techniques which Freud subsequently developed to bring the subjective mental effects of drugs into the domain of science with careful observation and methodology. And in this context perhaps we can see Freud's radical idea that all psychoanalysts should themselves be analysed as a manifestation of the same impetus which led Moreau to encourage doctors to experiment on themselves with hashish.

But it was outside the world of psychiatry where Moreau's project was to have a far more immediate and dramatic effect. Like Humphry Davy with nitrous oxide, Moreau was interested in the effects of hashish not only on the sick but on the exceptional: artists, poets, men of genius. To this end he made his supply of hashish available to a loose-knit network of

acquaintances, journalists and artists, under appropriate conditions which he set up in a lavishly furnished upper room of the Hotel Pimodan on the Île de St.Louis in Paris. These salons were to become the archetypal drug scene of the nineteenth century and, in a classic counterculture manoeuvre, to claim the Orientalist spectre of hashish for themselves with the name 'Club des Haschischins'.

℘ ℘ ℘

The Club des Haschischins was introduced to the literary world by Theophile Gautier, whose description of an evening there was first published in the journal *Revue des Deux Mondes* in 1846 and remains the classic account of proceedings. Although in truth a founder member, Gautier describes his experience as a trembling neophyte, making his way through the foggy winter night to the "half-worn, gilded name of the old hotel, the gathering-place for the initiates". He raps the carved knocker, the rusty bolt turns and an old porter points the way upstairs with a skinny finger. (These gothic trappings should probably not be taken too literally: as Gautier himself admitted in later life, "it was the fashion to be pale and greenish-looking; to appear to be wasted by the pangs of passion and remorse; to talk sadly and fantastically about death".)

But the first figure he encounters, though described in rather spectral terms, is more likely rooted in reality: the master of ceremonies, "Doctor X". The Doctor spoons a morsel of green paste onto an elegant Japanese saucer and profers it to the novice with a phrase of cod-Assassin initiation: "This will be deducted from your share in Paradise". (Other accounts speak of the Club being styled as an Order of Assassins, with novitiates, initiates and a Sheikh or Prince of Assassins – presumably Moreau de Tours.) The *dawamesc* is washed down with Turkish coffee and a feast begins – a beggar's banquet served in Venetian goblets, Flemish jugs, porcelain and flowered English crockery, no two pieces alike. The other guests are a flamboyant bohemian crew, complete with beards, medieval poignards and Oriental daggers. Gautier notices hashish's

derangement of his senses beginning with taste: "the water I drank seemed the most exquisite wine; the meat, once in my mouth, became strawberries, the strawberries meat". Then his companions become distorted creatures with pupils "big as a screech owl's" and noses like probosces; the meal is over and the cry goes up, "To the salon!".

The salon is "an enormous room of carved and gilded panelling, a painted ceiling whose friezes depicted satyrs chasing nymphs through the grasses . . . here one inhaled the luxurious airs of times gone by". Slowly it fills up with fantastical characters "such are found only in the etchings of Callot or the aquatints of Goya", a "bizarre throng" which sends Gautier on a series of visions, hilarious and grotesque, which are interrupted by a piano recital. We don't learn from him the identity of the pianist but we do have, probably from the same year, a pencil sketch by Gautier under the influence of hashish depicting "Moreau as seen from behind playing the piano, in Turkish dress". This sends Gautier into further baroque raptures, first ecstatically soulful and then – the already familiar trope of pleasures and pains – nightmarish, with demonic forms taunting him to escape and then cackling as he finds his movement slowed to a snail's pace by an unseen force. The narrative reaches a climax filled with gigantic courtyards, Classical monsters and the Funeral of Time, before the clock indicates eleven, time is reborn, everything returns to normal and the shell-shocked initiate finds his carriage waiting for him below.

Such is the reportage from the Club des Haschischins, which has subsequently become a myth almost as well-entrenched as the Assassin legend it gleefully plagiarises and debunks. It's hard to tell how literally it was taken by its initial readers, though its enduring appeal is certainly more as a fantasia of the perfect upmarket hashish debauch than a faithful record of events. The demi-monde of 1840s Paris which it conjures brings together a set of lifestyles, attitudes and causes which were probably never combined before but have spontaneously replicated themselves ever since: long hair, outlandish dress, radical politics, getting up late and staying up all

night, sexual libertinism, heavy drinking and, of course, a voracious curiosity about drugs. Many of the subcultures which have followed in their wake have also found their way either to the Assassin myth or the Hashishin counter-myth, or a combination of both – from later French poets like Arthur Rimbaud, whose *The Time of Assassins* insists that "this poison will remain in our veins", to the beat voices of William Burroughs, Brion Gysin and Alex Trocchi, for whom the Assassin myth becomes a metaphor for unspoken initiatic currents silently reconfiguring a fractured society. Today, the myth has diffused through countless esoteric subcultures, the Old Man's garden of Paradise often fusing with the stoned Parisian feast in a manner which would doubtless horrify von Hammer-Purgstall but delight Gautier.

In the manner of a genuine secret society, the Club des Haschischin was successful in launching an enduring myth while at the same time leaving many of its mundane historical details in doubt. It's said to have been held once a month, and attracted a huge gathering of the artistic and literary elite: the usual roll-call includes Gautier, Gerard de Nerval, Alexandre Dumas, the painter Joseph Ferdinand Boissard, Honoré de Balzac and Charles Baudelaire. But it's likely that this picture of regular meetings and initiates are part of the set-dressing, the ceremonial ambience which it projected as a parody of the profane mysteries of the Assassin Order. For a start, the Hotel Pimodan seems to have been used only for a short period, the salons subsequently convening in smaller private rooms. Few of the celebrity members seem to have used hashish very often, and for many once would probably have been enough – indeed, there were probably at least a few who were quite happy to add their names to the coveted list of initiates without having to swallow several grams of bitter paste and submit to an intense and prolonged derangement of the senses. While acknowledging the legacy and mystique which the Club succeeded in engendering, we might get closer to the truth by stripping away the ceremonial trappings and viewing it as Moreau de Tours' extracurricular experiments: private parties for a few invited friends, who included some

sensation-hungry journalists. Much of Moreau de Tours' master-of-ceremonies role can be seen as a theatrical expression of the practical detail that he was the member of the circle with the hashish supply, and also probably that he felt medical supervision was advisable: we can perhaps also understand the ceremonial ambience and his extravagant 'Prince of the Assassins' persona as at least in part an elegant way of putting his subjects at their ease in a situation where medical props might fill them with alarm and trigger negative reactions.

We certainly need to strip back much of the myth in order to approach the artist who's now the most famous of the Haschischin, Charles Baudelaire. His hashish writings were by no means the distillation of years as a dedicated initiate in the Club, but quite possibly of a single hashish experience. There's no record, in fact, that he ever attended a single session at the legendary Hotel Pimodan, even though he lodged there for a while: the only occasion on which it's recorded that he took hashish was at the luxurious apartment of the dandy-about-town and 'idol of Paris' Roger de Beauvoir – presumably with Moreau de Tours supplying the drug and also being present himself. Baudelaire for his own part seems to have regarded his drug essays mainly as homages to the work of his hero, de Quincey, and would probably be most surprised to discover that *On Wine and Hashish* and *The Artifical Paradises* remain the nineteenth century's most admired writings on hashish, and among his own best known work.

℘ ℘ ℘

Baudelaire, like Coleridge and de Quincey, probably first took opium for a childhood illness and revisited it frequently in adulthood, vacillating between high spirits and self-disgust as he increased and reduced his doses – but, unlike the English opium-eaters, he seems to have stopped taking it for long periods and had probably been clean of it for several years by the time he died. He was among the first of the French literati to read de Quincey – in 1845 – and found deep solace in the pleasures and pains of the English Opium-Eater, who he felt had descended into the depths of opium's clutches and

returned to report his condition as no-one before. When he started toying with the idea of writing essays on drugs for magazines like *Le Revue Contemporain*, he felt that on the subject of opium he could do no better than to translate, summarise and comment on the *Confessions*, which he did with great elegance. On hashish, though, he spent many years working his own ideas through different forms – it was the best part of a decade between his early essay comparing the creative influences of wine and hashish and its cannibalised, reworked and highly-polished sequel, the prose poem in *The Artificial Paradises*.

Unlike Gautier's lurid mock-gothic phantasmagoria, Baudelaire's account of hashish intoxication, if not strictly scientific in intent, is a far more rigorous and precise evocation of the drug's effects: Gustave Flaubert was among many of its readers to point out how successfully "you've succeeded in being classic, while, at the same time, remaining the supreme Romantic whom we all love". Baudelaire's technique is a clear and measured hybrid of poetry and philosophical treatise, united in his overarching metaphor of 'The Seraphim Theatre': an artificial and ultimately stagebound visit to the uncanny realms of heaven and hell. He begins his essay by describing what he calls man's "taste for the infinite" and how, far more than alcohol, drugs like opium and hashish can conjure the "Artificial Ideal" of extending the reach of the imagination. He then proceeds to a concise survey of the history of hashish, citing de Sacy, von Hammer-Purgstall and Herodotus' story of the Scythians; after this Orientalist overture, he raises the curtain on the Seraphim Theatre itself.

Baudelaire sets the scene by stressing de Quincey's point that we're not about to escape from our own natures to some transcendent, depersonalised world: "throughout its duration, the intoxication will be nothing but a fantastic dream, thanks to the intensity of colours and the rapidity of the conceptions, but it will always retain the particular quantity of the individual". Nevertheless, it will be an exhilarating and potentially nerve-shattering evening, which will be experienced in three acts. The first will be characterised by mirth, gaiety and

"giddy cheer", a sense of vertiginous acceleration into a bizarre new world of incongruity and coincidence, a tickling delight at the realisation that "the Demon has invaded you". The second will plunge you into a convulsive experience of rebirth, strange sensations of pressure and physical distortion "as if your former body could not support the desires and activities of your new soul". During this phase, your former senses are scrambled into a synaesthesia where "ideas are distorted; perceptions are confused . . . sounds are clothed in colours and colours in music". The boundaries between the self and the world are breached, and you become whatever you see. In this stage hallucinations will occur, but Baudelaire adheres to the distinction between 'pure hallucination' and 'illusion' which was crucial to the theories of Esquirol and Moreau de Tours. You won't be presented with nonexistent objects which you're unable to distinguish from reality, as might occur under the influence of fever, plant deliriants like *datura* or even alcohol withdrawal; rather, objects which are genuinely there will gradually become something else. A sound, for example, will seem to be something other than what it is, but you're unlikely to imagine sounds without some 'real' stimulus. Nevertheless, "this turbulence of the imagination, this ripening of the dream, this poetic birth" will enable the subject to inhabit a bewildering and constantly changing world of the imagination which can become undeniable in its relentlessness. Finally, as the hallucinations subside, the third act will unfold: its keynote will be the post-convulsive calm and transcendent bliss evoked by the Arab expression *kief*, a "glorious resignation" tinged with a melancholy sense of loss.

The fact that this speaks to a far more intense experience than most of today's casual hashish-smokers would either expect or probably want is testimony not so much to Baudelaire's famously heightened senses as to the effect of a huge dose taken orally. As such, it corresponds far more closely to the effects of a major psychedelic like LSD – and, indeed, most formulations of the effects of modern psychedelics fall into a three-stage model of which Baudelaire's

account is both the original and among the finest. But there's more to come: Baudelaire insists that we now "put aside all these tricks and great marionettes, brought forth by the smoke of immature minds" and turn to the most important part: the moral of the tale.

It's here, in the final section of the *Poem of Hashish*, that Baudelaire takes de Quincey's pleasures-and-pains model to new heights, or depths. With opium, the tolerance and with-drawal mechanisms of physical dependence provide an organic trigger for the pains which accompany prolonged use. With hashish, where no such dependence occurs, the pains are cut loose from this physical cause-and-effect to be ignored or indulged at will – and Baudelaire indulges them to the hilt. First, he makes the point that any quenching of the "thirst for the infinite" by such means is temporary, and we cannot expect such magic to repeat itself indefinitely; then he pro-ceeds to a metaphysical argument that even the temporary use of these drugs represents a doomed quest, one which however sublime its intentions can only succeed in manifesting the bestial, even the Spirit of Evil itself. The very urge to taste the infinite speaks to "a natural depravity" in man, a remorse which makes itself felt the morning after: "alas! the morrow! the terrible morrow!" when physical and nervous exhaustion "tell you that you have played a forbidden game". For Baudelaire, this self-disgust is axiomatic, and he becomes perhaps the first though certainly not the last drug user to cop the 'stop-me-I'm-mad' plea and insist that his experience should be made illegal, as Napoleon declared it in Egypt: "Can you imagine a State whose citizens all took hashish? . . . Even in the East, where hashish use is so widespread, some governments have understood the need to put the drug under ban. Assuredly, it is forbidden to man . . ." Hashish users can never obtain happiness, as "magic dupes them and kindles a false joy, a false light": only as a result of hard work and a "solid nobility of purpose" can we "enjoy the miracle that God alone grants us".

The sanctimonious tone of this conclusion was recognised by many of Baudelaire's readers as a departure from the clear

descriptive writing of the earlier sections into a series of presumptions more closely related to the author's own temperamental and religious struggles. His distinguished colleague Flaubert, whose *Madame Bovary* had been banned around the same time as Baudelaire's *Fleurs du Mal*, concluded his admiring comments with a cavil at the confusion of the general and personal in this final section. "You have insisted too much", he wrote, "on the spirit of evil. One can sense a leavening of Catholicism here and there. I would have thought it better if you hadn't blamed hashish and opium, but only excess". Correctly speaking, Baudelaire's conclusion bears on the effects of excess itself, rather than the drug: perhaps the fact that his experience with opium was far greater than with hashish also made it impossible for him not to project the evils of addiction and self-destruction onto the backdrop of the Seraphim Theatre. Certainly Flaubert was more impressed by Baudelaire's rendering of the pleasures than the pains: he concludes, "These drugs have always aroused a great longing in me, and I've even got some excellent hashish made up for me by Gastinel the chemist". Flaubert was inspired by the hashish milieu and probably also his own experiences to develop notes towards a projected novel, *La Spirale*, whose protagonist is a hashish-taking painter who suffers many adversities and ends up confined in a mental institution, but retains a God-like, oceanic sense of his elevation above the state of common humanity.

We find another fictional weaving of the Club des Haschischin in Alexandre Dumas' epic *The Count of Monte Cristo*, completed in 1845. Dumas elegantly conflates the Marco Polo myth with a sly recapitulation of the Parisians' hashish nights, and wraps them up in an *Arabian Nights* story cycle stuffed with the tropes of Aladdin and Ali Baba and presented in the book as a tale of Sinbad the Sailor. The protagonist, Baron Franz d'Epinay, takes a boat to go hunting on the supposedly deserted island of Monte Cristo, but finds some smugglers on the island who invite him down, blindfolded, into an underground cave lavishly decordated with Turkish rugs and oriental finery. They offer him some "green jam";

he asks what it is, and is told the story of the Old Man of the Mountain as related by Marco Polo. Its effects, he is told, will transform him into a veritable emperor of dreams: "to see whatever you wish . . . reality must give way to dream, and dream must become the master, so that dream becomes life and life becomes dream". Franz swallows the jam and begins to live the day's realities once again, but this time under the aegis of dream: the island, previously a rocky waste, now becomes a fertile oasis full of Classical and Egyptian statues, on which he finds himself sucked into powerful erotic fantasies: "a dream of passion like that promised by the Prophet to the elect . . . lips of stone turned to flame, breasts of ice became like heated lava . . . he gave way and sank back breathless and exhausted beneath the enchantment of that marvellous dream". He awakes to find himself in a dank cave on the beach of the rocky island; he searches for the underground palace, but it's nowhere to be found.

As Flaubert's letter to Baudelaire indicates, cannabis – mostly in the form of an alcohol-based tincture – was becoming more generally available by the mid-century. This was largely in a medicinal context, but its widespread presence had the effect of joining the dots among the interested public between the traditional hemp and the Oriental hashish, and of making the drug available for experimental purposes to a younger generation of Romantics fired by the literature of the Club des Haschischin.

℘ ℘ ℘

The medical rediscovery of cannabis began with William O'Shaughnessy, a British doctor in Bengal who noted the prevalence of 'Indian hemp' both as a medicine and as an intoxicant, and made various experiments with it as a medical aid to treatment with, in his view, great success. This led him to publish in 1837 a monograph entitled *On The Preparations of Indian Hemp*, initially in the proceedings of the Medical Society of Bengal and subsequently as a book for a wider readership.

His thorough research into its use in the 1830s led him to conclude that, despite its widespread use across Asia, Africa

and South America "by the dissipated and depraved, as the ready agent of a pleasing intoxication", and also as a "popular medicine", its use in Europe "either as a stimulant or as a remedy is equally unknown" – with the possible exception of "the trial, as a frolic, of the Egyptian 'Hasheesh' by a few youths in Marseilles". On the basis of this probably correct summary, he sets out the properties and the preparations of the plant from scratch, characterising its mind-altering effects as "extatic happiness, a persuasion of high rank, a sensation of flying, voracious appetite and intense aphrodisiac desire". But his main interest lay in its medical applications, and he began his programme by testing increasingly large doses on dogs. The canine subject on which he made his experiments became "stupid and sleepy", then recovered and began "wagging his tail extremely contentedly", then "ate some food greedily" and "staggered to and fro", while his "face assumed a look of utter and helpless drunkenness". Six hours later he was "perfectly well and lively", and O'Shaughnessy decided it was safe to shift the arena of his work to human subjects.

The results of his project are somewhat piecemeal and – as with much nineteenth-century medicine – hard to separate from the clinical assumptions of the period, but a picture emerges which correlates to a large degree with the evidence of cannabis' effectiveness as a symptomatic treatment for muscular stiffness, tremors and seizures which has recently been re-emerging. He found hemp to be generally beneficial in "stimulating the digestive organs", "exciting the cerebral system" and "acting on the generative apparatus" – effects which are generally now more noted by recreational users – but his more specific recommendations were for its use in treating symptoms of muscle spasm and tension. Both acute and chronic rheumatic patients, for example, were "much relieved of rheumatism", one even being discharged quite cured within three days; he also found it particularly effective for relaxing muscles in tetanus cases, and even in reducing the symptoms of rabies.

But, despite his medical focus, he's moved to record the baffling effects of some extracurricular research by one of his

pupils, who decided to take a large dose to assess the subject-ive effects. O'Shaughnessy wandered into this experiment to find the pupil "enacting the part of a Rajah giving orders to his courtiers", and then "entering on discussions of scientific, religious and political topics with astonishing eloquence." "A scene more interesting", he concludes, "would be difficult to imagine", comparing what he's witnessed to the trance-wisdom of the Delphic Oracles. Nevertheless, he contrives a remedy against this "delirium caused by hemp inebriation" which reminds us to put the rest of his medical claims into perspective: "blistering to the nape of the neck, leeches to the temples and nauseating doses of tartar emetic with saline purgatives".

O'Shaughnessy's work was widely diffused among doctors, itinerant medical lecturers and chemists searching for new ingredients for their patent medicines, and by the 1850s can-nabis, or Indian hemp, was available from herbalists and wholesale suppliers and being recommended for all manner of ailments from asthma to insomnia to opium withdrawal – even, in the Philadelphia medical lecturer Frederick Hollick's *Marriage Guide*, as an aphrodisiac. It was also becoming a common ingredient in homeopathic medicine, thanks to its founder Samuel Hahnemann's opinion that it was a suitable treatment for nervous disorders, "less heating" than opium or hyoscyamine. Demand reached the point where an attempt was made to set up a medical hemp plantation in the south London suburb of Mitcham, but the poor yield from temper-ate crops and the regular supply from the British Government in India meant that the business stabilised around import from the colonies. James Johnson's *Chemistry of Common Life*, pub-lished in New York in 1855, includes a chapter summing up the mid-century knowledge of cannabis, the drift of which can be gauged by a selection of its headers: "The Common European the Same as the Indian Hemp – Its Narcotic Resin more Abundant in Warm Climates – Antiquity and Extent of its Use – Origin of the Word 'Assassin' – Experience of M.Moreau – Errors of Perception – Influence on Orientals Greater, On Europeans Less".

℘ ℘ ℘

It was in America that patent preparations of Indian hemp first took off – particularly the Tilden & Co preparation (labelled "Indian Hemp, Foreign. Phrenic, anaesthetic, anti-spasmodic and hypnotic", and assuring its customers that "the true *Cannabis Indica* is imported from India") – and, not entirely coincidentally, it was in America that the next outbreak of bohemian hashish-eating occurred. If the Tilden preparation supplied the means, the motive was perhaps the cosmic, nature-worshipping Transcendentalist strain in American literary culture which had imbued thinkers like Emerson, Thoreau and Whitman with a fascination with ancient India and its spiritual mysteries, and prepared a generation who had also drunk deeply of Baudelaire and his associates to experience the mysteries of 'hasheesh' at first hand.

The first American hashish-eater to offer his confessions in print was Bayard Taylor, a poet and journalist whose light-hearted travel piece *The Vision of Hasheesh* appeared in *Putnam's Monthly* in 1854 and subsequently in his book *Lands of the Saracen*, dedicated to Washington Irving. Taylor and a couple of fellow travellers each took a large lump of hashish on the roof of Antonio's Hotel in Damascus, a dose which Taylor later estimated was "enough for six" and which, at least in his written account, followed the already familiar course from intense hallucinations – while being aware throughout that they remained on the hotel roof – to vertiginous night-mares, leaving all the party considerably the worse for wear the next day. For several hours one of Taylor's companions was apparently under the illusion that he had become a loco-motive, pacing around, exhaling, turning his hands like wheel-cranks, and insisting that his mouth had turned into brass. Taylor, who had a similar sensation of dry mouth and metallic taste, offered him a pitcher of water, to which he replied: "How can I take water into my boiler, while I am letting off steam?"

But the man who made his name synonymous with hashish

in America was a twenty-one year old poet and essayist named Fitz Hugh Ludlow, whose *The Hasheesh Eater, being Passages from the Life of a Pythagorean* was published in 1857. Ludlow was clearly aiming with this title to stand on the shoulders of de Quincey, and in this he succeeded perhaps too well: he became an instant curiosity as 'The Hasheesh Eater', but was unable to surpass this epithet throughout the rest of a life similarly devoted to scrappy journalism of varying quality and a terminal struggle with opium addiction.

Ludlow's first experiment with Tilden & Co's Indian hemp took place while he was a teenage student in Pough-keepsie, where his father was a Presbyterian minister and he was a precocious, flowery and derivative poet. He had befriended the town apothecary and was in the habit of spending afternoons rummaging among his stores and surrep-titiously sampling his chloroform and ether, when the apoth-ecary received his first shipment of *Cannabis Indica*. Ludlow's curiosity was piqued, and he read the entry in *The Chemistry of Common Life* in the local library which excited him further, as did the apothecary's warning that "that stuff is deadly poison". His first trial was with a sample too small to manifest any effects either for good or ill, but his second – with two grammes – was a formative experience. He was sitting with friends when it announced itself with the growing sensation that everything – every comment, every piece of furniture, every tap of the foot – was of overwhelming cosmic signifi-cance. His head seemed to be growing, the room shrinking, and he made his excuses and went for a walk, to be confronted with sublimely beautiful and terrifyingly wicked hallucin-ations. He panicked and stumbled into the local doctor's, hiss-ing confidentially that he had taken a huge dose of hashish and was about to die of apoplexy. The doctor replied "Bah!" and offered him a sedative. While he was waiting for the doctor's servant to prepare the sleeping powder, Ludlow was first imprisoned by a gnome; then the doctor's house was floating on an expanse of ocean; finally he watched a massive army file past. Returning home and lying down on his bed, the hallucinations finally gave way to Baudelaire's

post-convulsive *kief*, and he was flooded with the realisation that the experience had changed his life. His formulation of its significance speaks to the Transcendentalism of Emerson and his future mentor Walt Whitman, while still not betraying his religious upbringing: "In the presence of that first sublime revelation of the soul's own time, and her capacity for an infinite life, I stood trembling with breathless awe. Till I die, that moment of unveiling will stand in clear relief from all the rest of my existence."

Ludlow continued his hashish experiments, writing up his hallucinations in baroque and arabesque detail which leaves little doubt as to his literary inspirations. "Oriental gardens waited to receive me", he announces. "From fountain to fountain I danced with inimitable houris, whose foreheads were bound with fillets of jasmine . . . In gay kiosks I quaffed my sherbet, and in the luxury of lawlessness kissed away by drops that other juice which is contraband unto the faithful". Each vision of ecstacy is matched, of course, by a phantasmagoric nightmare – "Oh! horror immeasurable!" – where the author is crushed with corpses in stone coffins, or tormented by fiends who "sing the lullaby of Hell" eternally. Ludlow began to interweave these purple passages with philosophical essays which – shades of both Davy and William James on nitrous oxide – claimed that hashish gives its subject the power to penetrate the world of "ideal forms", and furthermore that Pythagoras must have experienced hashish himself to have perceived the numerical order behind the universe. The Transcendentalists, in this light, offer the true metaphysics of hashish – an empiricism which accepts the modern scepticism of Hume but nevertheless holds the door open for the possibility of the divine.

The book was published anonymously, with the preface signed by "The Hasheesh Eater, the Son of Pythagoras", to reviews which unfailingly (and unsurprisingly) compared it to de Quincey's *Confessions*, but many of which felt it had an energetic, if naive, optimism which was preferred in America to de Quincey's sometimes sour misanthropy. "The Hasheesh Eater" unmasked himself and was admitted to the small

Bohemian circle of literary New York, hobnobbing at Pfaff's with Whitman and Mark Twain. While hashish-eating never became a fully formed vogue in these circles, Tilden & Co's Indian hemp preparation seems to have been used sporadically in Bohemian New York for more than anaesthetic and antispasmodic relief. But even a *Harper's Magazine* exposé of the 'habit' in 1858 was forced to conclude that "we are, however, in very little danger of becoming a nation of hasheesh-eaters" – primarily for racial reasons. Unlike Orientals, "the vast majority of experiments made by Europeans and Americans resulted in naught but a general and painful disturbance of the nervous system". It signed off with the unfortunate prediction that "the hasheesh fantasia seems physically unattainable to the great majority of the Anglo-Saxon race".

℘ ℘ ℘

So, unlike opium, cannabis entered the last decades of the nineteenth century with few public anxieties attached to its use: this was probably not so much due to its medical harmlessness as to the fact that the working classes had shown little or no interest in 'abusing' it. Its limited vogue among bohemians, artists and aesthetes if anything reinforced the feeling that this was a foreign and frightening habit, an acquired taste only of interest to literary *poseurs* and perverts.

Within the fast-evolving medical world, though, its benefits and dangers engendered rather more debate. Then as now, its acceptance by the profession was hampered by the difficulty of identifying and extracting the active alkaloids, and making clinical preparations of standardised dosage. Whereas morphine, codeine and the rest had been cleanly isolated from the opium poppy and even chemically modified, various processes had produced different cannabis extracts of indeterminate strength. Nevertheless, tincture of cannabis had its high-profile champions within the medical profession, conspicuous among them one of Queen Victoria's personal physicians, J.R.Reynolds, who described it in *The Lancet* in 1890 as "one of the most valuable medicines we possess". In the same article he enumerates its many effective uses: for

insomnia, migraine, spastic paralysis and convulsions. It's from this testimony that it has been assumed, though of course not documented, that he prescribed cannabis tincture to Queen Victoria for menstrual cramps and perhaps childbirth: the closest reference is perhaps his comment that it's a "most valuable medicine in nocturnal cramps of old and gouty people".

But there was also a strand of medical opinion which was becoming vociferous about its dangers, mostly as a result of encountering its casual use in the colonies. British doctors in Cairo Asylum in 1894, echoing or perhaps parroting the old fear of the *hashishin*, warned of its connection with violent insanity; in 1891 there were questions in the House of Commons from the anti-opium lobby about reports that "the lunatic asylums of Bengal are filled with ganja smokers", and voicing broader concerns about "the moral conditions of the people". As a result, a Royal Commission on Hemp Drugs was set up in 1894 to run alongside the Royal Commission on Opium. The research took place under the aegis of the British army in India, Bengal and Burma, interviewing over eight hundred witnesses and assembling a thorough and intermittently fascinating seven-volume report totalling over three thousand pages. Some witnesses contended that "a ganja smoker never talks on any important moral, social or religious subject, nor does he mix with good people"; others contended that "it helps a man travel long distances without food. I had a syce [groom] who went sixty miles in eighteen consecutive hours merely smoking ganja and was quite fit the next day". Overall, the conclusions were even more of a whitewash than those of the Opium Commission. Hemp was typically used in moderation, and much of its use could be regarded as medicinal. In excess, its mental effects may be injurious "in the case of specially marked neurotic diathesis", and may "indicate and intensify moral weakness and depravity", but excessive use was the exception to the rule. "Their moderate use produces no moral injury whatever", and "even the excessive consumer of hemp drugs is ordinarily inoffensive". Most significantly, "there is little or no connection

120

between the use of hemp drugs and crime", and any attempt to control or ban hemp preparations would – the conclusive refrain – undoubtedly lead to far more serious problems with alcohol. While the Opium Commission did little to stem the tide of medical, racial and temperance concerns, the Hemp Commission was the last word on the control of cannabis until well into the twentieth century.

<p align="center">℘ ℘ ℘</p>

The 1890s also saw a diffusion of 'luxurious' cannabis use into *demi-monde* subcultures around Europe and America on a slightly broader scale than those of the mid-century, thanks in part to the realisation that a milder and more manageable intoxication could be achieved by smoking the raw plant in the Indian style rather than eating large doses of the extract. The New York journalist H.H.Kane describes the practice of mixing *ganja* leaves with tobacco in his article *A Hashish House in New York: The Curious Adventures of an Individual who Indugled in a Few Pipefuls of the Narcotic Hemp*, a rococo pastiche of Gautier's Club des Haschischin reportage which describes a visit to a richly furnished and perfumed 'hashish den' on the Hudson River. Though heavily fictionalised, it draws on a certain amount of verifiable context and includes the estimate that the community of occasional hashish-users in New York numbered about six hundred. In London, cannabis use is cited several times among the *fin-de-siècle* literati, though usually as an adjunct to opium, absinthe and – one of their most bizarre habits in the eyes of the British public – black coffee. It seems to have been quite familiar in the overlapping cliques of occultism (the Order of the Golden Dawn), parapsychology (the Society for Psychical Research) and decadent poetry (the Rhymers Club): W.B.Yeats, for example, a member of all three, used it first in Paris and then in London as part of a series of telepathic experiments with his lover Maud Gonne. The arch-Rhymer Ernest Dowson discovered it while at Oxford and continued using it until his early death, to which absinthe and opium both contributed. The writer and Golden Dawn occultist Algernon Blackwood took

hashish several times, parlaying his experiences into a newspaper feature and a short story, *The Psychical Invasion*, in which his occult detective John Silence materialises the evil spirits in a haunted house by spending a night there under the influence of *Cannabis Indica*. Sax Rohmer, who had smoked hashish in Egypt, uses it in one of his later Fu Manchu novels to ring the changes from the familiar Yellow Peril threat of opium. But none of this was seen as posing an insidious threat to the general public: in the absence of any sizeable immigrant communites who used it, cannabis remained a drug adopted by wasted artists who wished to affect foreign habits and, while opium became a motif of foreign degeneration too close to home, the literary image of cannabis constantly stressed its rare, exotic and *outré* provenance. When the movement to prohibit cannabis use finally built up steam in the early twentieth century, it had much less to do with *fin-de-siècle* decadence than with a resurgence of the early nineteenth century fears of the Drug of the Assassins.

The first stirrings came not from America or Europe, but Egypt – not a country which we now associate particularly with hashish, perhaps because Egyptian hashish is rarely available in the West, but nevertheless the *locus classicus* of hashish use among nineteenth-century Orientalists ever since Napoleon's invasion of Egypt had first brought it to their attention. The Egyptian campaign, in fact, had seen the first European-imposed prohibition of hashish, echoing the sporadic temperance campaigns of Egyptian mullahs throughout the Middle Ages, and it was in Egypt that de Sacy had located the use of the term *hashishin* as a pejorative designation for low-class hashish users. Throughout the nineteenth century Egypt continued to develop various forms of religious police state apparatus, and after the First World War it reconceived its traditional persecution of its dissolute *hashishin* in terms of modern public health. The Egyptian delegation to the League of Nations began to agitate for the prohibition of hashish in the 1920s, assembling doctors and psychiatrists who presented the problem not in terms of religious dogma but of medical

hygiene. Getting stoned was christened "acute hashism", and doing so regularly "chronic hashism".

This body of pseudoscience was enthusiastically developed in the United States by the single-minded chief of the US Narcotics Bureau, Harry Anslinger, against a background of racial anxieties about the expanding Mexican population. Anslinger's consciousness-raising about the dangers of cannabis-intoxicated Mexicans to the Anglo-Saxon community – particularly to white women – was hampered by the perennial problem that the hemp plant was a familiar fibre crop farmed by pillars of society from George Washington onwards. The strategy he adopted, familiar from the nineteenth century, was to refer to it by its Mexican name, marijuana, so that the "weed with its roots in Hell" could be conjured as an alien intruder, separate from the hemp whose cultivation remained the subject of enthusiastic wartime propaganda films like *Hemp for Victory*. Much of his demonisation of marijuana, too, continued to resound with half-remembered echoes of the Assassin legend. In the 1940s he was still claiming that its main use by 'addicts' was to blunt their consciences and thus render them more capable of acts of immoral violence; in fact, one of his early anti-marijuana statements was actually entitled "Assassin of Youth". Thus, with its criminalisation at the end of the 1920s, the shadow of the Assassins – elsewhere a forgotten and discredited bygone of nineteenth-century Orientalism – continues to fall over cannabis today.

4

Attack of the Vapours

Ether

The first recorded ether 'addict', or at least habitual user, brings us back to the beginning of the story: the alternative health circuit of Bristol and Bath in the 1780s and 1790s where nitrous oxide was first inhaled. This is appropriate in that the story of ether in the nineteenth century runs in some ways parallel to that of nitrous oxide, manifesting itself across the same unlikely trinity of worlds – medical anaesthesia, public frolics and metaphysical revelation. But if the arc of the story is similar, the cast of characters combine to play it quite differently. While the gas gives us a narrative of Romantic awakenings and transcendental revelations, the vapour offers a far less edifying tale of low comedy shot through with black farce and queasy tragedy.

Our first ether user, James Graham, exemplifies all these comparisons. Though a famous radical practitioner in a parallel milieu to the Pneumatic Institution, he was no Thomas Beddoes: in as much as his name has echoed down through history, it's done so with the soubriquet "the Emperor of Quacks". He attained the height of his brief fame after moving from Bristol to the Adelphi in London, where he set up the 'Temple of Health and of Hymen', a bizarre and briefly lucrative mélange of theatre, hospital, electrical laboratory and religious sanctum which made irresistible copy for fashionable Georgian London.

The Temple was by all accounts something to behold, a phantasmagoric complex of drapes, statues, murals, electrical apparatus and orchestral "medical music" which transported the visitor into Graham's world of miraculous cures. The walls

of its ground floor were hung with crutches, ear-trumpets and other supposed relics of the grateful cured; its basement housed Leyden jars which generated sparks for electrical therapy; the lecture theatre featured a "Magnetic Throne", where Graham would personally channel the healing energies at a guinea a time. But its centrepiece was the first-floor "Celestial or Magnetico-Electrico Bed", a fertility shrine which Graham claimed was "the grand reservoir of those reviving invigorating influences which are exhaled by the breath of the music and by the exhilarating forces of electrical fire" – not to mention, in true huckster tradition, "the first and only ever in the world". The Celestial Bed guaranteed not only fertility but "children of the most perfect beauty", and was offered to married couples for the considerable sum of £50 a night.

But away from the public gaze of the Temple, it seems that Graham had developed a secret treatment not available to his customers. He offered an ambitious range of nostrums including "Electrical Aether", "Nervous Aetherial", "Imperial Pills" and even an "Elixir of Life", and these preparations naturally required frequent trips to the chemist. But, while there, he was also in the habit of asking for a two-ounce phial of ether, and sitting at the chemist's counter with his thumb over the top of the glass, removing it sporadically to inhale the volatile liquid "with manifest placidity and self-enjoyment". When asked by a fellow doctor what effects he felt, he replied: "Soothing . . . soothing to an immeasurable degree". Already in his Bristol days he would drop into the chemist's two or three times a day for this solitary treatment.

The Temple of Health may have been briefly the talk of the town, and the Celestial Bed a staple of the satirical press, but few of the goggling visitors seem to have signed up for the treatments and cures. A few months after opening, Graham was still claiming audiences of nine hundred for his evening lectures, but when Horace Walpole turned up he counted eighteen visitors listening uncomfortably to an evident fraud. Within a year Graham had moved to the less salubrious Pall Mall – according to him to house a more magnificent Celestial State Bed, but according to other observers to escape

from his growing mountain of debts. Within a year or two he'd also sold up Pall Mall, having received a series of religious revelations, and become instead an itinerant preacher. For Graham, although in many ways the quintessential quack, was no deceitful charlatan. Devoutly religious from beginning to end, he saw himself like his contemporary John Wesley as a Man of Destiny, whose mission was an "essential service to the public health". Notwithstanding the press lampoons on his Celestial Bed, he was no seducer or libertine but a man of strict sexual mores who railed against masturbation as the wasteful spilling of the "vital principle" and was determined to restock the nation with the healthy specimens which his Celestial Bed would produce. Bankrupt and increasingly mad, he attempted to set up a reformist religious sect, but eventually died in obscurity. But at least one of his habits died hard: despite a surviving note in Graham's own hand thanking a pharmacist for refusing to sell him ether "for the purpose of immoderately sniffing it up my nose and thereby affecting my brain", a late testimony from Robert Southey, the pneumatic enthusiast, records that towards the end Graham "would madden himself with ether, run out into the streets and strip himself to clothe the first beggar he met".

℘ ℘ ℘

Ether is a strange volatile substance, at room temperature occupying a highly flammable state halfway between liquid and gas. It's most simply produced by combining distilled alcohol with sulphuric acid, which was probably first accomplished by the Arab alchemists who invented the process of distillation, and is recorded in thirteenth-century Spain under the name which it retained throughout the Middle Ages and Renaissance – 'sweet vitriol'. But, though familiar to chemists for centuries, it was difficult to produce, purify and contain until the Enlightenment advances in chemistry. James Graham's era, the late eighteenth century, marks the beginning of its general production and availability, and its diffusion into the world of everyday medicine and beyond.

Since it's hard not to inhale ether while working with it, it

was noted from the Renaissance onwards that it produces a brief but extremely marked intoxication. Paracelsus, who referred to ether compounds as "stupefying vitriol salts", characterised it as "narcotic, analgesic and hypnotic . . . in its natural condition it is sweet, and liked by chickens, in which it causes a quite harmless sleep". Using a fuller set of nineteenth-century references, its subjective effects might be characterised somewhere between the expansive dissociation of nitrous oxide and the dizzy rush of strong alcohol. After a few inhalations, it takes hold in the form of a swelling sensation in the head, a seething of mental activity, a ringing in the ears which crescendoes to a point of brief swooning or unconsciousness. Vision becomes grainy and particulate, both blurred and somehow hyperfocused, the eyes streaming, the tongue numbing and the throat seeming to freeze as the ether evaporates off it and permeates the breath. Coordination becomes messy, motion stumbling and out of control, but within a minute or so normal consciousness ebbs back, leaving shards of oceanic *déjà-vu*, a tantalising sense of having reached the edge of things but in the process having forgotten what one saw.

But there's something about the brevity, intensity and toxicity of ether which makes it a rather brutal high. The rush brings in its wake a corresponding jag, a sense of exhaustion, low blood pressure, swimming eyes and blurred vision, often a savage headache. The rawness of the liquid can blister the lips and throat, and leaves the entire system with an afterburning sensation like petrol or alcohol. The numbing and loss of coordination make physical injury quite common, and the possibility of combustion from candles or tobacco is a further and significant risk, especially in binges where ether is spilt on clothes or surroundings. The hangover from a session is at least as debilitating as alcohol, and can last for days. Unlike nitrous oxide – which, as Davy noted, exhibits a reverse tolerance – ether is also mildly addictive, and intensive use leads to increased tolerance and a stepping-up of the dose to more toxic levels.

If all these are reasons why recreational ether use is rather rare today, they were no impediment to its proliferation

through the nineteenth century. Apart from the omnipresent alcohol, ether was one of the most widely used recreational drugs of the era, though usually concentrated in local scenes. While cannabis in the nineteenth century was an acquired minority taste, ether was in some ways the cannabis of its day: a tool of hedonistic and often deliberately irresponsible abandon, a spur to social 'frolics' and outlaw behaviour, a passport to a subculture beyond the pale.

℘ ℘ ℘

During the 1780s and 1790s, ether made its first modest appearance in modern medicine, mostly as a treatment for pulmonary phthisis or tuberculosis. Patients were given a couple of ounces in a glass – the same delivery method which Graham found so soothing – to inhale, sometimes with a towel over the head to trap the vapours; after a few minutes the liquid would all have evaporated away. Although this would have had no lasting or curative benefits, the sensation of coolness in the throat and lungs offered a brief suppression of the symptoms; the treatment became popular particularly among Scottish doctors, and Beddoes experimented with it in the early days of his pneumatic project. The doctor Sir Thomas Watson talked later about prescribing a saucer of ether to a woman suffering from asthma in 1806, noting that as she inhaled it under a shawl a "delightful sense of tranquillity ensued", and she felt "as if she was going to heaven".

This quite typical account reveals how, from its earliest medical beginnings, another effect of ether became apparent: that whenever it entered the medical pharmacopeia its vapours would show a tendency to diffuse into the pursuit of pleasure. By the beginning of the nineteenth century extra-curricular 'ether frolics', initially among doctors and medical students, had become a minor phenomenon noted not only in Britain but in Germany and America, the harbinger of a syndrome which would repeat itself on an increasingly larger scale throughout the century as ether use became more wide-spread. And because, unlike nitrous oxide, ether needed no special inhalation apparatus beyond a bottle and a rag, this

extracurricular use extended far more widely into the public domain than that of the gas. Doctors, of course, cautioned strongly against non-medical use from the beginning: a typical early warning from an 1818 scientific journal related how "by the imprudent use of ether, a gentleman was thrown into a very lethargic state . . . for many days the pulse was so much lowered that considerable fears were entertained for his life".

Throughout the first half of the century ether, like nitrous, had the air of a substance of great power and potential which was still searching for its killer application. It remained of use in tuberculosis treatment, and spread to similar applications for asthma and catarrh, without advancing beyond the role of short-acting symptomatic relief. With hindsight, of course, it's clear what that killer application was: surgical anaesthesia. But during the first half of the century, the word 'anaesthesia' had yet to be coined, and the territory was occupied by notions of 'mesmeric sleep', a marginalised and largely disreputable fringe science. Numbing and insensitivity to pain had been noted among ether's effects from its early days, but it would be fifty years before the benefits of introducing it into the operating theatre were recognised to outweigh the doubts about controlling the plunge into oblivion and the hazards of introducing flammable solvents into the already complex and critical procedures of surgery.

It wasn't, though, as if nobody had the idea. In 1824 a young doctor from an old and modestly respectable Worcestershire family, Henry Hill Hickman, seems to have discovered the secret of ether anaesthesia which would be claimed and contested with incredible bitterness a generation later. Hickman's work is obscure and his own documentation of it fragmentary, but it seems to have sprung from an interest in 'hypnotic trance' and 'mesmeric sleep', and a desire to elucidate the physical underpinnings of these elusive phenomena. Consequently he conducted a series of animal experiments in the search for "Suspended Animation" – techniques which could suspend basic bodily functions like respiration and intellect without causing damage or death. In his small country laboratory Hickman methodically eased various laboratory animals

towards the point of death from various different avenues: asphyxiation, gases from Davy's *Researches* like carbonic acid – and, apparently, ether inhalation, since he states that "the agency of sulphuric acid and carbonate of lime . . . produced the desired effect much sooner than any of the others".

Despite the grotesque images conjured up by his strange work – images inescapably close to *Frankenstein*, attempting to separate his experimental creatures from their life-spirit and then rejoin them – it seems that Hickman was largely motivated by kindness. He gave up a day every week to free treatment of the local poor, and was clearly upset by the suffering which he had no choice but to inflict during surgery; it is with this in mind that we must approach his records of placing a puppy in an airtight box, waiting for it to pass out and then docking its ear. He concluded after many such experiments that these various techniques of controlled asphyxia could not only be used to eliminate pain during surgery, but also had the secondary benefit of decreasing blood loss and the risk of haemorrhage during swift operations.

But the young doctor's privately published pamphlet on the subject, obscure and rather muddled, sank without trace. Hickman, whose family had strong ancestral Royalist leanings, decided that he would receive justice and recognition from the French Royal Academy and its patron Charles X, and set off for France in 1828. He received a hearing at the Academy, but the idea of painless surgery through asphyxia met with incredulity and a resounding silence: the cutting edge of French ideas still revolved around bleeding patients in advance of operations to reduce blood loss during the actual surgery. Returning to England the next year, he sold his medical practice and retreated into his laboratory, refining and expanding his "Suspended Animation" techniques. Vague claims leak out from his letters, clues that the secret lay in "introducing certain gases into the lungs", but he published no further results, and we can only speculate on the extent to which he pioneered the anaesthetic revolution of the next generation – or, indeed, proceeded towards something which has since become an entirely lost science.

When Hickman died in 1830 – at the young age of thirty and probably, ironically, from tuberculosis – the first search for inhalation anaesthesia seems to have died with him. But when ether anaesthesia finally emerged, it would be one of the defining medical triumphs of the century; and, in violent contrast to Hickman's genteel private research, it would be accompanied by one of the most virulent and bitter public controversies in medical history.

℘ ℘ ℘

The idea of using ether in surgery, when it next recurred, was prompted by self-experimentation. Dr. Crawford Williamson Long, a young surgeon from Jefferson, Georgia, was one of the many young medical men who had discovered the pleasures of inhaling nitrous oxide; one evening in 1841, a temporary shortage of the gas led him to introduce ether to "a company of young men", promising that it would produce "equally exhilarating effects". The company all inhaled the ether and "they were so much pleased with its effects that they afterwards frequently used it and induced others to do the same, and the practice soon became quite fashionable in the county".

As the boisterous ether fad ran its course, Long himself leading the charge, he began to "frequently, at some short time subsequent to its inhalation, discover bruised or painful spots on my person which I had no recollection of causing". He also noticed that "my friends while etherised received falls and blows which I believed were sufficient to produce pain on a person not in a state of anesthesia". These observations led him to the conclusion, obvious at least with hindsight, that "anaesthesia was produced by the inhalation of ether, and that its use would be applicable in surgical operations". Thus, in 1842, he removed a tumour from the neck of a patient under ether.

One might have thought that this would be the end of the story of the discovery of ether anaesthesia, but it wasn't even the beginning. Long didn't publish the results of his experiment, an omission which he would bitterly regret when, in 1846, the controversy over the invention of ether anaesthesia began in earnest.

As it turned out, the beginning of the 'official' discovery of ether as an anaesthetic agent was the suicide of Horace Wells in his prison cell after his failed attempt to demonstrate nitrous oxide anaesthesia to the world. Wells' partner in this endeavour had been another East Coast dentist, the Boston practitioner William Morton; but whereas Wells seems to have been destroyed by the unjust failure of his nitrous trial, Morton was clearly spurred on to further action. This seems not to have been a quest to expand medical knowledge for its own sake, nor even (at first) to take credit for a major discovery: Morton was a dentist who specialised in fitting prosthetic plates, which required the extraction of all the patients' rotting and broken tooth stumps, and the pain of this procedure was a significant deterrent to his business. Thus, in the pursuit of another anaesthetic agent, he made the acquaintance of a Boston chemist called Charles Thomas Jackson and picked his brains about the likely suspects – and, not surprisingly, ether was drawn to his attention.

How this happened is much disputed. Morton's version of the story is that he asked Jackson: "Why not ether instead of nitrous oxide?" and Jackson, recalling ether frolics he had attended at Cambridge, Massachusetts, replied that it would certainly render the subject "dull and stupefied". Morton sub-sequently acquired some ether from the chemist and began to experiment privately. His first animal experiment was unpropitious: he attempted to etherise a goldfish, whose lack of lungs turned out to be an insurmountable obstacle. But he had more success with a dog, which "wilted away" as he held its head over an ether bowl. Encouraged, he sprinkled some ether on a handkerchief and inhaled it himself. "I felt a numb-ness in my limbs", he recalled, "with a sensation like a night-mare . . . I thought for a moment I should die in that state, and the world would pity and ridicule my folly". But, on recover-ing, he was persuaded that there had been around seven or eight minutes of oblivion during which he would barely have noticed a tooth being pulled. Finally, on September 30th 1846, he painlessly removed a tooth from a local businessman called Eben H. Frost.

Morton had clearly learned much from Wells' failure with nitrous oxide, and also appreciated more fully this time round how financially advantageous it might be to demonstrate an effective, repeatable anaesthetic with a reliable chemical action. Whereas Wells' first plea on recovering from his pioneering nitrous operation was "let it be as free as the air we breathe!" Morton applied himself single-mindedly to cornering the market. The trouble he faced was that ether was an extremely well-known and widely available substance, and that all it needed to administer it was a bottle and a cloth. Undeterred, Morton began leaking his version of his accomplishment to the local press: he had discovered a new anaesthetic agent called 'letheon', and designed a special means for dispensing it effectively. This was a complicated rig – patentably so, Morton hoped – comprising a glass cone with an ether-soaked sponge in the large end and a fitting to attach it over the patient's face.

Press reports of this sensation led to medical interest, for which Morton was this time well prepared. The 16th October 1848 was to be a red-letter day in the annals of medical history, and an unforgettable triumph for the still-fledgling American science. Morton gave a public demonstration of surgery under ether in Massachusetts General Hospital with the venerable old surgeon Dr. John Collis Warren who had, in fact, been in the habit of prescribing ether for lung inflammations as early as 1805. Morton wheeled in his "cone of oblivion" and administered the newly discovered 'letheon' to the patient, a twenty-year old man who was having a congenital malformation removed from his neck. With the words "Your patient is ready, sir", he turned the young man over to Dr. Warren. As the incision began, Dr. Warren announced to the assembled luminaries: "Gentlemen, this is no humbug". After the surgery the patient stated that "I did not experience pain at any time, though I knew that the operation was proceeding".

The operation was reported far and wide and, in a stroke, medical anaesthesia was born. The lines attributed to anaesthetist, surgeon and patient became, within medical tradition, as clearly and solemnly recalled as the lines spoken during the moon landing. The building in Massachusetts

Hospital where the operation took place is known to this day as the 'Ether Dome'. While it would take another fifteen years and 75,000 tooth extractions by the ex-carnival showman Gardner Quincy Colton for nitrous oxide to make its way into the medical canon, ether was there in one small step, one giant leap for mankind. The magnitude of this leap was commemorated a month later when the poet and journalist Oliver Wendell Holmes wrote to Morton suggesting that a new word, "anaesthesia", should be coined to describe this new phenomenon of loss of consciousness, to distinguish it from the familiar "analgesia", the mere tolerance of pain produced by agents like opium.

In 1820, the British essayist Sydney Smith had been able to ask smugly, "Who reads an American book, or goes to an American play, or looks at an American picture or statue? What does the world yet owe to American physicians or surgeons?" By 1848, at least the last part of this question had a resounding one-word answer.

℘ ℘ ℘

After October 1846 Morton's place in medical history was, so he thought, assured: the more pressing question was how exactly he was to profit from it personally. From the beginning, 'letheon' was a nonstarter: all the doctors involved, including old ether hands like Dr. Warren, were aware from the first whiff of the identity of his 'mystery substance'. But he still maintained high hopes for his "cone of oblivion", and gave up his dental practice to attempt to exploit it, and to petition the US Congress to recognise him as the inventor of ether anaesthesia and reward him for it.

Meanwhile the chemist Charles Thomas Jackson emerged from the shadows, maintaining that it was he who had turned Morton on to ether and that he was entitled to a share in any patents or rewards. It turned out that this wasn't Jackson's first attempt to share, or steal, the glory: in 1837 he'd tried to lay claim to his former friend Samuel Morse's invention of the electro-magnetic telegraph. Morton dismissed Jackson's claims and continued his solo crusade; Jackson, meanwhile,

wrote up the discovery and procedures and submitted them to the French Academy, who had been nonplussed by Hickman's demonstration of the same effect twenty years before. Jackson's strategy showed splendid low cunning: he sent a sealed missive only to be opened on his instructions, while he waited to see if 'etherisation' would fail subsequent trials. But Morton continued to demonstrate it effectively; Jackson ordered the breaking of the seal; and this time Hickman's fond hopes of the Academy were belatedly realised, as they offered a prize of 5,000 francs to be divided between Jackson and Morton. But Morton preferred to refuse the money than to share it, and publicly accused Jackson of giving away his 'secrets' to the French Academy, collecting sworn statements about Jackson's alleged 'falsehoods' from doctors whose patience must already have been wearing thin.

But this was only the opening salvo in the Morton-Jackson feud. By the end of 1847 it was clear even to Morton that there was no chance of enforcing a patent on wafting a common substance under people's noses, and he began to focus all his energy on making presentations to Congress and demanding a reward for its discovery. In a public-spirited gesture he offered his services as an etherisation consultant to the US Army in the Mexican War, but the army declined. After several years of petitions, patents for new inhaling devices and increasingly straitened circumstances, Congress finally issued an Appropriation Bill in his favour for $100,000. But this was immediately contested not only by Jackson but also by Horace Wells' widow, on the grounds that Wells and Morton had both experimented with ether before Wells' death. As the wrangle assumed greater public dimensions, William Crawford Long was finally persuaded to come forward and testify that he had been using ether anaesthesia years before any of the above. After two more years of denunciation and litigation, the Senate finally rejected the bill on the grounds of "multiplicity of claimants".

The collapse of the Appropriation Bill was really the end for Morton, but his tenacity died hard. During the next decade he and his family retired to the country, where Morton's

monomania succeeded in reducing them to grinding poverty in the pursuit of lawsuits and patents. The end didn't come until 1868, when he was stung to a renewed fury by a new article, this time in the *Atlantic Monthly*, reiterating Jackson's claim of "his discovery" of ether anaesthesia. Morton set off immediately to New York to order his lawyer to slap an injunction on Jackson; he arrived in the middle of a heatwave and died of an apoplectic seizure on the way to the lawyer's office. His wife, identifying him at the hospital, announced to the assembled house physicians: "Young gentlemen, you see lying before you a man who has done more for humanity and the relief of suffering than any man alive".

But even this wasn't the end of the *folie à deux*. Later that hot summer, Jackson was unable to resist a final triumphant (and drunk) visit to Morton's grave. But when he located the plot, he discovered, carved on the gravestone, an inscription:

> *William Thomas Green Morton*
> *Inventor. Revealer of Anaesthetic Inhalation.*
> *By whom pain in surgery was averted and annulled.*
> *Before whom in all time surgery was agony.*
> *Since whom science has control of pain.*

Jackson apparently gazed silently at the gravestone for some minutes, then began to scream and flail around savagely. Members of the public became alarmed and summoned the park attendant, who in turn summoned the police. They were forced to restrain Jackson, and he was carried off to a New York asylum, where he died ten years later.

Thus the three chief claimants to the discovery of anaesthesia – Wells, Morton, Jackson – all perished both strangely and miserably, like the murderous trio in a vapour-soaked *Treasure of the Sierra Madre*, or the protagonists of some parable of hubris against a vengeful god. But Crawford Long, who had exhibited little greed for recognition, escaped the curse: he survived until 1878 and eventually died, aged sixty-two, only hours after delivering a child under ether anaesthesia. And throughout the controversy Henry Hill Hickman, the

precursor of them all, slept the sleep of the dead in his family plot in a Worcestershire country churchyard.

φ φ φ

One of the side effects of the widespread adoption of ether anaesthesia was, of course, an increase in ether's production and availability, not merely to surgeons but to local pharmacies, vets and GPs – and, given its socially volatile nature, into the wider community. It's from 1847 that we begin to see the widespread recreational use of ether, and the corresponding stepping-up of anxieties within the medical profession about 'etheromania' or, more broadly, 'toxicomania' among the general public. The first full case study appeared promptly in the *Lancet* in 1847, and described the "great cerebral derangement produced in a highly talented and intellectual individual by too freely inhaling ether". The patient in question developed a "strange delusion that he could expand the powers of his mind *ad infinitum* if he could obtain a free supply of ether", a delusion which apparently, and rather chillingly, persisted "until his mind was so impaired that it was necessary to place him under permanent restraint".

These cases might have remained within the relatively small milieu of renegade doctors and intellectual experimenters were it not for a second circumstance which led to the rapid diffusion of ether: not only was it suddenly more available, but alcohol was more tightly controlled. The 1850s saw the beginning of massive excise and duty hikes on spirits in various parts of Europe and America, and in many of these often rural areas ether seems to have filled the vacuum with a vengeance. In parts of northern Germany mass 'etheromania' took hold, particularly among Lithuanian immigrant communities; among rural peasants from Russia to Galicia, Norway to Michigan we hear reports of ether being consumed "in inconceivable quantities". But the best documented of all these outbreaks, and one of the most remarkable accounts of mass drug culture in nineteenth-century Europe, took hold in and around Draperstown, a market town in Northern Ireland. It lasted for about fifteen years, and became

so notorious that an English doctor and Temperance campaigner, Benjamin Ward Richardson, made the lengthy and unpleasant journey to the scene of the crime to observe the practice and file what remains one of the most striking reports of a drug epidemic ever recorded.

℘ ℘ ℘

The first spur to the Draperstown outbreak, according to local legend, was the Temperance mission of a Father Matthew in 1840 which succeeded in almost eradicating the well-entrenched habit of whisky drinking in the town. Father Matthew's success may well have been embroidered with hindsight to give some rationale to what followed, but in any case a second circumstance seems to have provided the eventual trigger: the onerous British government tax on ethyl alcohol instituted in 1855, which also coincided with an unusually efficient police operation to close down the illegal production of the local moonshine, poteen. Shortly thereafter, reports began to emerge that the town was in the grip of a mass etheromania, much to the dismay of Temperance activists like the Society for the Study and Cure of Inebriety who feared that Draperstown might be the beginning of a wider epidemic. "What guarantee is there", demanded one of the Society's members, "against its spreading over the length and breadth of Ireland and clouding the spirit and sapping the physique of the finest peasantry in the world?"

Richardson's journey to Draperstown takes place in a fog of deep foreboding reminiscent of Jonathan Harker's approach to Dracula's castle. From Ballymena, Cork, Dublin, Waterford, Belfast and Coleraine he hears tales of the ether-drinkers, and as he finally takes a carriage into the remote valley he scents its whiff from the distance of half a mile. "Making my way to the lower part of town", he reports, "where business was being carried on, sure enough there was the enemy." The crowded market and the array of grocers and provision stores were permeated with the telltale reek "as certainly as if I had been in the sickroom using spray for an operation".

It didn't take him long to track the enemy to its source: it

was being supplied from under the counter of two or three of the town shops, and most of its customers were knocking it back on the spot. Here, its habitués had graduated beyond sniffing it from a bottle or a rag, and had developed a technique for drinking it by the glassful. The drinkers (or "topers", in the contemporary slang) would begin by washing their mouths out with water, then swallow a little ether "to cool the throat", then toss down a full glass of it and chase it with a glass of water to "keep the ether from rising" or evaporating up the oesophagus before it could reach the stomach. Richardson, who considered that a quarter or perhaps half an ounce of ether was a massive dose, was astonished to see full wine-glasses containing as much as three ounces being despatched in this manner: "in a little time", he notes, "the 'trick' is easily acquired by members of both sexes". Local enquiries also established that the Protestant community were almost entirely "free of vice": almost all the topers were Catholics, many from the outlying villages. Train guards testified that the stench of third-class railway carriages on market days was "disgusting and abominable".

Richardson records the effects of ether in great detail: "quick excitement, flushing in the face, rapidity of the pulse, elevation of the mind and rapid, unsteady motion of the body". The majority of topers stop once they're intoxicated, but some continue to down repeated doses, eventually becoming either violent or insensible. But these are the exception rather than the rule. The toper "is free of his mind and sometimes shows his teeth but, generally, laughter like that of a person in hysterics is the sign of ether-drinking". Despite its grotesque outward appearance, "all ether drinkers agree that it is a pleasurable form of intoxication". In fact, once Richardson is confronted with the "enemy" in the flesh, much of his initial Temperance spirit evaporates. "I am bound", he admits, "to state the truth that ether intoxication is actually far less injurious socially, morally and physically than is the alcoholic intoxication", a view which he marshalls many reasons to support. The ether drinker is "sooner restored to sobriety" – an effect which, incidentally, made

ether use almost impossible to police, since by the time even the most reeling toper was hauled down to the police station the effects had passed. He generally also "falls before he is hurt or violent" and, though he may briefly become a "savage", rarely becomes a "sot" in the manner of a chronic alcoholic. No crimes of violence are plotted under ether – "it is a volatile fury, volatile as the fluid which produced it". During the entire outbreak, the local doctor recorded only one death and three "near-deaths" from the habit, mostly as a result of its fire hazards: one toper lit his pipe under the influence and "the fire caught his breath", but his friends poured water down his throat. (Persistent urban legends circulated throughout the late nineteenth century – often from medical sources – about etheromaniacs spontaneously combusting as a result of belching in the vicinity of gas lamps, but it's likely that this scenario was extrapolated from the fire hazards, well-known to doctors, of performing ether surgery by candlelight.)

Richardson's surprisingly benign assessment of ether intoxication was increasingly recapitulated throughout the overlapping Temperance and medical communities as the century progressed – a measure of the extent to which alcohol was seen as the most dangerous substance of abuse throughout the century. The President of the Society for the Study of Inebriety, Norman Kerr, also studied the Draperstown outbreak but concluded that ether abuse was little more than a footnote both to alcohol abuse and to ether anaesthesia. His assessment also echoes the American national pride in the discovery of anaesthesia: "To America the whole world owes a deep debt of gratitude for the introduction of ether as an anaesthetic by Dr. Morton in Boston, 1846, and any saddening misuse of this grand mode of alleviating human suffering ought not to lessen our appreciation of this splendid boon to humanity". Doctors broadly agreed that ether didn't produce the "gross lesions" of the brain associated with chronic alcoholism, and it wasn't directly connected to insanity in the way in which alcohol increasingly became. Richardson himself concluded that ether drinkers didn't develop an "alcoholic constitution", and that its worst physical effects were "dys-

pepsia, hysteria, flatulence and post-depression": without apologising for ether-drinking, he was firm in his view that whisky was worse. Despite regular warnings about the non-medical use of ether, its dangers were typically seen in terms of the temptation to pleasure which it offered, and the consequent "profound degeneration of the moral character" of those who succumbed.

℘　℘　℘

But Richardson's ether account has a further surprise in store: an enthusiastic, even rhapsodic account of the subjective effects of ether on himself. This further dimension of ether use completes the trinity which it shares with nitrous oxide – surgical anaesthesia, public frolics and philosophical revelation – and in Richardson's case the link is explicit, as he is consciously following in the footsteps of Humphry Davy. Whereas the popular use of ether is seen to a greater or lesser extent as a public menace, the precedent of Davy, who had subsequently become the President of the Royal Society and among the most significant contributors to the public understanding of science of the century, gives Richardson permission to explore the alien shores of consciousness which ether reveals. He cites Davy's "memorable, perfect and original work" on nitrous oxide as a milestone in modern science: "a description of intoxication refined to the extremest degree"; within the Temperance context in which he's writing he's particularly careful to characterise Davy's combination of the gas with large quantities of alcohol as an example of self-sacrificing scientific heroism, to which "for the sake of experiment" he "subjected himself systematically".

Richardson turns out, in fact, to be something of an ether connoisseur. Methyl ether – the commonest compound – is apparently the best, and in his view "more pleasurable in action when inhaled than nitrous oxide". Ethyl ether is inferior – "grosser", and producing nothing more than "foolish dreams, forgotten upon awakening". But on methyl ether Richardson reports, very deliberately in the style of Davy, the sensation "as I came under the influence, that

141

periods of time were extended immeasurably . . . the small room in which I sat was extended into a space which could not be measured . . . the ticking of the clock was like a musical clang from a cymbal with an echo; and all things touched felt as if some interposing, gentle current moved between them and the fingers". His final assessment of the experience both concurs with Davy and prefigures William James: "They who have felt this condition, have lived as it were in another life, however transitory, are easily led to declare with Davy that 'Nothing exists but thoughts'."

Such reports were not uncommon throughout the nineteenth century: the crescendo of the ether rush can produce marked sensations of dissociation, disembodied sounds, *déjà vu* and vivid dreams and, while it lacked the high-profile poets and philosophers associated with nitrous oxide, the 'inhalation revelation' survives piecemeal in various medical and nonmedical accounts. The most conspicuous literary etherdrinkers were the French decadents Guy de Maupassant and, particularly, Jean Lorrain, who began to use morphine for his tubercular symptoms and progressed to ether-drinking. Under its influence he wrote a cycle of ether-drinker tales, *Contes d'un Buveur d'Ether*, which are de Quinceian not only in title but in their dark, hallucinatory landscapes of haunted houses, syphilitic nightmares and characters in terrifying masks; he found that under its influence the apartments where he lived accreted phantasmal layers of ghosts and poltergeists. His habit eventually ulcerated his stomach to the point where he needed intestinal surgery. Another *fin-de-siècle* ether enthusiast was Aleister Crowley, who began using ether in his ritual magic but before long was inhaling it to control his night terrors during withdrawal from cocaine and morphine: he described his romance with it in an article for *Vanity Fair* as "to woo a flask of ether – breathing it as if it were the very soul of your Beloved – and you will perceive the heart of Beauty in every vulgar and familiar thing."

But Oliver Wendell Holmes, the coiner of "anaesthesia", gives perhaps the best remembered description of ether inhalation, and certainly the most knowing and ironic. He

records inhaling a large dose of ether "with the determination to put on record, at the earliest moment of regaining consciousness, the thought I should find uppermost in my mind". He experienced the rush as "a triumphal march into nothingness" accompanied by stirring music which seemed to be encouraging him to a superhuman divinity; the "veil of eternity was lifted" and the wisdom of the ages revealed to him. He staggered to his desk and wrote it down with numb fingers and sprawling script. As the ether ebbed, he looked down at the paper. "The words were these (children may smile, the wise will ponder): 'A strong smell of turpentine prevails throughout'."

℘ ℘ ℘

Another consequence of the discovery of ether anaesthesia was the search for other less toxic and hazardous anaesthetic agents, a search which promptly turned up another and in many ways preferable substance, chloroform. Chloroform, or trichloromethane, had first been synthesised in the 1830s and had in fact been investigated by Horace Wells, who was probably its first habitual user: he was under its influence during his ill-fated acid-throwing escapades, and its first use as an anaesthetic was almost certainly his own prison-cell suicide. Within a year of Morton's triumphant ether surgery, it was proposed as an alternative by the authoritative figure of James Young Simpson, the professor of midwifery at Edinburgh University. Simpson commended it as being "more agreeable and pleasant" than ether, without the bad smell, skin irritation and fire hazard. It was also, he added, cheaper: less of it was required, it was longer lasting and – this still in the era of Morton's Heath-Robinson patent contraptions – it needed "no special inhaler", but could simply be poured onto folded cloth and held under the patient's nose. Subsequent to Simpson's commendation, chloroform substantially replaced ether for surgery, particularly in his own field of obstetrics.

All these medical advantages were, of course, also non-medical ones, and the 'luxurious' use of chloroform spread along with ether – often in combination or even physically

143

mixed together – in the following decades. Chloroform has a distinctive sickly smell, reminiscent of a cough-candy-laden Victorian sweetshop – indeed, both chloroform and ether were common ingredients in cough medicines – but is less pervasive and somewhat more refined than its cruder cousin, lacking its raw solvent reek. This led it to a markedly different social profile characterised by its use in towns and smarter society, and as a result a new set of anxieties began to develop about ether- and chloroform-taking not in backwoods rural communities but in cities and among the middle and upper classes. "Jolly old chlorers" became popular among society women, who would sniff it either to calm an anxious disposition or in swooning group 'frolics'; students and white-collar "brain-workers" began to use it for insomnia and general relaxation after working long hours; various rumours of the penetration of inhalants into the aristocracy include the toxicologist Louis Lewin's unfortunately vague account of an "etheromaniac earl" who "committed extravagances which, from a moral point of view, classified him among mental deficients".

Although not substantially addictive, these substances clearly had the potential to become habit-forming inasmuch as they offered an immediate coping mechanism for nervous stress. Medical warnings of "morbid craving" – and the inevitable new taxonomy of "chloralism" – shaded into broader concerns that abuse of these new chemical substances was becoming part and parcel of modern life, and that drugtaking might not be merely primitive and atavistic behaviour which civilisation would eventually stamp out but could perhaps be reconfiguring itself as a response to the stresses and strains of civilisation itself. Richardson, in his influential *Diseases of Modern Life* – writing with his Temperance hat firmly repositioned – expresses precisely these concerns about the new "narcotic luxuries": ether, chloroform and chlorodyne (a liquid admixture of various sedatives, usually including morphine, cannabis and molasses). After rehearsing various ancient and barbaric practices of intoxication, among them the Scythian hemp tent, he stresses that "in our own civilised communities there exist at this time considerable populations of men and women

who . . . pervert the advances of science to their set and wanton purpose". Within this complex of concerns we can see perhaps the first stirrings of today's anxieties about modern or 'designer' drugs from valium to prozac to ecstasy.

Chloroform also shares ether's ability to produce strange sensations at the borderlines of consciousness, and although there are few accounts of these being pursued for their own sake there's a great deal of anecdotal evidence that they were widely known and exercised a pervasive influence on the dreamier reaches of the Victorian imagination. A doctor named George Wyld wrote to the *Lancet* to report that, in 1874, he had been inhaling chloroform to ease the pain of a kidney stone when he found himself having a classic out-of-body experience, watching himself from a distance lying on his bed. He then undertook a survey of local surgeons and anaesthetists, and discovered that these spectral experiences were quite common, and frequently recounted by patients after administration. One doctor had experienced "exactly similar sensations" himself; another had been told by a patient that "I thought I had got to the bottom of the secrets of nature". Another recalled a further version of the Perennial Philosophy of the inhalant user: "When under chloroform, the Platonic idea came to me that Matter was only phenomenal, while the only reality was that which underlay Matter – viz. its spiritual substance". By the end of the century, the revelatory dimensions of chloroform anaesthesia were sufficiently familiar for H.G.Wells to use them as a springboard for one of his trademark fictional excursions into vast cosmic perspective: his successful short story *Under the Knife* begins with the protagonist inhaling chloroform on the operating table before being precipitated into an out-of-body voyage above the earth, beyond the stars and finally to a vantage point where the entire galaxy is revealed as a mote of dust in the disembodied hand of a mysterious Creator.

℘ ℘ ℘

The broad-spectrum use of ether and chloroform seems to have had its heyday in the 1870s and 1880s, a period which

represented a brief window between the decline of the traditional opium of the early century and the proliferation of high-tech and more potent alternatives which accelerated towards the century's end. The first flush of medical warnings about opium addiction in the 1870s produced a modest but unmistakeable decline in its excessive or problematic use, to the point where even crusading doctors like Richardson took the view that opium was gradually "dying out"; by the late 1880s the combination of morphine and hypodermic syringes was offering far more potent alternatives to the committed narcomaniac. The last decades of the nineteenth century also saw a huge range of alternative sedatives hit the market, courtesy mostly of the German chemical industry. The earliest and most successful was chloral hydrate, developed in 1869, a powerful knockout compound which was initially hailed by the medical profession as largely abuse-proof, having neither the dreamy appeal of opiates nor the lightheaded rush of chloroform or ether. But the chemical cosh of chloral proved surprisingly popular, especially among sleep-deprived office workers, insomniacs, stimulant abusers and other victims of modern life, and by the time it had been joined by paraldehyde, sulphonal, veronal and finally heroin, the market for volatile inhalants had largely evaporated, supplanted by a more efficient – though also more toxic, debilitating and addictive – sedative culture.

By the 1890s, the pressure of Temperance societies had caused the British government to review their *laissez-faire* policy towards strong spirits, a revision which included statutory limitations of the sale of ether which are still broadly in force today. Neither ether nor chloroform have been added to the list of illegal substances – their industrial uses would make this bureaucratically inconvenient and unpopular – but nor have either of them found any but the most marginal position in modern drug culture, their profile of use probably being most closely approximated by glue-sniffing or amyl nitrate. Perhaps, in fact, the closest ether comes to the modern drug habit is its widespread use in South America as a solvent for converting coca leaf paste into cocaine.

5

"Watson, The Needle!"

Cocaine

The discovery of the coca plant by Europeans dates not to the second wave of exotic plant drugs which descended on the nineteenth century, but to the first wave which broke three centuries earlier with the discovery of the New World. Tea, coffee, tobacco and cocoa were all introduced to Europe at this time, and all of them took decades, if not centuries, to establish themselves against widespread resistance to strange and primitive foreign habits. All of them were banned at various times and places, and all of them initially found favour with small groups of devotees before percolating into wider society. In each case, too, the new 'soft drugs' eventually found mainstream acceptance by developing a new set of associations which reinvented them as 'modern' European habits, distinct from the barbarous practices which had characterised their indigenous use. Tea and tobacco were surrounded with modern medical claims for their health-giving properties; coffee was served in a new type of establishment, the coffee-house, which was frequented by well-heeled businessmen as an alternative to the ubiquitous tavern. Tea, coffee and cocoa were all repackaged by the addition of milk and sugar, which had never been part of their traditional preparations.

But somehow, in this first wave, coca missed the boat. It's present in the main sourcework for the first wave invasion, the 1569 monograph by the Seville doctor Nicholas Monardes entitled *Joyful Newes out of the New-found Worlde, wherein are declared the rare and singular virtues of divers herbs . . .*, where the virtues of tobacco and cocoa were also first extolled: Monardes

notes that the natives barter coca for cattle and salt, that they mix the leaves with shells burnt and ground to lime, and roll them round in their mouths. He also observes that coca is used, especially while travelling, to suppress fatigue, hunger and thirst, and that it gives its habitués "great contentment"; furthermore, that when they chew it together with tobacco, they "go out of their wittes". But while the other new habits eventually caught on, coca remained an ethnographic curiosity.

The reasons for this are most likely practical ones. Coca leaves need to be chewed in a large quid and periodically mixed with lime or ash to release the active alkaloids; while this practice is attended with much sophisticated ritual paraphernalia in the Andes, chewing large mouthfuls of dried leaf would have been difficult to square with European notions of decorum. Also, coca leaf is highly variable in quality and tends to lose its potency when dried: right up to the nineteenth century, a large proportion of the coca which was despatched to Europe seems to have arrived more or less inactive.

But were it not for these hurdles, there's no reason to suppose that coca-chewing – or, indeed, coca tea drinking – wouldn't have become at least as popular in Enlightenment Europe as tea, coffee or tobacco. When correctly released and ingested, coca is a mild stimulant of similar potency to coffee, but more euphoric, less diuretic, easier on the digestive system and without caffeine's side effects of sweats and racing pulse. It contains only around one per cent cocaine (of which, obviously, more later), along with a combination of oils, vitamins, minerals and other alkaloids which have the effect of smoothing the rough edges of its stimulant effects. Because its traditional methods of preparation only allow it to be absorbed slowly, it's almost impossible to abuse, as it never offers more than a gentle stimulus. Doubtless, if coca had taken its place in this context in early modern Europe, the story would have progressed rather differently.

As it was, by the end of the nineteenth century a huge arsenal of modern techniques for accessing these benign effects had been developed: coca or mild cocaine preparations were widely available as tonics, digestive wines, lozenges,

coca-leaf cigarettes or cheroots, suppositories and, of course, Coca-Cola. But by that time, too, the genie had been released from its bottle: pure cocaine had been isolated and extracted, offering the possibility of an effect many hundreds of times more potent than the coca leaf, with all the escalation of both benefits and dangers which could be expected. By the end of the century, cocaine had become a story simultaneously of soft drinks and hard drugs, a Jekyll and Hyde, a Frankenstein's monster both benevolent and terrible.

℘ ℘ ℘

Throughout the first half of the nineteenth century coca remained, in the eyes of the West, little more than a botanical footnote. It was entered into encyclopaedias, specimens were pressed, and accounts of its effects on Indians were occasionally collated. These focused on its role not as a ritual or recreational substance but as a stimulant accessory to physical labour: it was the "marching powder" which enabled Indians, especially at altitude, to shrug off fatigue, ignore hunger, and keep walking or mining for days at a time. One lighthearted letter to the *Gentleman's Magazine* in 1814 suggested on the basis of these reports that a super-strength coca would be most desirable, and that the already proverbial drug experimenter Humphry Davy was the man for the job: "Now, if Professor Davy will apply his thoughts to the subject, there are thousands even in this happy land who will pour their blessings on him, if he will but discover a temporary anti-famine, or substitute for food . . . by which any person might be enabled, like the Peruvian Indian, to live and labour in health and spirits for a month now and then without eating". All in all, coca's profile was similar to, for example, betel – another mild stimulant which was becoming familiar at the same time from exploration in South-East Asia, and which was also accompanied by practices of chewing and spitting which ruled out its entry into civilised society.

Coca might long have attracted mild curiosity but no proper study if it hadn't been for a young Italian doctor, Paolo Mantegazza, who spent four years practising in Argentina in

the mid-1850s. His travels in the north-west of the country brought him into contact with coca-chewing Indians; he experimented with it and soon took it up regularly, continuing for several years, and when he returned to Italy in 1859 he published a detailed monograph on the subject.

Mantegazza's *On the Hygenic and Medicinal Virtues of Coca* is in many ways analogous to Moreau de Tours' pioneering work with hashish. It combines objective clinical reporting with elegant descriptions of moods and mental states, including wild stream-of-consciousness hallucinations; it lays out an ambitious range of medical applications for the plant; and it represents a decisive beginning in the process of separating the properties of the drug from its exotic ethnographic background and bringing it into the purview of modern science. He begins by using it regularly for a couple of years as an evening tonic to allow him to work after dinner, and then starts methodically chewing his way through larger and larger doses to investigate its more intense effects.

The picture he assembles of its mechanism of action is, like Moreau de Tours' assessment of hashish, remarkably consistent with subsequent scientific findings. It stimulates the stomach and assists digestion, while also having a central stimulant action on the entire nervous system. At low doses these effects are barely noticeable, but at medium doses they impinge on consciousness to a marked degree. Muscular power is increased: although it's possible to sit around in a state of "perfect laziness", Mantegazza also finds that "a new strength gradually drenches one's organism in every sense, as a sponge soaks itself with water", and "one feels stronger, more agile, and readier for any kind of work". In this state, he discovers that he can accomplish remarkable feats if he's moved to do so. "Once", he records, "I easily jumped upon a high writing table so nimbly and safely that I moved neither the lamps or any of the books upon it". The same effect seems to be exerted upon the intelligence: it becomes "more active, the speech more vigorous", but at the same time one loses the motivation for routine intellectual tasks and finds oneself simply lounging in a euphoric state of tranquillity.

But when he pushes his dose to the practical maximum, repeatedly chewing over an ounce of leaf at a time in swift succession, he experiences a new spectrum of effects which would only become more broadly familiar after the isolation of cocaine – in his words, "the delirium of coca intoxication". This is marked by a racing pulse, minor heart palpitations, a surge of "extraordinary happiness", and the transformation of the world into "images that were more bizarre and splendid, in terms of colour, than could ever be imagined". This starts him talking in rapid fire to a colleague who's witnessing the experiment, but "I spoke with such vehemence that he was not able to take down more than a few of the thousands of words with which I was deafening him". Taking pity on the first though by no means the last after-dinner-guest to be subjected to an interminable cocaine-fuelled rant, Mantegazza relapses into a "delirium" where a rapid succession of images pass before his eyes, from which he emerges only occasionally to interject essential *aperçus* like "God is unjust because he made man incapable of *sustaining the effects of coca* all life long. I would rather have a lifespan of ten years with coca than one of 1000000000 centuries without!" In a later experiment, Mantegazza attempted to write down some of the visions which were flying through his mind, missing most of them through the labour of writing but struggling against "indescribable bliss" to record, "A cave of lace through the entrance to which can be seen, toward the back, a golden tortoise seated on a throne made of soap . . . a battalion of steel pens fighting against an army of corkscrews . . . a ladder made of blotting paper lined with rattlesnakes from which several red rabbits with green ears come jumping down . . . looms made of matchsticks upon which cicadas are weaving pine trees made of sulphur . . ." Though the effect of Mantegazza's monograph was to divorce the effects of coca from their Andean context, this rapid-fire fantasia perhaps gives a clue to understanding the traditional use of coca in oracles and divination from at least the Incas onwards.

℘ ℘ ℘

Like Moreau de Tours', Mantegazza's essay aroused a great deal of professional curiosity but his stirring claims for coca – although largely verified later – weren't taken seriously enough to be widely pursued. But, unlike Moreau de Tours' they were taken seriously enough by one chemist to procure a sample of the plant from which the active ingredient was isolated, and a new substance – cocaine – released upon the world.

Shortly after Mantegazza's work was published, a round-the-world expedition was mounted by the Austrian government in a man-of-war called the *Novara*: essentially a nationalistic showpiece voyage in the manner of the times, but including a scientist named Carl von Schertzer. En route, von Schertzer received a request from a Professor Wöller of Göttingen to pick up some coca leaf from the west coast of South America. Wöller doesn't refer to Mantegazza specifically, but gave his reason as "work on the active principle of coca leaves, the action of which is described . . . as so remarkable that it is of the utmost importance to find out the active component". He was presumably aware of various anecdotal reports of coca from South America, but it's likely that Mantegazza's account was the spur for the urgency of the request.

When the *Novara* docked at Valparaiso, von Schertzer discovered that Peru was at war and that it would be impossible for the ship to make its way that far up the coast; nevertheless, he struggled up by land to war-torn Lima where he procured 25 kilos of coca leaf. He presented the leaves to Wöller on his return in 1860, and Wöller turned them over to his young assistant Albert Niemann. Niemann isolated from the leaves an unusual, crystalline organic base, which was christened 'cocaine'.

Momentous in retrospect as this achievement may have come to seem, it was attended with little fanfare at the time and brought no fame to its discoverer. Niemann died the next year, aged only twenty-seven, and only a few scraps of documentary evidence of his life survive, such as a letter asking to be excused from the usual practice of defending his thesis in Latin. Nor was cocaine taken up with any enthusiasm by the

medical profession: in fact, the next decade saw something of a backlash against Mantegazza's claims. Though cocaine was largely a medical curiosity, coca preparations were gradually beginning to make their way into the non-medical world, particularly into the world of competitve sport. French racing cyclists tried coca extracts and found they were helpful with energy and endurance; the Toronto Lacrosse Club added coca to their regime in the year they won the world championship. This attracted some medical curiosity: the doctor Sir Robert Christison tried it on some of his students at Edinburgh, and noted that "it not only removes extreme fatigue, but prevents it".

But an influential article in *The Lancet* nipped much of this early interest in the bud. It reported coca's first thorough scientific trial by G.F.Dowdeswell at University College in London, who obtained various samples of leaf, had his students chew them mixed with lime, and then put them through a battery of tests. These included standard measures like pulse and temperature, and also a particular preoccupation with quality and quantity of urine, which Dowdeswell had heard was supposed to be a reliable clinical marker of coca's effects. He had great trouble with mail-order supplies of the leaf, most of them arriving "inert as so much weather-beaten hay would be", but even with superior samples his results were disappointing. He could measure no increase in heart or pulse rate, no diminished fatigue after walking, and the subjects' urine was sadly unremarkable. He concluded that "without asserting that it is positively inert . . . its action is so slight as to preclude the idea of its having any value either therapeutically or popularly", and that, in a period where the medical profession was becoming increasingly keen to distance itself from any quackery, it was a nostrum without scientific validation. And as for centuries – indeed, millennia – of its traditional use in the Andes, he could only assume that its "reputed effects on the Indians" were "partly due to imagination, association and habit" – in other words, largely in the savage mind. This assertion was echoed quite widely throughout the medical profession, on the grounds that

the Indians' life was so miserable that coca, though little more than a placebo, nevertheless "breaks the unbearable monotony of their existence".

So cocaine languished in the lab, and coca remained a marginal nostrum, but during the next twenty years the West would make up for lost time with a vengeance. Circumstances may have conspired to exclude it from the first wave of Enlightenment drugs, and even from the formative stages of the second wave; but while in 1880 few people had even heard of it, by 1890 it had become a new wonder of anaesthesia, a massively popular tonic, a bestselling pharmaceutical, a high-volume global commodity, an instantly recognisable literary touchstone, the basis of shadowy but significant subculture, the focus of a mass panic and the face of an emerging social menace.

℘ ℘ ℘

The 'discovery' of cocaine in the 1880s is associated in hindsight with a young neurologist who was to become, even more than Humphry Davy, perhaps the most famous scientist to self-experiment with drugs in the nineteenth century: Sigmund Freud. In fact, Freud was only one of a number of scientists involved in the early investigation and promotion of cocaine, and his story was at the time only part of a larger groundswell within the profession. But it makes sense to tell the story from Freud's perspective: first, because it brings in most of the other protagonists along the way, and second because his 'cocaine episode' has been much misunderstood. The effect of Freud subsequently becoming such a towering figure, and of cocaine subsequently becoming such a thoroughly demonised drug, has set up a kind of historical dissonance which makes the episode almost too strange to understand. As a result, the near-consensus is that it was, like Davy's *Researches*, some kind of juvenile aberration, driven by misguided ambition and drug-induced recklessness – an explanation which, with a little stretching, allows us to keep our views of both Freud and cocaine somewhere close to our preconceived notions. This consensus unites both Freudians –

most significantly his chief English-language biographer and apologist, Ernest Jones – who in the light of the subsequent image of cocaine have been keen to marginalise its role in the Great Man's career, and anti-Freudians, who have in the same light focused on it as circumstantial evidence for the essentially bogus nature of the later claims of psychoanalysis.

As a result, there are two headline claims for the 'cocaine episode' which have dominated the way it's been perceived since Freud came to prominence at the turn of the century. The first – echoing closely the perception of Davy's nitrous oxide work, and perhaps for similar reasons – is that Freud overlooked the 'obvious' application of cocaine as a local anaesthetic, which was subsequently 'discovered' by one of his colleagues, Carl Koller. The second is that he overlooked the addictive potential of cocaine, insisting that it was a safe and effective treatment for morphine addiction and tragically addicting a friend and patient as a result. Both of these claims are at least partly true, but they don't give the whole picture of a remarkable investigation which not only set new landmarks in the fledgling science of psychopharmacology but was also crucially formative for many aspects of Freud's later career.

The story starts in the winter of 1883, when we find Freud in a nervous, frustrated and largely unhappy period of his life. He was in the second year of his studies at the Physiological Institute of the University of Vienna, demonstrating and teaching the principles of physiology and working long hours to finish his paper on the structure of nerve cells in the cray-fish. This post separated him from his fiancee, Martha Bernays, who he could afford to visit near Hamburg only occasionally and with whom he was looking at a long period of establishing his reputation and gradually increasing his salary before they could afford to marry. His letters to her from this period are famously full of hopes that he might make some great discovery which would short-circuit this dreary and daunting process.

He first encountered coca in a paper in a German medical journal by a military surgeon called Theodor Aschenbrandt, who had been running tests of its effects on some of his

Bavarian recruits. He had added cocaine solution to their drinking water without telling them, and claimed that they had demonstrated better endurance of hunger, strain, fatigue and heavy burdens, and rather terrifyingly concluded with his hopes that "in this way the soldier can dispense with food for eight days". Aschenbrandt's methods were fairly rudimentary – no control subjects, and more than a suggestion of wishful thinking – but Freud was clearly intrigued by the idea of a nervous system stimulant, and he followed Aschenbrandt's potted history of coca back to the writings of Mantegazza, which impressed him greatly. He then checked for references to coca in the *Surgeon General's Index* and found a scattering of American journal articles recommending coca as a treatment for the ominous new scourge of morphinism. One, in the *Detroit Therapeutic Gazette*, suggested that "one feels like trying coca with or without the opium habit. A harmless remedy for the blues . . . ".

On the basis of these fragmentary clues Freud ordered a sample of cocaine from the German suppliers – Merck, in Darmstadt – and took a small sample dissolved in water. He was immediately released from doubts about its efficacy: both the first time he took it, and on many subsequent occasions, he experienced "a sudden exhilaration and a feeling of ease". He gave it to several of his friends and colleagues and noted the same reactions from most of them, although some required a larger dose and others perceived the sensations as nervous and uncomfortable. Over the next six months he took it frequently (though always in modest doses of less than a tenth of a gram), surveyed the medical literature extensively and performed a battery of tests on himself under the influence.

This undoubted surge of enthusiasm for cocaine could be ascribed, as it usually has been, to juvenile ambition or psychological addiction to the drug, but Freud was also genuinely on the trail of a major discovery. First of all, he established beyond doubt that the medical scepticism about coca was unjustified: the effects which researchers like Dowdeswell had failed to find were definitely there, and the traditional claims

of the Andean Indians were entirely valid. Second, and more importantly, he discovered in cocaine a genuine centrally-acting stimulant. At this stage medicine was relatively rich in sedatives – opiates, chloral hydrate and the new generation of synthetic narcotics – and these had all found their uses in treating hyperactive or anxious patients. But the only available substances for taking the metabolism in the opposite direction – giving energy and vigour to weak, underactive or depressed subjects – were mild pick-me-ups like coffee and tea or the ubiquitous but problematic alcohol. The possibility of stimulating the nervous system to operate at a more vigorous level was a key to a potentially vast and undiscovered world of medicines and clinical treatments – a world which Freud, with the sporadic assistance of cocaine, began to explore.

The first fruits of this exploration emerged in the summer of 1884 with his paper *Über Coca (On Coca)*, an elegantly written and comprehensive survey of coca use, the mechanisms of action of the alkaloid cocaine and the effects both subjective and objective on the user. Despite a wealth of clinical detail, *Über Coca* certainly reads like a sales pitch. This is partly due to Freud's correct opposition to the medical scepticism about coca, which he refers to as "undeserved" and even "slander", but also to his attempt to communicate the euphoriant effects of the drug by the use of strikingly non-medical language: he refers to a dose as a "gift", and its effects as "the most gorgeous excitement", and insists that these euphoriant effects are crucial to understanding the nature of the drug and its possible applications. It's here that we see the clearest prefiguring of the Freud to come and, simultaneously, the claims which disturbed his medical colleagues and led – once the less benign effects of cocaine had emerged – to the view that he had overstepped the boundaries of scientific professionalism.

With hindsight, we can perhaps say that Freud was more honest than cautious. For him, the euphoria was one of the central effects of cocaine, and he deliberately stressed this in the style and wording of his paper: in the section on *The Effect of Coca on the Healthy Human Body*, he states explicitly that cocaine's "exhilaration and lasting euphoria . . . in no way

differs from the normal euphoria of the healthy person" and "is enjoyed without any of the unpleasant aftermaths which accompany exhilaration through alcoholic means". He was certainly not mistaken in this: subsequent advances in the neurochemistry of cocaine have stressed this repeatedly, to the extent that the bulk of cocaine research today consists of attempts to block, interrupt or override the euphoria it produces. But he underestimated the effect of this claim on the evolving medical profession, who were increasingly presenting their role as chemical custodians of the general public. For the profession to endorse a claim that a drug produces euphoria was increasingly to become an admission of responsibility for the abuse of that drug. Thus, once this claim had been made, their options were either to insist that the drug in question wasn't strictly medical (and cocaine would rapidly become too important for that), or to close ranks against those medical voices who had been tactless enough to stress its pleasurable effects.

But Freud's stress on cocaine euphoria also shows him moving towards the radical view of the mind which would soon be his hallmark. One of his first perceptions of cocaine was that it made him feel more powerful, as if his muscles were simply capable of exerting more force than usual. To test whether this was simply in his mind, he performed a series of experiments with a dynamometer to measure the force he was capable of exerting: sure enough, he discovered that his muscles were performing more effectively under the influence of the drug, and that the effect was particularly marked on subjects who were weak or in ill-health before they took the "gift". But whereas anyone else would have taken this as proof that cocaine was a centrally-active stimulant, Freud went further, noting that the peak of muscular power corresponded with the peak in mental euphoria. From this he not only concluded (correctly) that cocaine was both a stimulant and a euphoriant, but that it was in some sense the euphoria which produced the muscular strength, which was "brought about by the creation of an improved over-all state of well-being" – a theory of the interaction of mind and body which

was considered heretical in Vienna but which was simultaneously being established in Paris by Charcot's work on hysteria, later to become the foundation of Freud's new science.

The final sections of *Über Coca* present a series of medical scenarios in which cocaine may become useful and include, in different ways, the seeds of all the controversies to come. His first recommendation is for its stimulant effects, "in those functional states which we now cover by the the name neurasthenia" (his wording, perhaps, giving a half-formed hint of the revolution in psychiatry to come). His second is for the treatment of indigestion, and his third "in the withdrawal of morphine". At the end of the list we have, as clear as Humphry Davy's pronouncement on the use of his gas in surgery, "some additional uses of cocaine, based on its anaesthetic property, will probably be developed in the future".

Perhaps we should pause briefly at the moment of *Über Coca*'s publication in the summer of 1884 to savour a moment of optimism both for Freud's career and for cocaine itself. A promising young physiologist had overturned the orthodox medical scepticism about cocaine, and had outlined a series of exciting possibilities for its application: both drug and doctor were looking forward to a glowing future. But Freud's cocaine episode, like the West's in general, would demonstrate the repeated tendency for the history of cocaine to reproduce the effects of the drug itself: a surge of euphoric excitement followed by a period of overstimulation and instability, followed in turn by a crash into a trough of depression corresponding more or less to the peak of the previous high.

℘　℘　℘

In the wake of the positive reception of *Über Coca* – praised, it should be noted, as much for its literary style as for its 'discovery' of a valuable new drug – Freud began collaborating with various Vienna colleagues including two young opthalmologists, Leopold Königstein and Carl Koller, who were interested in the suggestion that cocaine might be used in eye

treatments as an analgesic and a vasoconstrictor to limit capillary blood flow. He gave his friends an oral dose of cocaine and put them through his dynamometer tests: both were impressed by its action, but Carl Koller particularly noted the way in which it numbed the tongue on contact. This was a familiar effect, but meant more to Koller as, unlike the others, he'd been undertaking a systematic search for a local eye anaesthetic – something of a surgical Holy Grail, given that even powerful agents like morphine and ether couldn't reduce eye sensitivity enough to stop the eye's reflex twitching and pain responses. Koller decided not to voice his suspicions to the others but to go away and do some quiet experiments on his own, thus ushering in, after nitrous oxide and ether, the century's third and final controversy over the discovery of anaesthesia.

Freud, meanwhile, left Vienna for Hamburg and Martha, a visit prefaced with his famous letter anticipating that "you shall see who is the stronger, a gentle little girl who doesn't eat enough or a big wild man with cocaine in his body": one of the applications he lists in *Über Coca* is *Coca as an Aphrodisiac*, which is based on experimental reports of its "violent sexual excitement". Königstein, meanwhile, spent the summer testing the powers of cocaine to relieve the pain of diseases like trachoma and iritis, while Koller cut to the chase and performed the single, simple experiment which would give cocaine its first major medical application. In the presence of his supervisor Professor Stricker, he dripped cocaine solution into a frog's eye, and within a minute or so was able to touch its bulging cornea without provoking any reflex reaction. In short order they performed the same tests on a rabbit and a dog, with the same results; then they dripped the solution into their own eyes and, using mirrors, prodded their own corneas with the heads of pins. Both exclaimed, jubilantly and simultaneously, "I can't feel anything!"

Koller continued to move fast: his next step was to write up a brief account of the experiment and pass it to a colleague to read at a medical conference, thus establishing his priority.

Freud returned to Vienna in October just in time for Koller's full presentation of his paper at the Physician's Society of Vienna, with the news of the discovery flying around the medical world and the name of Sigmund Freud relegated to a couple of citations.

Contrary to various later versions, this news doesn't seem to have upset Freud greatly at first: he seems, in fact, to have been delighted at the success of their joint endeavour and to have been more focused on the future possibilities for cocaine than on questions of priorities and credits. Not so Königstein, though, who stood up at the Physician's Society meeting to contest the dates Koller had given for his discovery and to assert that he, Königstein, had already demonstrated ocular anaesthesia by this stage. (In fact, as with the other anaesthetics, it later turned out to have been modestly but convincingly demonstrated by the pharmacologist Vassily von Anrep several years before.) Freud was cast in the role of peacemaker, and it may be thanks to him that the discovery of anaesthesia wasn't attended with the bitter wrangling of the Morton-Jackson ether feud − or even worse, since Koller, a reserve officer in the army and fervent German nationalist, had a reputation for duelling. Shortly afterwards, in fact, Freud reunited them for a glaucoma operation on Freud's father: in Freud's presence, Koller administered the cocaine and Königstein performed the surgery, and Freud was deeply gratified by the opportunity to demonstrate to his father that he'd been involved in a discovery of great worth.

But it's clear that, with hindsight, the older Freud developed severe regrets about how this aspect of his 'cocaine episode' turned out. Sometimes he took to blaming Martha for dragging him away from the heat of the action; more often he blamed himself for a streak of dilettantism which he later took pains to eradicate. It was no real surprise that the discovery had gone to Koller, since he was an opthalmologist through and through, focused from the beginning on the search for a local eye anaesthetic; Freud, by contrast, was bored with physical neurology, yearning to move on into psychiatry and already beginning to feel that he'd done the most important

job of describing the effects of cocaine, and should perhaps be leaving the details to others. As he put it in the *Interpretation of Dreams*, "I was not thorough enough": if he had begun investigating cocaine in order to make his name, why did he allow himself to fall at the last fence? But this is an older Freud speaking, and the younger one seems genuinely not to have cared about Koller's triumph: in fact, he and Koller became much closer friends after the discovery. The next year, though, Koller's duelling tendencies led him into trouble: called a "Jewish swine" by a colleague, he felt himself honour bound by his officer's code to challenge him, but as a doctor unable to break the new law against duelling, so he emigrated to New York. There Freud kept up a long correspondence with him, in later years drolly addressing him as 'Coca Koller'.

℘ ℘ ℘

So it's not true that Freud 'missed' the use of cocaine as a local anaesthetic because he was too intoxicated by the drug's euphoriant effects. Like Humphry Davy, he explicitly mentioned it but saw it as a minor application for a substance with a far greater potential. Unfortunately, with the discovery of cocaine anaesthesia accomplished, Freud's next attempt at realising this potential was much more damaging both to his own reputation and to that of cocaine.

In 1885 Freud applied for and won a travelling fellowship from the University of Vienna, and was able to study for six months in the milieu which interested him most: with the neurologist J.M.Charcot in Paris, whose work with hypnosis and hysteria at the Salpetrière Infirmary had brought him to worldwide attention. Freud continued to publish supplementary papers on cocaine, and a new edition of *Über Coca* which picked up on the debates which had followed its occasional release was even abstracted in *The Lancet*. An American pharmaceutical company, Parke Davis, added cocaine to its stock and paid Freud to analyse its product and compare it with that of Merck, the German supplier, which he did with scrupulous accuracy. He also continued to take cocaine regularly, skipping meals and working long hours; his French was

poor and he found that at events like dinner with the Charcot family he needed "some cocaine to open his mouth".

Back in Vienna, an opportunity – perhaps, even, an obligation – presented itself to investigate in more detail the sporadic claims that cocaine was an effective remedy for morphine addiction. A senior doctor at the Physiological Institute who Freud admired greatly, Ernst Fleischl von Marxow, was in the grip of such an addiction, and an especially distressing and painful one. He'd had a thumb amputated some years earlier, and had been driven to distraction by the pain which had repeatedly been made worse by failed remedial surgery and experimental treatments like electrical stimulation of the nerves, and had resorted to morphine in ever increasing doses; the combination of the drug and the pain was clearly destroying him. Freud offered Fleischl cocaine, which he accepted, and for a time this helped him to stabilise and then reduce his morphine use, sharpen his mind, and restore him to better health than he'd felt for years.

At around this time Freud prepared another cocaine paper which he read to the Psychiatric Society in Vienna, entitled *On the General Effect of Cocaine*. Most of it consisted of further details of his dynamometer measurements, but the final section reiterates his hope that cocaine may have beneficial psychiatric applications: first, in the treatment of melancholia, and second in "certain cases of withdrawal treatment" from morphine. Although this final passage is hedged around with cautions and relies mostly on the testimony of other practitioners, the sudden massive interest in cocaine and the primacy of Freud's name among the flurry of new papers meant that *On the General Effect of Cocaine* identified him more intimately than before with the morphine treatment.

It wasn't long, though, before Fleischl's regime broke down. He began taking enormous quantities of cocaine, discovering in a way which Freud never had that large doses of the pure drug set up a whole new dynamic of use, including powerful cravings, massive escalation of doses, inability to eat or sleep, chaotic mental processes and paranoid hallucinations. The affair reached a climax when Freud was forced to spend a

harrowing night with a demented and delirious Fleischl who was convinced that white snakes were crawling over his skin and demanding ever larger doses of cocaine. Overnight, Fleischl had gone from being the first patient cured of a morphine overdose with cocaine to the first European to manifest a full-scale addiction to cocaine in its own right.

There's no doubt that this represented a serious professional blunder by Freud, but it was one which was being made simultaneously by several other doctors as the medical world struggled to grasp the fact that the same substance which had been considered for decades to be extremely weak and marginal in its effects was also capable of being one of the most powerful mind-altering drugs known to science. Cocaine addiction, too, remains to this day more obscure than opiate addiction: its cravings are more psychological than physical, and it doesn't display the opiates' predictable and chronic metabolic tolerance, presenting typically instead as short-lived out-of-control binges rather than a lifelong dependence. It's also hardly accurate to blame this misjudgement on Freud's own self-experimentation, except perhaps in the sense that he was too cautious. Unlike Humphry Davy, who took nitrous oxide in huge and heroic doses and combinations, Freud had never taken cocaine in anything other than small amounts, and had never personally felt any craving to take more – rather, as he observed in *Über Coca*, a slight revulsion at the idea of further or larger doses.

Nevertheless, as other cases like Fleischl's began to emerge from surgeries across Europe and America, the cocaine literature began a violent mood-swing towards stressing the dangers of the drug, and a virtual witch-hunt for those who had made the most optimistic claims for it – among whom Freud, of course, was most conspicuous. The charge was led by Albrecht Erlenmeyer, a doctor who announced that Freud and his colleagues had unleashed in cocaine "the third scourge of mankind", after alcohol and opium. Freud was led to a swift rebuttal, and his final paper on the subject, entitled *Craving for and Fear of Cocaine*, finds him on the back foot and more than a little off balance – technically correct on many

points but still sounding evasive and defensive. He claims that cocaine treatment for morphinism is problematic in practice, as patients are likely to obtain private supplies and thus escalate their doses to dangerous levels; he insists that all this new rash of 'cocaine addicts' are properly described as patients pre-addicted to morphine and that "cocaine has claimed no other, no victim of its own"; perhaps most disingenuously, he maintains that he never recommended injecting cocaine, for it's here that the danger lies. The first two points are justifiable, but the last is true only in the narrowest sense, as he certainly gave subcutaneous injections to Koller and described the practice to his colleagues. But even if all these points are defensible, he's clearly using them to cover his retreat. He never wrote on cocaine again: his next papers turned to hysteria, Charcot, hypnotism and the collaborations with Breuer which launched his historic career. But, from later dreams and events recounted in 1900 in his *Interpretation of Dreams*, it's clear that he carried on using cocaine personally both as a tonic and a medicine for many years.

Because of the retrospective prominence of Freud's 'cocaine episode', it's often assumed that his blunder was the moment at which the medical profession realised *en masse* what a dangerous substance cocaine was; but this was far from the case. The discovery of the dangers of cocaine in the treatment of morphine addiction represented the first sharp swing away from the idea, itself only a year or two old, that cocaine was a valuable panacea – which in turn, of course, represented a sharp swing away from the previous idea that coca was essentially inactive. The next pendulum swing came promptly the next year with the leading American neurologist and former Surgeon-General Dr. William Hammond's rejoinder, *Cocaine and the So-Called Cocaine Habit*. Hammond had been using cocaine extensively, both medicinally for a spinal irritation and as a general tonic; he had drunk it, injected it, taken large doses (a gram injected over twenty minutes), and prescribed large doses to others; his conclusion was that the cocaine habit was "similar to the tea or coffee habit". Unlike opiate habits, where the patient clearly manifested physical dependence on

the drug, Hammond insisted that there wasn't "a single instance of a well-pronounced cocaine habit" where the addict couldn't simply stop taking the drug by the use of will-power. The debate continued to swing backward and forward for the rest of the century, assisted no end by the ponderous and constantly-shifting definitions of addiction which were obscurely formulated in terms of heredity, morbid craving, diathesis and moral insanity.

A final illustration of the effect of Freud's subsequent fame on the cocaine debate should perhaps be the toxicologist Louis Lewin's *Phantastica*, an influential drug text published late in his career in the 1920s. When Lewin mentions "the unfortunate theory that morphinism could be cured by cocaine", the implied reference to Freud is clear, and he continues "I at once objected [in 1885], predicting a 'two-fold craving'. This, and worse, is what in fact happened. Cocaine was soon used by itself as a pleasure-producing agent." Thus the blame for the recreational use of cocaine is laid squarely at Freud's door; but we also have a letter written by Lewin in 1887, on a steamer bound for New York, when he finds himself a little dizzy and with a headache. "Ah! I thought, cocaine!", he writes. "Out with you, prophylactic phial . . . 0.05g cocaine disappeared, dizziness and headache vanished magically; cheerfulness returned and I inhaled the refreshing sea breeze with delight."

℘ ℘ ℘

The contrasting claims made for cocaine – 'miracle drug' and 'scourge of humanity' – massively boosted its profile among the general public and, almost immediately, the popular coca and cocaine trade. It was the great pharmaceutical story of the 1880s, going in a few short years from a minor item in specialist catalogues to a major seller in a huge range of preparations and formats in high-street chemists, grocers and general stores. The effect of its scientific 'discovery' was to present it to the public as a wonder of modern medicine, to which its traditional use in the Andes was little more than an obscure footnote. At exactly the time when opium was increasingly being

painted in sinister Oriental hues and hashish as a magic carpet ride to the world of the *Arabian Nights*, cocaine arrived in the high street with the same neutral provenance as aspirin.

Furthermore, the versatility which Freud had claimed for it as a general tonic and treatment for various minor ailments struck an immediate chord with the general public. The head-line claims of the medical controversy – local anaesthesia and morphine cure – were neither here nor there in the huge range of symptoms and general complaints which cocaine preparations claimed to alleviate. It was particularly effective, as Freud had specified from *Über Coca* onwards, for digestive complaints and minor gastric upsets. It's also notable that both mild coca preparations and strong cocaine solutions coexisted side by side, and its availability in powerful forms never significantly diminished the market for the gentle panaceas, tonics and pick-me-ups. Cocaine was both soft drink and hard drug right through to the end of the century.

The main distinction between the different preparations was not primarily between high and low dose preparations but between 'ethical' and 'patent' forms of supply. Ethical preparations came from pharmaceutical companies – primarily Merck in Germany and Parke Davis in the States – and were explicit about their contents and dosages; patent preparations came from general food and grocery suppliers, and included fairly unspecific quantities of cocaine in largely inscrutable combinations with different drugs and admixtures. The most famous and successful of these were the range produced by the Corsican pharmacist and entrepreneur Angelo Mariani, who had begun in the 1860s to produce a wine for the French market by steeping coca leaves in sweet burgundy. 'Vin Mariani' was the first and most effective brand to penetrate the new market in Europe and America after 1884, and was gradually accompanied by a large ancillary range of different preparations for different therapeutic applications. By the late 1880s these included Pâte Mariani (cocaine lozenges for catarrh), Thé Mariani (a concentrated coca tea recommended for drinking before long walks), Pastilles Mariani (for coughing fits) and several others. Part of the secret of

Mariani's success was that during coca's wilderness years of the 1870s he had begun to pay close attention to the different potencies of different types of coca leaf and the variatons in the different extraction techniques, giving him a march on his competitors who were either learning this by trial and error or industrial espionage. As pure 'ethical' cocaine became more widely available, this advantage was gradually eroded and both the products and the ambitions of his competitors became more potent.

Mariani is largely remembered today for the many volumes of testimonials to his products which he collected assiduously from the great and good: twelve volumes of these are still preserved in the British Library. This was partly a PR exercise and partly the vanity project of a self-made industrialist, but he was also alert from the mid-1880s onwards to the anxieties about coca and cocaine which were emanating from the medical profession, and sensed that it would be increasingly crucial to counter any accusations which might emerge about the potential dangers of his products. The result of this combination of salesmanship, paranoia and vanity is a remarkable picture of the reception of coca products during this period. Louis Bleroit revealed that when he undertook his famous flight, "I took the precaution of bringing a small flask of Vin Mariani along with me . . . its energetic action sustained me during the crossing of the Channel". Anatole France noted that "coca wine . . . spreads a subtle fire through the organism". President McKinley thanked him for a sample of the product "with whose tonic virtues I am already acquainted"; Jules Verne opined "very gratefully" that "since a single bottle of Mariani's extraordinary coca wine guarantees a lifetime of a hundred years, I shall be obliged to live until the year 2700!" Further testimonies came from two Popes (Leo XIII and Pius X), Thomas Edison, the kings of Spain, Greece, Sweden and Serbia, Auguste Rodin, H.G.Wells and Henrik Ibsen.

Mariani also produced volumes on the therapeutic value of coca, buttressed by pages of small-print columns of doctors' recomendations, and leapt into print whenever coca's integrity was challenged by the medical profession,

taking pages in newspapers to wheel out this ammunition to support his claim that "Vin Mariani has never produced cocainism". "The so-called unhappy consequences of the use of coca", he insisted repeatedly, were extremely rare and "an entirely immoderate use of the drug must be made before any such result follows . . . the constant use of reasonable doses of coca appears to produce a diametrically opposite effect". He also used the medical concerns opportunistically to stoke up public fears about his competitors and warn them to "beware of imitations": cocaine can be dangerous, but Mariani products are guaranteed safe. He also began to play up the exotic Andean provenance of the coca leaf, reconceiving the miracle of modern medicine as a traditional panacea whose use had extended over thousands of years without the 'cocainism' syndrome ever emerging.

But one of Mariani's lesser-known competitors was, of course, to eclipse his fame entirely. John Pemberton, a small-scale Atlanta druggist, began to supply a 'Peruvian Coca Wine' in the mid-1880s; when the city of Atlanta adopted alcohol prohibition in 1886, he removed the alcohol and produced a gloopy syrup masking the bitter active ingredients of coca leaf extract, cocaine, caffeine and cola nut (a natural caffeine source), and christened it 'Coca-Cola'. In 1891 he was bought out by a promoter called Asa Chandler who set up 'The Coca-Cola Company', promoting the "nervine tonic" as a cure for "headaches, hysteria and melancholia" and pushing slogans like "the Temperance drink" (which, in a sense, it remains – the bar-room alternative to alcohol) and, more ambitiously, "the intellectual beverage". Chandler took Coca-Cola's sales to over a million dollars a year by the end of the century, and provoked a flurry of copycat products with names like Koca Nola, Celery Cola, Rocco Cola, Wiseola and even Dope Cola.

We might expect the 'ethical' pharmaceutical suppliers to have furnished a more sober alternative to this kind of hucksterism, but the promotion of cocaine especially by Parke Davis made the likes of Mariani look bashful by comparison. Their 1885 catalogue offered cocaine in powders, solutions,

tablets, lozenges, even cigars and cheroots, all accompanied by copy claiming the drug to be "as the facts recorded would now indicate, the long sought for specific for the opium habit . . . the most important therapeutic discovery of the age, the benefits of which to humanity will be simply incalculable". Their range expanded to include toothache drops, cocaine-impregnated bandages, haemorrhoid remedies and, from the 1890s, asthma and catarrh inhalers which made use of cocaine's vasoconstrictive properties to dry up the nasal passages by spraying more or less pure cocaine straight up the nose. Statements that cocaine "can supply the place of food, make the coward brave, the silent eloquent" ran alongside ads for hypodermic injection kits – smart pocket-sized steel cases like enlarged Zippo lighters containing cocaine, morphine and miniature needles.

What the pharmacists and patent hucksters both discovered was that you could sell cocaine for almost any treatment which came to mind, and the customer would very likely feel better after using it. There was a sound basis for some of its analgesic uses like toothache, and for ailments like catarrh and haemorrhoids which are relieved by mucus membranes and blood vessels being constricted; and, of course, its central stimulant and euphoric properties had an effect on a range of general symptoms like depression and lassitude. But others were far more tangential, like Burroughs Wellcome's 'voice tabloids', strong cocaine tablets which were claimed to "impart a clear and silvery tone to the voice . . . used by the leading singers and public speakers throughout the world". It's hard to see how these could actually have done much beyond drying the throat and nasal passages, but easy to understand how people could feel confident that their speech and singing were more fluent and masterly after taking them.

All this cocaine had to come from somewhere, and the 1880s also saw a huge boom in coca leaf production not just in Peru and Colombia but from entirely new territories. The coca plants which had been growing in Kew Gardens for decades as horticultural curiosities were transplanted to high-altitude tea-growing regions in the colonies such as Ceylon

and Assam; those in Assam grew well, though with a rather low cocaine yield, and persisted as a low-level cash crop for years. But the Dutch, traditional horticulture experts, had a far more successful escapade in the Dutch East Indies. They exported seedlings to the Botanical Gardens at Buitenzorg in Java, still extant a few miles outside Jakarta, and found that they not only grew well but, whether by luck or judgement, developed into a cultivar with a higher cocaine yield than anything ever seen in South America. Much of the Javanese cocaine was sold to Merck in Darmstadt, whose cocaine production multiplied tenfold during the 1880s while its price dropped by half. Parke Davis' prices fell even further: before 1884 cocaine had been a special-order import at around $5 per gram, whereas by 1900 it was offered at 25c.

℘ ℘ ℘

Throughout this period of the cocaine boom – in retrospect, the euphoric high before the crash – it's hard to get a sense of any consensus about whether it was a miracle or a scourge. Probably, a future historian examining our attitude to drugs today would find a similar babble of voices either enthusiastically in favour or implacably opposed to them, with a mildly interested mainstream swaying in the breezes of countervailing opinion. Most likely, the majority of people held in their heads the contradictory notions of miracle and scourge, one or the other taking precedence as their moods, their company or the newspaper ads and headlines ebbed and flowed. Even within the medical profession, neither Hammond's enthusiastic promotion or Erlenmeyer's dire warnings seem conclusively to have 'won'. Mild coca preparations like Mariani's were welcomed by some doctors as a symptomatic treatment for conditions which would otherwise have taken up their time, and criticised by others as quack nostrums which trespassed on their rightful patch; abuse of cocaine at high dosages was still rare enough for most doctors never to have encountered it. But perhaps the best gauge of the ways in which cocaine impacted on the general consciousness can be found in the two enduring literary

characters which emerged from the cocaine boom, one dealing with it implicitly, the other explicitly: Dr. Jekyll and Sherlock Holmes.

Robert Louis Stevenson's *The Strange Case of Dr. Jekyll and Mr. Hyde* was the earlier of the two, emerging in 1886 and providing Stevenson with his first palpable hit at the age of thirty-five. Although he seems to have conceived it essentially as a Gothic potboiler, referring to it as "a good crawler" or "a fine bogy tale", he had inherited a serious interest in the duality of man and the reality of evil from his Calvinist upbringing and was to return to the theme throughout his subsequent career. The drug which unleashes Mr. Hyde – "a large quantity of a particular salt, which I knew, from my experiments, to be the last ingredient required . . . late one accursed night, I compounded the elements . . . " – is a literary prop rather than a reference to any real substance, but the spirit of cocaine lies both behind the description of its effects and in all likelihood behind the writing process itself. Stevenson was sickly and tubercular, and his wife Fanny was a nurse with a keen interest in medicines, and his symptoms of "nervous exhaustion" were among those for which coca preparations were indicated. Moreover, not only did he write the book in six days but destroyed the first draft after three at Fanny's insistence; it's likely that he worked day and night under the influence of a stimulant, of which cocaine is by far the most plausible.

There's also much in the description of Jekyll's transformation into Hyde which reads like a heightened version of the mood swings which Stevenson exhibited throughout his life, and which would have been intensified by cocaine: in fact, Hyde's altered state of being on transformation to bestial consciousness could in places almost have been lifted from *Über Coca*. "There was something strange in my sensations", he writes, "something indescribably new and, from its novelty, incredibly sweet. I felt younger, lighter, happier in body; within I was conscious of a heady recklessness". Looking at his Hyde-image in the mirror, Jekyll "was conscious of no repugnance, rather a leap of welcome . . . it seemed

natural and human. In my eyes it bore a livelier image of the spirit . . .". Stevenson is counting on his readers to recognise the notion that a 'new drug' could achieve these effects, even perhaps to recognise such effects from their own experience, and it's unlikely that these ideas would have resonated so strongly before 1884.

But *Jekyll and Hyde* does more than play with the zeitgeist of the cocaine boom: it's oddly prophetic of the ideas which would underlie the attack on cocaine which was to come in succeeding decades. The euphoria produced by the drug, while it seems to the subject to be entirely beneficent, is in fact the very root of its danger. In Stevenson's Calvinist rubric, evil is more powerful than good, and anything which eradicates fear and moral probity releases the atavistic and bestial self which is unrestrained human nature. As the movement against cocaine built, the Jekyll-and-Hyde motif would be recalled ever more frequently to characterise the essential danger of cocaine: that it makes evil feel good.

If *Jekyll and Hyde* bears only an implicit relation to cocaine, it nevertheless offers a basis for inferring the ways in which the possibilities and dangers of the new drug were being processed in the broader culture. But the second emblematic character of the cocaine boom, Sherlock Holmes, gives us far more than this: first it offers a fully-realised cocaine user of the late 1880s, conceived by a doctor who had brushed against the drug repeatedly in the course of his medical career; and subsequently it provides a barometer of how the public mood began to turn against the 'cocaine vice' throughout the 1890s.

℘　℘　℘

There's no doubt that, at least as he was originally conceived, the primary motivation of the world's most famous fictional detective is cocaine. "My mind", he tells us in the famous passage which opens *The Sign of Four*, "rebels at stagnation. Give me problems, give me work, give me the most abstruse cryptogram . . . I can dispense then with artificial stimulants". Part of Holmes' enduring appeal is precisely that he's drawn to his profession not to 'do good', but to stave off boredom.

His few – and mostly late – sententious statements about public service and the common good are substantially outweighted by his expressions of coldness and misanthropy, his rhetorical question that "Was there ever such a dreary, dismal, unprofitable world?" What motivates him, and makes him distinct from the vast majority of subsequent fictional detectives, is that his primary interest is in pleasing himself, and ultimately the only reason he bothers to solve crimes at all is to keep his mind active enough to dispense with his "seven per cent solution".

The Sign of Four emerged in 1889, and it's this first period of Sherlock Holmes stories which are sprinkled most liberally with drug references. In the first published short story, *A Scandal in Bohemia*, we hear that Holmes "had risen out of his drug-created dreams, and was hot on the scent of some new problem". In *The Five Orange Pips*, Watson describes him as a "self-poisoner by cocaine and tobacco". But it's the exchange between Holmes and Watson at the beginning of *The Sign of Four* which establishes for all time the nature of Holmes' habit and Watson's attitude to it. The story starts in Holmes' study, with the detective taking a syringe from a "neat morocco case" and injecting it into an arm "all dotted and scarred with innumerable puncture marks". Watson tells us that this has been going on "three times a day for many months", and remonstrates with Holmes about the habit. Watson's argument against it reads like a wicked pastiche of the medical views of the period: "It is a pathological and morbid process, which involves increased tissue-change, and may at last leave a permanent weakness" – an opinion simultaneously ominous-sounding and yet so vague that it could just as easily refer to masturbation. (The most frightening thing about Watson's view, as we shall see, is that it's probably exactly what Conan Doyle himself believed.) This prompts Holmes to issue his famous justification and ultimate motive for his career: "I abhor the dull routine of existence. I crave for mental exaltation. That is why I have chosen my own particular profession, or rather created it, for I am the only one in the world."

Why did Doyle, in 1888, seize on the cocaine habit as a central plank in the character of his new detective? At the time it seemed to reviewers "a curious touch", but it struck an immediate chord with the public and Doyle continued to thread it through the stories. It was copied, too, by other writers: M.P. Shiel's exotic detective Prince Zaleski, who emerged in 1895, sits in his room full of arabesque antiques where the air is heavy with "the fumes of the narcotic *cannabis sativa* – the base of the *bhang* of the Mohammedans – in which I knew it to be the habit of my friend to assuage himself". Doyle's idea seems to have been to create a bohemian character of acquired and exquisite tastes, a character quite unlike the author himself who, as a practising GP in provincial Southsea, was far closer to Dr. Watson. Doyle had immersed himself in the 'yellow', decadent writings of Bloomsbury, and even briefly met Oscar Wilde: it's likely that he had Wilde at least partly in mind while conceiving the "pallid", "languid" detective. Holmes' props – the violin, the Meerschaum pipe, the batchelor apartment in the metropolis and the cocaine habit – are all intended to establish him as one of the new bohemians: eccentric, sophisticated, and tantalisingly immune to public opinion. Unlike the masses swilling their patent coca tonics, Holmes would have taken the trouble to research and acquire the finest quality of stimulant: his cocaine, we can imagine, by mail-order from Merck in Darmstadt and his hypodermic kit not the standard Parke Davis set but specially tooled by a bespoke chemist in Piccadilly or Mayfair.

The inner Holmes, as well as the outer, was faithfully con-ceived around the bohemian stereotype. He is solitary, and haunted by an existential darkness – the "black moods" which come over him, his bipolar swings from insomnia or focused, obsessive, day-and-night work to his days and weeks "in the dumps", when he doesn't "open my mouth for days on end". For a doctor like Conan Doyle, this would have been a recognised medical syndrome associated with the highly-strung, neurasthenic 'type', the febrile 'brain-workers' who were increasingly identified in the medical literature as a high-risk group for drug abuse. It's interesting that, in *The*

Sign of Four, Doyle mirrors these unstable mood-swings with a dual dependence on morphine and cocaine, but the morphine is never subsequently mentioned: perhaps Doyle felt that morphine had rather too strong a whiff of a medical condition, where by contrast cocaine was at most a 'vice'.

But there are also several reasons why Doyle himself should have been familiar with cocaine; although in his later autobiography he insists that "I had no great interest in the more recent developments of my own profession", he's perhaps being a little disingenuous. He went to study medicine at Edinburgh University in 1876, the same year that the Edinburgh medical professor Robert Christison attempted an early coca leaf trial which he published in the *Lancet*; Christison selected several students to chew the leaf and, although Doyle wasn't one of them, it's likely that he was aware of the trials. In 1885 the annual conference of the British Dental Association was held in Doyle's home town of Southsea, and cocaine anaesthesia was the major new development discussed. Finally Doyle, in an attempt to set himself up as a Harley Street specialist, went to study ophthalmology in Vienna. He only stayed two of the six months he had originally intended, finding the technical German too hard to understand and in any case rapidly losing interest in medical practice and becoming ever more committed to making a living as a writer, but he could hardly not have heard of Koller's revolutionary discovery and may even have worked with cocaine himself.

Furthermore, Doyle's earliest professional interest was in toxicology: he achieved the feat – as remarkable then as now – of getting his first article published in the *British Medical Journal* while still in his third year at Edinburgh. It was on the action of a poison called gelsenium, an extract from a jasmine root and an ingredient in Gowers' Mixture, a neuralgia treatment: his experiment included self-poisoning with a substantial dose of 200 minims. Doyle's interest in toxicology bleeds through into his fiction: there are several exotic poisons in the Holmes stories, all conceived with far more attention to scientific detail than Stevenson's *Jekyll and*

Hyde potion. One of them, in fact, the hallucinogenic 'Devil's Foot Root' in the short story *The Adventure of the Devil's Foot*, has actually made its way into some of the medical and etnobotanical literature, presumably originally planted by a Sherlock Holmes afficionado and subsequently taken as real. All this suggests that Doyle was well aware of the existence and properties of cocaine, and was using his professional understanding of it to underscore Holmes' character.

But the great detective's career, which ran until the 1920s, witnessed a dramatic turnaround in cocaine's public image. Concern about its effects built throughout the 1890s, and by 1900 the serious lobbying to control and prohibit it had begun. This was mostly taking place in the United States, but by this stage the Sherlock Holmes stories were being serialised to an enthusiastic American audience in *Collier's Weekly*, which was also running editorials about the 'cocaine menace'. Doyle had been gradually pruning back the references to Holmes' habit throughout the 1890s, limiting them to the occasional dark reference to his hero's "weakness", but in 1904, in *The Missing Three-Quarter*, he closed the chapter by stating that Holmes had been "weaned" from his "drug mania" by Dr. Watson – an incongruous detail which lacks support in any of the earlier stories – and, furthermore, that this "drug mania" had "threatened to check his remarkable career", an interpolation which is entirely inconsistent with the original set-up. Holmes, too, recants thoroughly, calling the hypodermic syringe an "instrument of evil". But *Collier's* were happy: Doyle's position was explicit, even if incompatible with his original intentions, and Holmes' cocaine habit remained in the early and formative fictions to be enjoyed and reassessed by successive generations.

℘ ℘ ℘

When the crash came, as with all cocaine crashes, you could see it coming. The euphoric overselling, particularly by the pharmaceutical companies like Parke Davis, was inevitably followed by a backlash which began even before the end of

the 1880s: already in 1887 the *British Medical Journal* was observing that the "undeniable reaction against the extravagant pretensions advanced on behalf of this drug has already set in". It's since been recognised that the most common pattern of cocaine abuse isn't, as with opiates, a lifetime of dependence, but a three to five year binge of excessive and increasing use leading to a crisis which is followed by one of three outcomes: abstenance, a substitute dependence on opiates or sedatives, or a scaling-down of cocaine use to manageable levels. The West, which had delayed so long in the discovery of coca and its alkaloids, binged its way to crisis in a few short years and, horrified at its own reflection in the mirror, fled in panic towards the path of abstinence.

Much of this path was, of course, already being beaten by governments and medical professions in the control of opiates. Patent medicines came under much tighter scrutiny during the 1890s, and their use of cocaine was gradually hedged in with more stringent controls and regulations. The medical profession, too, was beginning to see its first 'cocainomaniacs' – excessive users, mostly injecting – and though these were few in number the very fact of their existence, as with 'morphinomaniacs', was terrifying to the medical profession and the public alike. The injecting drug user remains one of the most potent shock images in the media today: we can only imagine how much more nightmarish it must have seemed when the syringe was a relatively new instrument which had only ever been seen before in the hands of doctors. And, as with morphine, it's likely that much of the early cocaine abuse took place within the medical profession itself. An article in the *Philadelphia Medical Journal* in 1901 estimated that even then, at the height of the panic, at least a third of cocaine addicts were physicians or dentists: the profession's logic would have been that, if doctors are unable to resist such temptations, what hope for the general public?

But the medical view of 'cocainomania' which emerged was significantly different from that of opiate 'narcomania'. Opiate use was much more easily interpreted as a disease: the patient undergoes marked and predictable physical changes

like increased dosage tolerance and acute systemic symptoms in withdrawal, which more clearly resemble the kind of physical illness which it's the doctor's business to treat. By contrast, even extreme cocaine use is attended by much less in the way of physical symptoms: the patent presents as someone who's not fundamentally ill, but simply lacks the will-power to resist the craving. Thus cocainism, from the beginning, was not so much a 'disease' as a 'vice': the subject had far greater free will to desist than the morphine addict, being driven not by the avoidance of pain but purely by the pursuit of pleasure. Consequently the cocaine 'addict' was given a much harsher and less complicated treatment than the opiate addict – typically, abrupt withdrawal while incarcerated for their own good.

From this medical view emerged a stereotype of the cocaine habitué which was quite distinct from that of the 'unfortunate' or 'enslaved' morphinist. The cocaine user was addicted not to the drug, but to pleasure itself; he (or often she) lacked any moral fibre, any will to resist temptation. According to the addiction specialist Thomas Crothers, cocaine offered "a foretaste of an ideal life", which the weak-willed assumed would be theirs in perpetuity simply by taking more and more of the white powder. Even the doctors and scientists who had recommended it (the most salient name here would, of course, become apparent with hindsight) had been seduced by its euphoriant qualities and lost the ability to evaluate it objectively. Like Dr. Jekyll's potion, it eradicated the sense of social and moral responsibility, and made its subjects incapable of seeing any reason why they should cease to gratify their baser instincts.

While this psychological account is understandable, the difficulty comes in attempting to establish how many people actually succumbed to the ravages of cocainomania thus expressed: all we can be certain of is that the numbers were far fewer than those which began to be claimed during the tabloid panic of 1900 to 1910. In Britain the numbers were certainly small: almost the only example we have from the 1890s is that of the Great Beast Aleister Crowley, still at this stage a member of the Order of the Golden Dawn, and his

later disciple (and former analytical chemist) Allan Bennett. Bennett, originally Crowley's magical mentor, had begun taking drugs including ether and cocaine as asthma treatments but had cottoned on to their ancient traditions of use in magic, leading the two apprentice sorcerers on an extended quest for the ways in which drugs could elevate them to occult levels of consciousness – a quest which, probably more than his writings, would eventually be responsible for Crowley's posthumous elevation to the countercultural pantheon. According to Crowley's later confessions, he and Bennett graduated from morphine to cocaine in 1898, and took it for a few weeks until they started to "see things" and calmed themselves down by switching to chloroform. But the drug's profile was different in the United States, where the mass consumption of over-the-counter cocaine products gradually slid, around the turn of the century, into one of the defining drug panics of the modern era.

℘ ℘ ℘

It was around 1900 that the spectre of the 'coke fiend' began to loom across the States. The image was of dissolute young 'toughs', often squaddies returning from the Spanish-American War in the Pacific, beginning to cluster in the tenderloin districts of towns like San Francisco, hanging out in bars and billiard halls and using the stronger cocaine preparations from the pharmaceutical companies to sniff or inject, becoming rowdy, getting into fights and committing violent crimes against persons and property. Anxieties about this destructive new craze spread quickly to small town America, fuelled by tabloid rumours of cocaine 'pushers' selling packet doses in bars and even soda fountains to other youngsters with too much time on their hands. It was against this background that many of the patent medicine sellers removed the small quantities of coca or cocaine from their products: in 1904, Coca-Cola began extracting the cocaine from their coca leaf, using the 'decocainised' leaf in their recipe and selling the extracted drug to the pharmaceutical industry.

But it was among the black population of the Southern

States that the image of the coke-fiend took hold most vigorously. The first 'dry counties' had been created with local prohibition laws in the 1880s, and cocaine drinks had become a cheap popular alternative, to the point where barmen in 'wet' states and counties sometimes offered a pinch of cocaine in whisky to 'pep it up'. In 1898 the first rumours emerged that the cocaine which was floating around the South in powder form had become popular among the blacks. Black soldiers who had travelled back up the west coast of South America had been initiated into cocaine-sniffing in the ports and red-light districts of Colombia and Panama, and had brought the habit back to New Orleans, where doctors began to warn that cocaine-sniffing was on the rise. From here the habit spread through the South, from ports to rail-heads to work gangs, distributed through the inscrutable and pervasive network of bell-hops, shoeshine boys and porters. Cheap cocaine was smuggled in from South America and offered in '5-cent sniffs' to the itinerant working community, helping them to work long hours with little food but also leading to over-excited and dangerous binges.

This is the story which was depicted with increasing frequency and alarm through the 1900s, but the hard evidence for it has yet to come to light. It's clear from blues and jazz lyrics of the period that cocaine was familiar to the black community, but most of the claims made by white journalists, doctors and politicians are hyperbolic in the extreme. Most of them clearly revolve around more general anxieties about the Southern blacks "forgetting their place" and committing violence against whites, with a relentless and prurient stress on the nightmare of negroes raping white women. The 1900s were the era of the first full segregation laws, the restriction of black voting rights and the high-point of black lynchings in the South, and the "coke-crazed nigger" was an image which served to justify a broad scheme of repression and white retaliation. Stories abounded of the superhuman strength of the coke-fiend, even that guns were useless against him: "Ordinary shootin' don't kill him", a Southern police officer told *Everybody's Magazine*, and it was

regularly repeated that Southern police forces were requesting that their standard .32 revolvers be upgraded to .38s to give them a better chance of fighting back. Various estimates by the police blamed "70% of crimes" on cocaine. The idea that cocaine had the potential to transform even 'good' negroes into maniacs was prevalent: Edward H. Williams, a doctor who toured the Southern States in 1913, claimed that "A large proportion of the wholesale killings in the South have been the direct result of cocaine, and frequently the perpetrators of the crime have been hitherto inoffensive, law-abiding negroes". Similar testimony had been presented to the Committee of the House of Representatives in 1910, when a hearing devoted to the black cocaine problem had been told that "The coloured people seem to have a weakness for it. It is a very seductive drug, and it produces extreme exhilaration . . . it produces a kind of temporary insanity. They would just as leave rape a woman as anything else and a great many of the Southern rape cases have been traced to cocaine".

It will never be possible to prove the negative that no black man ever raped a white woman under the influence of cocaine, but the demonisation of the "coke nigger" in the Southern Bible-belt States seems to have been formed and perpetuated without any substantive evidence, and with a host of plausible reasons why, once started for whatever reason, it should have snowballed as rapidly as it did. Furthermore, there's much circumstantial evidence against its truth: for example, the medical director of a Georgia asylum, appraised of the 'cocainomania' problem, investigated the 2,100 negro admissions to his institution over the previous five years and discovered that only two had been cocaine users – and, indeed, that in neither case had this been relevant to the diagnosis.

Nevertheless, by 1914 cocaine had been voluntarily removed from all patent medicines and the calls to prohibit its non-medical use were enthusiastic and unanimous from the medical profession, the media and politicians of all sides. It was attached to the bill which prohibited the retail sale of

'narcotics': even though it's a stimulant, the opposite of a narcotic, it was hurriedly reclassified as one, a nomenclature which has persisted in American legalese to this day.

℘ ℘ ℘

The prohibition of cocaine was adopted worldwide after the First World War, but over the last thirty years its use has developed into a new, global binge which dwarfs the craze which ended the nineteenth century. At the height of the global panic in 1910, the total amount of cocaine produced worldwide was less than ten tons; in 1995 it was 740 tons and rising.

Nevertheless, there are many dynamics of the current cocaine panic which continue to resonate with the nineteenth-century story, especially the role of the black community in the United States. The cheap hit of the '5-cent sniff' has been replaced by the 'rock' of crack, and the white perception of the particular dangers posed by blacks on cocaine is still clearly enshrined in the law. The possession of 5 grams of crack, a smokable version of cocaine, carries a mandatory minimum sentence of five years, whereas the same sentence is only triggered by 500 grams of powder cocaine. While the two preparations of the same substance aren't substantially different, the profiles of the users are: of the thousands sentenced for crack possession during the 1990s, 90% were black, and only 4% white.

But another largely forgotten casualty of the war on cocaine is coca, the traditional stimulant which arrived so late in the West only to be demonised within a few years along with the Frankenstein's monster of its hidden drug, cocaine. While excessive use of cocaine has repeatedly been shown to be dangerous, there's still no evidence that either coca leaves or equivalently weak cocaine preparations have ever been problematic, and a great deal of contrasting evidence that their traditional use is beneficial and healthier than equivalent preparations of caffeine such as coffee or tea. The example of coca-based patent medicine preparations in the late nineteenth century also demonstrates that, if legal, they would

appeal to Western tastes and develop a low-level popular use very much along the lines of the current vogue for 'stimulant' and 'energy' drinks. Meanwhile, traditional coca growers in the Andes continue to supply a dwindling and increasingly oppressed native population of coca-chewers and tea-drinkers but are prohibited from selling their leaves abroad, forcing most of them into a violent world where their produce is fought over by gangster cartels and increasingly militarised law enforcement agencies. Currently, the only legal purchasers of their produce are the Peruvian and Bolivian governments who sell to a small number of licensed buyers: multinational pharmaceutical suppliers and, still, Coca-Cola, whose recipe continues to include small amounts of decocainised coca leaf.

6

A New Artificial Paradise

Mescaline

In the autumn of 1799, when Humphry Davy was demonstrating the effects of nitrous oxide to the great and good at the Royal Institution, another remarkable psychedelic experience was recorded in London's Green Park, only a stone's throw away but in an entirely different world.

On October 3rd, a doctor named Everard Brande was summoned to the house of a poor family who were in the grip of a mysterious and perhaps fatal toxic crisis. The father, who Brande identifies only as 'J.S.', had begun the day in his customary fashion in the autumn by going down to Green Park at dawn to gather small field mushrooms, which he brought back and cooked up "with the common additions" – flour, water and salt – in an iron saucepan to make a morning broth for his wife and four children. But an hour or so after their breakfast the family began to suffer strange and alarming symptoms. 'J.S.' developed vertigo, losing his balance, black spots spreading across his vision; the rest of the family complained of poisoning, their stomachs cramping and extremities becoming cold. He headed out of the house to summon help, but within a few hundred yards was found in a confused state, having already forgotten where he was going and why, and the doctor was called.

By the time the doctor arrived, the family's symptoms were rising and falling in giddy waves: Dr. Brande noted their pulses and breathing intensifying and fading, periodically almost returning to normal before launching into another crisis. All of them were seized with the idea that they were dying except for the eight-year-old son Edward, whose symptoms

were the strangest of all. Edward had eaten a large portion of the mushrooms and "was attacked with fits of immoderate laughter", from which neither the threats of his father or mother could restrain him. Between laughing fits he exhibited "a great degree of stupor, from which he was roused by being called or shaken, but immediately relapsed". The pupils of his staring eyes were the size of saucers, and he seemed to have been transported to another world entirely, from which he would only return under duress to speak nonsense: "when roused and interrogated as to it, he answered indifferently, yes, or no, as he did to every other question, evidently without any relation to what was asked".

Dr. Brande treated these bizarre and frightening symptoms with emetics and fortifying tonics, and it was to these that the family's recovery was attributed when they returned to normality several hours later. Brande regarded the incident as exceptional enough to write a full description for the *Medical and Physical Journal*, on the grounds that these "deleterious effects of a very common species of agaric, not hitherto suspected to be poisonous" should be made known to doctors and public alike.

℘ ℘ ℘

It is, of course, clear to us today that this is a description of intoxication by Liberty Caps (*Psilocybe semilanceata*), the "magic mushroom" which grows plentifully across Britain and Europe through the autumn. But this account, preserved by the chance presence of a curious doctor, tells us many things about our most familiar indigenous psychedelic. First, and contrary to the opinion of various American scholars, it can't be a recent introduction from the New World where similar mushrooms have well-established ritual uses dating back thousands of years: our own magic mushrooms have clearly been with us for some time. Second, its accidental consumption was unusual enough at the beginning of the nineteenth century to be unfamiliar, even unprecedented. Third, despite the Libery Cap's highly distinctive Chinese-lantern cone shape, neither doctors nor

public had any idea which of the many small mushrooms growing in Green Park might have been responsible for these bizarre effects.

Powerful psychedelics are the arena where the mind-altering drugs of the nineteenth century differ most dramatically from those of today. Neither LSD, ecstasy or their designer chemical cousins were synthesised until the twentieth century, and are consequently absent from the nineteenth-century story. By contrast, the major psychedelics of the nineteenth century – nitrous oxide and large oral doses of cannabis – have largely disappeared from today's drug culture. But the understanding that there are certain plants which have powerful perceptual and psychic effects was an unbroken inheritance from classical and medieval antiquity, and one which by the end of the nineteenth century was clearly grasped and even heroically investigated. The first phase of this understanding was characterised by a focus on mushrooms – a focus more folkloric and literary than scientific, which emanated through classic tales like *Alice in Wonderland* without the scientific mysteries of species and chemistry ever being fully penetrated. The second phase revolved around a cactus – the peyote of the American Southwest – and ended with experimental trials and the isolation of its pure psychedelic alkaloid: mescaline.

℘ ℘ ℘

At the point when 'J.S.' and family took their involuntary trip, the study of plant psychedelics had only just taken its first steps to becoming a subject in its own right. For the vast majority of educated people it was still a miscellany, a subject glimpsed in the margins of classical studies, of folklore, of medicine, of explorers' ethnographic studies of savage societies. It was known from classical sources like *The Golden Ass* that the ancients had known of strange potions of transformation; it was reputed that similar potions had played a role in the Sabbats of witches, an episode in history from which the Enlightenment culture of reason had emerged recently, painfully and without the slightest interest in revisiting. The plants

implicated in most of these potions were the solanaceous nightshades – belladonna, henbane, mandrake – which were still used in medicine, mostly in small doses, their more extreme mind-altering effects simply interpreted as the deliriant action of a poison. The American cousin of these plants, datura, had already acquired its nickname Jimson Weed after an incident when a batallion of soldiers had eaten it in Jamestown and gone mad for eleven days. The mind-altering effects of ergot in contaminated wheat were well-known across Europe, and the fungus had some uses in German medicine. Russian explorers had noted that some Siberian peoples who had yet to encounter alcohol intoxicated themselves instead with fly agaric mushrooms; Captain Cook's crew had observed a similar use of the *kava-kava* root during their expedition to the Sandwich Islands in 1770. The variety of intoxicating plants had just reached enough of a critical mass for Carl Linnaeus, the father of modern botany and greatest plant taxonomist of his day, to compile the first ever list of plants with intoxicating properties. Published in his home town of Uppsala in Sweden in 1762 and entitled *Inebriantia*, it included opium, Syrian Rue, cannabis, datura, henbane, belladonna and tobacco. But Humphry Davy's revelation, that the effects of these substances on consciousness might be the way forward into uncharted realms of science and the mind, had yet to begin its diffusion. At the dawn of the nineteenth century, these plants were simply poisons, and their effects madness. By the end of the century, the story would be different indeed.

As it happened, the 'J.S.' family's experience prompted the first recorded identification of the Liberty Cap with its psychoactive properties. A botanist named James Sowerby was in the process of compiling a multi-volume illustrated gazeteer of *Coloured Figures of English Fungi or Mushrooms*, and the volume of 1803 includes a plate of clearly recognisable Liberty Caps, mentioning their "unwholesome" effects which "nearly proved fatal to a poor family in London, who were so indiscreet as to stew a quantity for breakfast". This identification is remarkable not only because it seems to be the first in

the European literature, but also because we must wait well over a century for any subsequent confirmation that the Liberty Cap is indeed a psychedelic mushroom. None of the medieval and early modern *pharmacopeias* and *materia medica*, many of which go into great detail about other psychoactive plants like poppies, mandrakes and belladonna, offer any positive identification of the distinctive pixie-cap mushroom: when they mention mushrooms or other fungi at all, they tend to stress their association with dung heaps and poison and recommend avoiding them. And looking forward from Sowerby's identification, the confirmation that the Liberty Cap genus contains a powerful hallucinogenic alkaloid called psilocybin was only finally made in the 1950s – by Albert Hofmann, after his discovery of its synthetic cousin LSD. Sowerby's listing probably failed to hasten this conclusion because it merely identifies the mushroom as poisonous, without any mention of its mind-altering effects: this is still common practice in modern mushroom guides, where psychedelic fungi are simply classified as 'toxic'.

But despite the pervasive vagueness about which mushrooms had these strange properties, the nineteenth century was nevertheless suffused with the idea that some mushrooms and toadstools offered a portal into uncanny worlds. In the Romantic tradition they maintained a morbid association with death and decay, from Keats' "fungous brood . . . coloured like a corpse's cheek" to Tennyson's "foul-flesh'd agaric . . . carrion of some woodland thing"; but within the hugely popular tradition of fairy lore, fiction and paintings they became an almost universal trope, associated with fairy rings, elves and pixies, hollow hills and the transportation of unwitting subjects to fairyland – and, as such, they remain a familiar part of the iconography of modern survivals of this tradition such as garden gnomes.

Much of this imagery has been interpreted with hindsight as covert description of psychedelic mushroom experiences, with which it certainly shares significant themes – shifts in perspective and dimensions, and the seething presence of elemental spirits – but it could equally have been assembled

without any direct knowledge of the magic mushroom. The fairy tradition offered various freedoms from constraint to its writers, artists, readers and viewers alike: an 'innocent' forum for exploring more erotic and sensuous themes than were permissible in the broader culture, an escape from industrial austerity into a rural, ancient and pagan otherworld, a Romantic re-enchantment of European natural history via classical and arabesque exotica. But fairyland's major source was the folk traditions of Britain and Ireland which were being enthusiastically transcribed and assembled by the mid-century along the lines established by pioneering folklorists like the Brothers Grimm; much attention was paid to the lore of flowers and plants in general, and recurrent mushroom images like fairy rings and toadstool-dwelling elves, along with flower fairies of other sorts, were absorbed and recycled through a pictorial culture of motif and decoration until they came to be emblematic of fairyland itself.

If there was any source where it's possible that these scenes of mushroom enchantment had any pharmacological basis, it would be within the Irish tradition, where the Gaelic slang for mushroom – "pookie" – associates it closely with the elemental nature spirit Pooka (whence Puck). "Pookie" remains the Irish drug culture slang for magic mushrooms, and the prime Victorian source for fairy tales and paintings, the folklorist Thomas Keightley's *The Fairy Mythology*, refers to "those pretty small delicate fungi, with their conical heads, which are named Fairy-mushrooms in Ireland, where they grow so plentifully". This is quite a clear description of the Liberty Cap, although it makes no mention of the idea that this particular mushroom contains a psychedelic drug: it seems that Keightley attributes their 'fairyness' to their pixiehood caps. On the basis of the 'pookie' complex, much recent drug literature has tended to assume that there has been an ancient and unbroken knowledge of the magic mushroom in Ireland going back to the Druids, or even to the megalith builders before them with their penchant for psychedelic swirls and spirals; all this is possible but, until any direct evidence emerges, the first confirmed magic mushroom tripper

in Britain remains the eight-year-old 'Edward S.', giggling uncontrollably on the floor of his London lodgings in 1799.

℘ ℘ ℘

Beyond these few tentative identifications of the Liberty Cap, there's no doubt which mushroom became most closely associated with fairyland during the nineteenth century: the unmistakable red-and-white-spotted Fly Agaric. This is the most spectacular of the generally spectacular Agaric family, which also includes the tawny Panther Cap and the prodigiously poisonous Death Cap, all of which grow under birches, firs and beech across northern latitudes from Siberia, via Britain and Northen Europe, to the American Northwest. It's the quintessential 'toadstool', a term which doesn't reflect any particular taxonomy of species so much as an attitude towards fungi in general which is broadly held among the cultures where the Fly Agaric grows. The tireless mushroom researcher Gordon Wasson noted that, across Europe and the Old World, cultures divide with striking clarity into 'mycophiles', who hold fungi in high esteem and assume all are edible except for the poisonous exceptions, and 'mycophobes' who fear them and assume them all to be poisonous until proved otherwise. Mycophile cultures include Russians, northern Slavs and a Mediterranean band from Italy to the Pyrenees, and are easily indentified by their large vocabularies for different types of mushroom: Catalan, for example, has over two hundred words for different fungi. Mycophobe cultures, by contrast, include Germans, Celts and Anglo-Saxons, and are united by a small mushroom vocabulary dominated by a general pejorative word tending to associate all species with toads: words analogous to 'toadstool' appear in Danish, German, Breton, Dutch, Irish and many other languages, but are untranslatable into French or other Romance tongues. Thus the Fly Agaric, the most conspicuous mushroom in the lands of the Northern mycophobes, has tended throughout history to accrete all of the morbid and fearful 'toadstool' myths in the cultures which cohabit with it.

The other salient fact about the Fly Agaric is that it, too, is

psychoactive. It contains a strange mixture of alkaloids which produce a rather unpredictable cocktail of effects including general wooziness and disorientation, sweats, drooling, numbness in the lips and extremities, nausea, muscle twitches, sleep and a vague, often retrospective sense of liminal consciousness, hallucinations and waking dreams. Prior to the nineteenth century, across Britain and Europe, these effects were simply ascribed to its poisonous action and avoided; when strange tales of its magical effects entered the century's consciousness, they did so not from local folklore but from travellers' accounts of its use in Siberia. By the mid-Victorian era these reports had accreted into an understanding that there were indeed mushrooms which altered consciousness, and that this had been demonstrated to the satisfaction of science with the Fly Agaric. This understanding may also have contributed to botanical amnesia about the more common and more psychedelic magic mushroom – as well as Europe's much rarer psychoactive mushrooms like *Panaeolus cyanescens* – as any anecdotal or folkloric accounts of mushroom intoxication were thereafter assigned not to the small, spindly pixie-caps but to the proverbial and unmistakable red-and-white toadstool.

Sporadic reports of the use of the Fly Agaric as an intoxicant in Siberia filtered out to Europe throughout the eighteenth century, from Swedish colonels and Russian explorers, but the Western imagination was most dramatically seized by the first European to experience their effects personally, a Polish traveller named Joseph Kopéc whose account appeared in 1837. He had been living in Kamchatka for two years when he was taken ill with a fever and was told by a local of a "miraculous" mushroom which would cure him. He ate half a Fly Agaric, and fell into a vivid fever dream. "As though magnetised", he was drawn through "the most attractive gardens where only pleasure and beauty seemed to rule"; beautiful women dressed in white fed him with fruits, berries and flowers. He woke after a long and healing sleep and took a second, stronger dose, which precipitated him back into sleep and the sense of an epic voyage into other worlds, teeming

with "things which I would never imagine even in my thoughts". He relived swathes of his childhood, re-encountered friends from throughout his life, and even predicted the future at length with such confidence that a priest was summoned to witness. He concluded with a challenge to science: "If someone can prove that both the effect and the influence of the mushroom are non-existent, then I shall stop being defender of the miraculous mushroom of Kamchatka".

Kopék's toadstool tales were widely reported, and began a fashion for re-examining elements of European folklore and culture and interpolating Fly Agaric intoxication into odd corners of myth and tradition. Perhaps the best example of this is the notion that the Berserkers, the Viking shock troops of the 8th to 10th centuries, drank a Fly Agaric potion before going into battle and fighting like men possessed. This is regularly asserted as fact not only among mushroom and Viking aficionados but also in text-books and encyclopaedias; nevertheless, it's almost certainly a creation of the nineteenth century. There's no reference to Fly Agaric, or indeed to any exotic plant stimulants, in the sagas or eddas: the notion of mushroom-intoxicated Berserker warriors was first suggested by the Swedish professor Samuel Ödman in his *Attempt to Explain the Berserk-Raging of Ancient Nordic Warriors through Natural History*, which was simply speculation based on eighteenth-century Siberian accounts, but by the end of the nineteenth century scholars like the Norwegian botanist Frederik Christian Schübeler had recapitulated it and taken Ödman's account as proof. The rest is history – or, more likely, urban myth.

Thus, by mid-century, the toadstool – and specifically the Fly Agaric – had not only become an instantly recognisable fairyland motif but had also, and separately, been established as a portal to the land of dreams. This doesn't invalidate the claim that the presence of mushrooms in fairy literature represents the concealed or half-forgotten knowledge of their genuine psychedelic properties, but it does offer an alternative explanation. Much fairy art and literature may well have been drug-inspired – an obvious candidate would be John Anster

Fitzgerald's phantasmic paintings of dreaming subjects surrounted by distended, other-dimensional goblin creatures – but the inspiration in question is far more likely to have been the all-pervasive opium. Perhaps the best way of focusing on the toadstool question is to look at the most famous and frequently-debated conjunction of fungi, psychedelia and fairy lore: the array of mushrooms and hallucinatory potions, mindbending and shapeshifting motifs in *Alice in Wonderland*.

℘ ℘ ℘

The facts in the case could hardly be better known. Alice, down the rabbit hole, meets a blue caterpillar sitting on a mushroom, which tells her in a "languid, sleepy voice" that the mushroom is the key to navigating through her strange journey: "one side will make you grow taller, the other side will make you grow shorter". Alice takes a chunk from each side of the mushroom, and begins a series of vertiginous transformations of size, shooting up into the clouds before learning to maintain her normal size by eating alternate bites. Throughout the rest of the book she continues to take the mushroom: entering the house of the duchess, approaching the domain of the march hare and, climactically, before entering the hidden garden with the golden key.

Since the 1960s this has been routinely read as an initiatic work of drug literature, an esoteric guide to the other worlds opened up by mushrooms and other psychedelics – most memorably, perhaps, in Jefferson Airplane's psychedelic anthem *White Rabbit*, which conjures Alice's journey as a path of self-discovery where the stale advice of parents is transcended by the guidance received from within by "feeding your head". By and large, this reading has provoked outrage and disgust among Lewis Carroll scholars, who seem to regard his critics' accusations of paedophilia as inoffensive by comparison. But, as with Conan Doyle, there's plenty of evidence that Carroll wasn't simply inventing potions and their effects at random: in fact, medication and unusual states of consciousness exercised a profound fascination for him, and he

read about them voraciously. His interest was spurred by his own delicate health – insomnia and frequent migraines – which he treated with homeopathic remedies, including many derived from psychoactive plants like aconite and belladonna. His library included several books on homeopathy as well as standard texts on mind-altering drugs like W.B.Carpenter's *Mental Physiology* and the self-experimenting F.E.Anstie's influential compendium *Stimulants and Narcotics*. He was greatly intrigued by the epileptic seizure of an Oxford student at which he was present, and visited St.Bartholemew's Hospital in order to witness chloroform anaesthesia.

But there's little evidence that Alice's mind-expanding journeys owed anything to the actual drug experiences of their author. Although Carroll – in everyday life, of course, the Reverend Charles Dodgson – was a moderate drinker and, to judge by his library, opposed to alcohol prohibition, he had a strong dislike of tobacco smoking and wrote sceptically in his letters about the pervasive presence in syrups and soothing tonics of powerful narcotics like opium – the "medicine so dexterously, but ineffectually, concealed in the jam of our early childhood". In an era where few embarked on personal drug exploration without both robust health and a compelling reason, he remains a very unlikely self-experimenter. In this sense, Alice's otherworld experiences seem to hover, like much of Victorian fairy literature and fantasy, in a borderland between naïve innocence of drugs and knowing references to them. But in this case it seems we can offer a more precise account. The scholar Michael Carmichael has demonstrated that, a few days before writing *Alice*, Carroll made his only ever visit to the Bodleian library, where a copy of Mordecai Cooke's recently-published drug survey *The Seven Sisters of Sleep* had recently been deposited. The Bodleian copy of this book still has most of its pages uncut, with the notable exception of the contents page and the chapter on the Fly Agaric, entitled "The Exile of Siberia". Carroll was particularly interested in all things Russian: in fact, Russia was the only country he ever visited outside

Britain. And, as Carmichael puts it, "Dodgson would have been immediately attracted to Cooke's *Seven Sisters of Sleep* for two more obvious reasons: he had seven sisters and he was a lifelong insomniac".

Cooke's chapter on Fly Agaric is, like the rest of *Seven Sisters*, a useful compendium of the drug lore and anecdotes which were familiar to the Victorians; it rounds up the various Siberian accounts, and also focuses on precisely the effects of mushroom intoxication which Carroll wove into Alice's adventures. "Erroneous impressions of size and distance are common occurrences", Cooke records. "A straw lying in the road becomes a formidable object, to overcome which, a leap is taken sufficient to clear a barrel of ale, or the prostrate trunk of a British oak." Whether or not Carroll read this actual copy, it seems overwhelmingly likely that the properties of the mushroom in *Alice* were based on his familiarity with Siberian Fly Agaric reportage. Thus he was neither the secret drug initiate nor the Victorian gentleman entirely innocent of the arcane drug knowledge subsequently imputed to him; but we can suggest, at least, that his arcane knowledge is more likely to have been sourced from Siberia than from any hidden British tradition of Fly Agaric-eating, let alone the author's own.

Cooke's discussion of Fly Agaric also offers a valuable summary of the state of knowledge of intoxicating British mushrooms in the 1860s. Throughout the rest of the book he includes the scientific knowledge of active plant alkaloids which was currently available – morphine as the source of opium's effects, for example – but in the case of Fly Agaric he maintains, rather verbosely, that "chemical investigations have not yet been directed into the channel leading towards the elucidation of the mysteries of these poisonous fungi"; he adds that "hitherto we know of no experiments having been made with a view to ascertain whether any of our indigenous fungi, other than the one already referred to, can be used in the same way". He then cites Dr. Everard Brande's account of the 'J.S.' family – sixty years old, but clearly not forgotten – as evidence that there are presumably such mushrooms around,

but they have yet to be identified. We will never prove the negative that no-one ever had an inadvertent mushroom experience which transmuted itself into fairy lore, but this is perhaps as close as we could hope to get to demonstrating that the 'toadstool complex' in Victorian fantasy was assembled without any direct experience of the mushrooms' psychoactive effects.

℘ ℘ ℘

Mind-altering fungi continued to make occasional appearances in fairy and fantasy literature throughout the century. One successful though largely-forgotten example was the outlandish *Etidorhpa, or The End of Earth*, a hollow-earth fantasy from 1895 by the chemist and botanist John Uri Lloyd, whose protagonist is transported underground and guided through forests of giant toadstools which taste of the most delicious fruit. He makes the mycophobic objection that "toadstools are foul structures of low organisation" but his subterranean guide explains that they are unnatural life-forms on the earth's surface, but wholesome down below: "out of their native elements these plants degenerate and then become abnormal, often evolving into the poisonous earth fungi known to your woods and fields . . . here they grow to perfection". The fantasy climaxes with an initiation via the "narcoto-intoxicant" fungi, in which the protagonist receives an extended lecture on the evils of intoxication – including a global litany of the barbaric and depraved forms of drunkenness from the *soma* of "the ancient dissolute Persians" to the impending death of the drunken modern West – while surrounded by a Dantean mob of drunken spirits consisting of freakishly distorted body parts. Nevertheless, his fungus intoxication affords a climatic glimpse of Etidorhpa (Aphrodite backwards), the "Soul of Love Supreme".

Etidorhpa is a deliberately cryptic novel which contains many threads of occult and Rosicrucian allegory in the manner of Bulwer Lytton's influential hollow-earth parable *The Coming Race*, and also includes gnomic parentheses about the author's own drug-taking. If, he tells us in a footnote to

the mushroom trip, a chemist should happen to stumble across a mind-altering substance in his experiments, "to sip once or twice of such a potent liquid, and then to write lines which tell the story of its power, may do no harm to an individual on his guard"; it would only be if such a chemist were to make his discovery known "and start it to ferment in humanity's blood", that it might "gain such headway as to destroy, or debase, our civilisation, and even to exterminate mankind". Presumably we are meant to infer that the author knows whereof we speaks, but he gives us no meaningful clues to the species or substance in question: the "narcoto-intoxicant" fungus is four foot high with an inverted spiral cap, and looks like a psychedelic bird-bath. Whether we take Lloyd's tantalising footnote literally depends on how willing we are to believe his often heavy-handed hints that this colourful pulp fantasy actually masks the hidden wisdom of the ages.

But a final example of mushroom fiction from the end of the century seems to confirm that there remained a consensus that intoxicating fungi existed but that there was no taxonomic clarity about exactly which they were. H.G.Wells' *The Purple Pileus*, published in 1897, is a hugely enjoyable romp through many of the author's favourite themes with the assistance of an inadvertent mushroom trip. The protagonist, Mr. Coombes, is one of many fictional versions of Wells' father, a feckless, henpecked and underachieving shopkeeper constantly on the verge of bankrupcy, who we meet on a Sunday with his house taken over by his bullying wife and her awful friends. He picks a quarrel, storms out of the house, takes a solitary walk through the woods, spots some spectacular purple toadstools and peevishly decides to commit suicide by eating them: "They were wonderful fellows, these fungi, thought Mr. Coombes, and all of them the deadliest poisons, as his father had often told him". Desperation conquers mycophobia, and he gathers up and eats them along with "some of those red ones with white spots as well, and a few yellow" – Wells leaves us in doubt as to whether the miracle which is to come is produced by Fly Agarics, Panther Caps or his fictional Purple Pileus. But, far from dying, Mr. Coombes is raised to a

peak of life-affirming ecstasy, and strides back to the house to insist that his wife and her friends partake of his preternatural joy. They are terrified by the transformed Coombes – "livid white, his eyes unnaturally large and bright, and his pale blue lips drawn back in a cheerless grin" – the guests flee in horror, his wife becomes thereafter respectful and obedient. When we meet Coombes again five years later, we find him sleek and successful with "a certain erectness of head that marks the man who thinks well of himself". He has, of course, edited the Purple Pileus out of his own version of the story: "I'm a mild man till I'm roused", he tells his young cousin, "there's nothing like putting your foot down".

This tale combines a typical Wellsian conceit – the worm turning, an inadvertent stroke of fortune producing an unlikely hero – with a typical Wellsian plot device, something both plausible and unearthly, in limbo between science and magic. Psychedelic fungi were perfectly pitched for Wells' purposes: he'd employed them previously in *First Men in the Moon*, and went on to spin tales around drugs both real and imaginary many times in his early fiction: the time-distorting substance in *The New Accelerator*, the chloroform anaesthesia of *Under the Knife* and others. But despite the pointedly mundane social drama which plays out in *The Purple Pileus*, the toadstool continues to convey the same idea which evolved through the fairy fiction of two generations before: that there lurks something in the woods capable of taking unsuspecting vistors to another world.

Thus the story of magic mushrooms in the nineteenth century is one of limited trajectory – from an unwitting experiment with an unknown species in 1799 to a popular fiction about an unwitting experiment with an unknown species in 1897. Apart from a few travellers' tales, we find little sense that the world of mushroom consciousness has been explored or navigated, or that science has turned its microscope lens inward to map the new terrain. The Siberian locus for mushroom use was far too remote for the Fly Agaric rite to travel by cultural contact, and the impression was consequently formed that the only reason these Arctic savages ate

the livid toadstools was because they had yet to discover the secret of alcohol. (This rather smug-sounding view turned out to be partially correct: the arrival of vodka in Siberia led to a marked decline in Fly Agaric use.) In any case, the taint of poison clung to the indigenous mushrooms of Europe, and it would be well into the twentieth century – in most cases, the 1970s – before its local psychedelic species were conclusively identified.

But the story of the other great genus of psychedelic plant species, the cacti, is different. Here, the traditional users of the plant – the Native Americans – came into much closer contact with the modern West, and as a result the species in question was firmly identified, the plant analysed, and the active ingredient isolated, named and experimented with by an influential handful of doctors, psychologists, poets – and even a society hostess.

℘ ℘ ℘

The peyote cactus is native to the deserts of Mexico and Central America, whose inhabitants have been aware of its mind-altering properties for at least three thousand years – as witnessed by archaeological remains – and probably a good deal longer. Along with various other psychoactive plants – morning glory, mushrooms, tobacco – peyote was (and still is) an integral part of their culture. It's used medicinally in small quantities, in slightly more perceptible doses for divination or finding lost objects, for strenuous walking or night-time hunting, and in full psychedelic doses for all-night communal singing and dancing rituals, and for solitary or initiatic vision quests. It features heavily in their creation myths, their art, their annual cycles and pilgrimages, and remains a defining feature of their world.

The West first became aware of this in the sixteenth century, during the Spanish invasion. From the beginning, Catholic priests were in no doubt that the use of peyote represented a vortex of withcraft and sorcery which had to be abolished by any means necessary. It was named "raiz diabolica" – the devil's root – and the peyote spirits were associ-

ated with Satan; as the Inquisition spread across the New World its supernatural uses, such as telling the future, were routinely punished with torture and death. Eyeballs were gouged out, crucifix incisions were made in Indians' stomachs and their entrails fed to ravenous dogs, but their use of peyote merely turned inwards and continued in secrecy. Today, various Mexican tribes like the Huichol and Tarahumara still maintain peyote rites and belief complexes which are probably very close to those of far antiquity.

Until the nineteenth century, peyote was only used in the southern deserts where it grew; but the ruthless dismantling of Native culture by the settlers led to its gradual spread across the United States. As the tribes became increasingly penned in reservations and their struggle for land rights took on a pan-Indian dimension, a network of 'road-men' spread up, travelling from reservation to reservation, and bringing previously separate tribes into a broader cutural network which hadn't previously existed. Some of these road-men, coming up from the south, brought peyote with them and introduced it, along with its rituals, to Northern tribes. These rituals varied, but tended to be voluntary convocations involving prayer, song and meditation around campfires rather than the all-singing, all-dancing village ceremonies; many also had strong Christian elements, the self-taught road-men having taken peyote alone and had visions in which Indian and Christian themes intermingled – Christ's tomb, for example, being empty because he had ascended to the moon and become a peyote spirit. The various rituals gradually merged into more or less standard 'full moon' and 'half moon' ceremonies, with a family of chants and songs and variations in the dressings laid around the central fire, and peyote began to substitute for the other plants – tobacco, datura, mescal bean – which had previously been used in the Northern vision quest traditions.

The spread of peyote was dramatically speeded up by the convulsive pan-Indian movement of 1890 known as the Ghost Dance, which began with a Paiute Indian's dream revelations of ancestral wisdom and prophecy and spread like wildfire through dozens of tribes including the Comanche,

the Arapaho and the Sioux. The revelation was an apocalyptic combination of traditional Native beliefs with the Christian missionary doctrine of the Second Coming, and predicted that America was soon to roll up like a blanket, causing all the white men to disappear, and then unroll in the pristine state in which it had existed before their coming. This was not a call to arms against the whites – in fact, the 'Messiah letters' which passed among the tribes stressed that all Indians should be especially nice to the whites in view of what was about to happen to them, and should refrain from mentioning the revelation to them. Rather, all the tribes should join in prolonged and ecstatic communal dancing, for five or six days and nights at a time, to hasten the coming transformation. These were apparently extraordinary scenes, with mass spirit possession and hypnotic trance prophecy, which terrified the American authorities: the massacre of the Sioux at Wounded Knee was largely triggered by fears of the Ghost Dance turning into a kamikaze anti-white frenzy.

When the Ghost Dance movement receded, it left a newly pan-tribal people shell-shocked and riven by opposing views of the way forward. The Ghost Dance had essentially been a reactionary assertion of their lost native culture, predicated on the apocalyptic belief that the future could be magically transformed into the past; but there were also more progressive voices in the tribes which insisted that the future must involve an accommodation between the new post-white dispensation and the core of their ancient and sacred practices. It was in this climate, during the 1890s, that the new peyote rites began to spread across the tribal landscape, and to evolve into a 'religion' modelled after that preached by the whites. Peyote users began to organise into small churches, combining their rites with Christian initiations: baptism, for example, with a cross of peyote juice. Their view was that they were Christians, but that their Christianity was different from the white man's: the Bible was the book for the white man who had crucified Christ, but the Indian, who hadn't alienated himself from his god in this way, was given peyote through which he could receive his divine instruction directly. 'Peyotism'

brought with it a strict code of ethics, known as the Peyote Road – teetotalism, sexual restraint, truth-telling, abstention from violence and witchcraft. Among the broken and crushed tribes, torn apart by alcohol, adultery and violence, the peyotists became a powerful influence for stability and civic responsibility.

This state of affairs brought peyote to the attention of the white American world for the first time, and also fortuitously delivered an ethnographic reporter of high calibre. James Mooney, a young journalist from Indiana with a deep fascination for Indian culture, applied in 1890 to the Smithsonian Institute's Bureau of American Ethnology to be allowed to cover the Ghost Dance movement for them; he attended many of the Ghost Dances, interviewed the leaders, and eventually wrote a huge and meticulous monograph on the whole episode. After the peak of the Ghost Dance he noted the growth of peyotism, and interviewed chiefs like Quanah Parker of the Comanches who were rejecting the Ghost Dance in favour of the peyote rite. He followed this up by observing several all-night peyote ceremonies, furnishing the first written description of them: although it was only a few years old by this time, it had already hardened into a ritual which is essentially identical to the one still practised today.

In Mooney's official reports to the Bureau of Ethnology he evades the question of whether he actually took peyote himself: although he describes peyote as having an "especially wonderful mental effect", the portrait he delivers implies his own role as that of objective witness, sitting round the fire and taking notes. He was introduced by the headman at the beginning of the ceremonies as an observer who would bear witness to the white man that the peyote worship was not an evil sorcery but the expression of a sincere and benign set of beliefs. But, in later writings for the medical journal *The Therapeutic Gazette*, he confirms what we might have suspected from his obvious urge to penetrate the mysteries of Indian culture as far as possible: that he was not only the first white man to witness and record the peyote ceremony, but also the first to partake of its sacrament. Caught between his

roles as intrepid explorer and conscientious reporter, he only ever took small doses: three or four buttons during the first round and no more thereafter, leaving him still in a fit state to take notes. At this level, and given the intensely colourful nature of the surroundings, he feels unprepared to assess the action of the drug in its own right, beyond its stimulant effects which kept him fresh and alert all night when without it he was always overwhelmed with "cold, numbness and exhaustion". His peyote nights are vivid and hypnotic, but he attributes this as much to the music and chants as to the cactus.

Mooney describes the men-only group assembling in a teepee at about nine in the evening, painted, feathered and in their finest buckskin, many of them also wearing crucifixes. The leader lays a dried peyote button on a cross-shaped bed of herbs beside the fire, lights the kindling, and the participants file into the tent and settle round in a circle on piles of fragrant wild sage. Each participant is then given four peyote buttons, and prayers are sung accompanied by a gourd rattle and drum: Mooney records that "these songs have a peculiar lullaby effect, which intensifies the dreamy condition produced by the drug, at times rising into a note of wild triumph and then again sinking into wailing sadness".

This continues until midnight, at which point the leader goes and fetches a bucket of water from the nearest spring and 'baptises' the worshippers to the accompaniment of an eagle-bone whistle. Prayers are said at this point for anyone who's ill or troubled, and sick women and children may enter for a blessing. Everyone smokes hand-rolled cigarettes, which are regarded as a sacred incense. Now the assembled company can help themselves to as much peyote as they want, and the singing and praying continues until daybreak, and often towards noon. As the last chant dies away, the rattle and drum are passed around the circle before being put away, and the participants leave the tent for a meal which has been prepared for them outside. One ceremony ended with a plea that Mooney should "go back and tell the whites that the Indians had a religion of their own which they loved".

Mooney did indeed spend much of the rest of his life explaining Indian religion to the American government and stressing that arbitrary and paranoid measures to disrupt it were not only unjustified but counterproductive. Nevertheless, many state and federal laws were passed during the 1890s prohibiting the use of peyote: any pan-Indian movement was suspect in its own right, and Indians moving between tribes were routinely stopped and searched, and when found with peyote were accused of 'drug trafficking'. It took many years of bitter struggle before finally, in 1918, the various associations of peyote worshippers incorporated themselves into a Native American Church with peyote as its official sacrament, and petitioned for their constitutional right to freedom of worship. Even after that, decades of further case law were required before peyotism was routinely allowed to proceed without arrest and harassment.

℘ ℘ ℘

In addition to Mooney's studies of the peyote ceremony, the substance itself was also being brought to the attention of American and European doctors and chemists. Parke Davis began distributing dried peyote buttons from a source in Mexico, and German pharmacologists like Louis Lewin set laboriously to fractionating them in the search for the active ingredient. Although both the peyote cactus and its effects are distinctive, even unmistakable, the inheritance of various muddled traditions made its entry into Western taxonomy rather confusing. It came to be referred to by scientists as 'mescal', a term which government administrators had been using indiscriminately for various Indian sacred substances. The word referred generally to the Mescalero Apaches but also, by extension, to three quite different plants: the agave cactus, from which the distilled 'mescal' spirit (tequila with the worm) is derived, the 'mescal bean', a highly toxic red bean in a peanut-like shell which was also used in vision quests by some tribes – and the peyote cactus itself, which no Indian ever referred to as mescal until the whites did. Lewin's research in Berlin led him to claim the species with his own

Linnaean designation, *Anhalonium lewinii*, but this later turned out to be identical with the already-bagged *Lophophora williamsii*. This confusion persisted through the 1890s, aided and abetted by the large number of different alkaloids which the cactus turned out to contain; it was 1897 before a rival of Lewin, Arthur Heffter, professor of pharmacology at Leipzig, finally pronounced that he had extracted a pure hydrochloride of the active ingredient, which he named 'mezcalin' – although Lewin's work led to suppliers like Parke Davis referring to it as 'anhalonium'. Heffter had identified mescaline by a laborious process of isolating different 'fractions' of the dried plant matter, feeding them to animals, finding that he couldn't identify which ones were psychoactive simply from the animals' behaviour, and eventually taking small quantities of all of them himself.

But by this time he was no longer the first white man, or even the second, to take a trip down the peyote road. A small handful of scientists, doctors, psychologists and poets had already, in their laboratories and studies, broken the traditions of millennia by experiencing mescaline's effects outside of the Indian sacred context, and opened the door to hitherto unsuspected dimensions of the human mind – in the phrase of one, a 'New Artificial Paradise'.

The Parke Davis 'anhalonium' sold slowly but steadily through the 1890s, mostly to doctors curious about its effects at small doses; James Mooney also supplied samples to some medical specialists on request. The dried cactus buttons were powdered and, in the absence of any firm identification of the active alkaloid, recomposited in liquid solutions and powders; after Heffter's discovery, Parke Davis' pure mescaline crystal and pills would take their place. Most of the medical applications seem to have involved a low dose of around one button's worth – the Indian ceremonial dose, of course, being closer to a dozen – at which level the drug was noted to produce a slight flushing, stimulation and lazy sense of well-being. These effects were parlayed into various remedies by doctors, most commonly a 'cardiac tonic' but also an antispasmodic, a treatment for neuralgia, depression and the general stresses of

modern life. But lurking behind these – as with the other central nervous stimulant of the age, cocaine – was a sense of a more generalised euphoria and expansion of mood, of which all these 'tonic' effects were merely symptoms. Gradually terms like "sense of well-being" began to enter the literature, and doctors began to wonder what the effects of a larger dose might be like.

These effects were first described at second hand, by a doctor and medical lecturer at Columbia University named D.W. Prentiss. Prentiss was among those who received a supply of buttons from Mooney via the Bureau of Ethnology, and in 1895 decided to test doses of four or five buttons on some anonymous experimental subjects. Thus the first white man to take mescaline in a clinical setting is known to us only as "Chemist; age twenty-seven, height, five feet five inches; weight, one hundred and twenty-three pounds".

"Chemist", according to his notes reconstructed after the experiment, colonised this new landscape of the mind with a blissful trip which has subsequently served as an unacknowledged template for millions. The bitter and nauseous taste of the buttons was succeeded by "a train of delightful visions such as no human being ever enjoyed under normal conditions". His mind was active, he could converse and write with ease, but whenever he closed his eyes and stretched out upon his bed he was greeted by "an ever-changing panorama of infinite beauty and grandeur, of infinite variety of colour and form". Fixed notions of time and space were swept away as "my pleasure so far passed the more ordinary realms of delight as to bring me to that high ecstatic state in which our exclamations of delight become involuntary". Prentiss, doubtless encouraged by this spectacularly benign experience, swiftly arranged for a second subject: "Reporter; age twenty-four; height, five feet eleven inches; weight, one hundred and fifty-eight pounds".

But "Reporter" furnished spectacular proof that moods which go up can also come down. As Aldous Huxley was later to exemplify in titling his second mescaline essay *Heaven and Hell*, intensity of sensation and vividness of imagination can

facilitate not only ascent to bliss but descent to the abyss. "Reporter", too, began to see spectacular visions of tubes and spirals – "no words can give an idea of their intensity or of their ceaseless, persistent motion" – but was uncomfortably struck by their disconnection from his body, which was being periodically monitored for respiration, pulse and pupil dilation. He tried to explain this, but was "at a loss for a word with which to explain his thoughts". He seemed to be divided in two: "a double personality – to be outside of himself looking at himself". Unable to explain his feelings, a wall of alienation and hostility rose up violently between himself and his medical supervisors. He felt mentally inferior to them, and consumed with the certainly that they had deliberately poisoned him and "were secretly laughing at his condition". When they offered him more peyote, his suspicions were confirmed: they were trying to kill him. He described his condition, with hindsight, as "insane", and recalled that he "would have attempted violence had it not seemed to him too much trouble in his lazy and depressed condition".

These wildly divergent responses were deeply puzzling to Prentiss, much as the conflicting reports of ecstasy and dread had been to Davy and the early nitrous oxide researchers. How could the same substance be responsible for such opposite effects? This confusion was intensified by the early pharmacological reports of Lewin and Heffter, who had fractionated a range of seemingly unrelated alkaloids out of the cactus – gloopy brown syrups and needle-shaped crystals, some seemingly inactive, some toxic. Prentiss speculated that the hallucinatory effects of peyote were most closely approximated by hashish, the stimulant effects by cocaine: did the cactus contain either hashish or cocaine, or both, or something else altogether?

James Mooney, who read the report of these experiments in the light of his own Indian experiences, had better instincts, locating the divergent trips not in chemistry but in the psychology of what we would now call 'set and setting'. In his view, the "horrible visions and gloomy depression" of Prentiss' sub-

ject could never be experienced by an Indian peyotist. Indians approach the experience with a mindset conditioned by a deep belief system from early childhood, rather than with nervous and vague overexcitement; they share the experience with a peer group who conduct and control the way in which the visions are understood. "The Indian eats [peyote] on Saturday night in order that he may rest and keep quiet on Sunday, while in several of the medical experiments the patient seems to have hastily swallowed a sandwich and plunged at once into exciting action."

But Prentiss' report was also read by one of the most distinguished members of the American medical profession who was inspired by it to take a dose of peyote himself and whose detailed subjective report, delivered to the American Neurological Society and published in the *British Medical Journal* in 1896, brought the full psychedelic effects of mescaline into the realm of science for the first time.

℘ ℘ ℘

Dr. Silas Weir Mitchell was in his late sixties, and one of the most famous names in the world of psychiatry. He'd studied neurology in Paris in the 1850s and had made his name as an army surgeon during the Civil War, where he had specialised in shell-shock and neurasthenia and developed the controversial 'rest cure' for nervous illnesses; it's likely that what interested him in both the Indian peyote ritual and Prentiss' account is the possibility that mescaline might be used therapeutically for nervous weakness or depression. He was also the author of several novels, psychological and historical romances which suggest that its effect on his imagination and powers of description also piqued his curiosity. In any case, "at 12 noon of a busy morning", he began to take gradual doses of a liquid peyote preparation, and by mid-afternoon he found himself being tugged into the current of a profoundly altered state of being. He began to feel flushed, with rushing pulse and dilated pupils, but also a private sense of languor and comfort. He continued to have consultations with patients, bounding up staircases two at a time without effort in a manner which

recalled to him the feats of endurance of "the mescal-eating Indians". At the same time his stomach seemed to be resisting the transformation, his guts roiling uncomfortably but somehow remotely. Shortly after four he went home, took another dose and sprawled on the sofa, noticing sporadic headaches but also a languid, sleepy ease. Quoting Tennyson's poem of the ecstatic, drugged *Lotos-Eaters*, he felt himself transported to "the land where it is always afternoon". Things around him seemed to have "a more positive existence than usual", but he searched in vain for the words to describe this presentiment more precisely. He had the strong sensation of being "more competent in mind" than normal, and set himself various tasks – writing letters, doing maths problems, reading a difficult monograph – and was surprised to discover that he performed neither better nor worse than normal. He abandoned his increasingly half-hearted aptitude tests – "a mood is like a climate and cannot be reasoned with" – and began to focus instead on the stars and coloured flashes which were dancing in front of his eyes. Sensing that this was where the action was, he went upstairs and lay down in a darkened room.

Here Mitchell's note-taking broke down, and the following "enchanted two hours" were recalled only in snatches: vivid colours surging in waves before his eyes, then forming into elegant and detailed hallucinations: ruined Gothic towers hung with glowing crystals like bunches of grapes, golden clouds floating over rippling purple aurorae of space and time. He tried to influence the forms of the visions, as he was wont to do with daydreams and morphine, but found them impervious to his conscious influence, unfolding like a revelation from an inscrutable other dimension. Little dwarfs, seemingly made of leather, blew through green glass pipes; huge and magnificent waves of colour and vibration broke across a still-recognisable Newport Beach. Eventually a knock on the door summoned him to dinner; he emerged into the bustle of early evening routine, and the visions began to fade. He remained awake until four in the morning, feeling enervated and delicate, recalling his visions with increasing difficulty until exhaustion finally submerged them.

The next day, he found himself ambivalent about the experience: "these shows", he observed, "are expensive". He had a persistent headache, and a "smart attack of gastric distress", and decided that the overall experience "was worth one such headache and indigestion, but was not worth a second". Large doses of mescaline, he felt, would have little of the therapeutic value he had hoped for – the stimulation achieved by the intensity of the effects would be undone by the weakness and enervation which followed them. Searching for parallels in the medical literature, he suggests that perhaps the closest comparison is the visions associated with some types of migraine. But the whole phenomenon seemed to him to hold enormous potential for psychological and cognitive research: "here is unlocked a storehouse of glorified memorial treasures". What might a blind person see, or someone congenitally colourblind? What responses might be invoked by music, or taste, or smell? "No-one", he notes, "has told us what visions come to the Red man. I should like to know if those of the navvy would be like those of the artist . . .".

Finally, he sounds the first note of concern about "a perilous reign of the mescal habit when this agent becomes attainable". How many people might choose to live in the land of the Lotus-Eaters rather than inhabit their quotidian lives? "The temptation to call again the enchanting magic of my experience will, I am sure, be too much for some men to resist after they have once set foot in this land of fairy colours, where there seems to be so much to charm and so little to excite horror or disgust". Once again, as with cocaine, the pleasure is the problem.

Initially, though, Mitchell's concern seemed to be unfounded. His report was noted with interest by many psychologists, but few seem to have been tempted to repeat his experiment, and several of those who did found that the physical discomfort made even a single experience one too many. William James, who was at the peak of his nitrous oxide enthusiasm, tried a small quantity but was overcome with waves of nausea at the bitter potion: "I shall", he wrote to his

brother Henry, "take the visions on trust". But one reader of Mitchell's report was to take the experience into new dimensions: across the Atlantic to London, and into the purview of art, poetry and the occult.

℘ ℘ ℘

Havelock Ellis is best remembered today for his monumental, multi-volume *Studies in the Psychology of Sex*, one of the founding texts of sexual psychology and the first to place 'deviant' practices like homosexuality and autoeroticism in the context of normative behaviour. When Weir Mitchell published his mescaline report, Ellis was in the process of writing the first and most controversial volume of the series, *Sexual Inversion*, with the homosexual artist John Addington Symonds: it was finished in 1897 but withdrawn amid scandal before its British publication, eventually seeing the light of day in America. Ellis was a young radical, an art historian and critic, an essayist and cultural theorist with socialist leanings, whose work was just beginning to find its market. The previous year he had written an ambitious essay entitled *The Colour Sense in Literature* for the *Contemporary Review*, which analysed the favourite colours of writers from Chaucer to Coleridge and drew conclusions about their aesthetic orientation. When he read Mitchell's article he was struck by its "very interesting record of the brilliant visions by which he was visited under the influence of the plant", read further into the still-scanty 'mescal' literature of Mooney, Prentiss and Lewin, and asked local pharmacists about getting hold of some of the cactus buttons. Potter & Clarke, of 60 Artillery Lane East, obliged with a large bagful. On Good Friday 1897 Havelock Ellis settled down at his rooms in the Temple, the quietest district in central London, boiled up three buttons and drank them.

Ellis' report was published in the *Contemporary Review* under the title *Mescal: A New Artificial Paradise*, bespeaking his sense that he was navigating similar waters to Baudelaire's essays and that the 'artificial paradise' of hashish was the closest comparative landscape to that in which he had found himself. His experience seems to have been similar to

Mitchell's in terms of dose, physical effects and duration, but his attitude to it demonstrates a turn of mind far more focused on the aesthetics of his visions, a curiosity broadly scientific but searching for meaning not in physiological mechanism so much as in the play of the senses and the imagination. His visions also begin with flickering colours, coalescing into "thick, glorious fields of jewels", eventually leading him also to lie down and concentrate on the experience in darkness. As he undresses and gets into bed, he notices his weak pulse, faintness and "the red, scaly, bronzed and pigmented appearance of my limbs"; eventually he becomes tired of the faint visions in darkness and turns on the gas light. This seems to send out waves and ripples of colour which "expanded and contracted in an enormously exaggerated manner"; he recalls the Indian practice of settling round an open fire, and is struck by the way in which the flickering light transforms and models the visions. Precise in his aesthetic comparisons, he records their similarity to Maori architecture, to the "effects of lace carved in wood, which we associate with the moucra-bieh work of Cairo", to the "hyperaesthesia" of modern painters like Claude Monet. He is particularly impressed that mescaline "exerts its magic powers" without dulling the intellect in the manner of alcohol: the mescal drinker "remains calm and collected in the midst of the turmoil around him", the "optical fairyland, where all the senses now and again join the play". He's also struck by the way in which, moulded by the gaslight, "a large part of its charm lies in the halo of beauty which it casts around the simplest and commonest things . . . it is the most democratic of the plants which lead man to an artificial paradise". But the most striking aesthetic parallel he finds is with Romantic poetry. "If it should ever chance that the consumption of mescal becomes a habit", he predicts, "the favourite poet of the mescal drinker will certainly be Words-worth . . . many of his most memorable poems and phrases can not − one is tempted to say − be appreciated in their full significance by one who has never been under the influence of mescal". In this, Ellis' marriage of scientific curiosity and search for the language of feeling come strikingly close to

recapitulating the nitrous oxide project of Davy, Southey and Coleridge almost exactly a century before.

Indeed, Ellis' first instinct was exactly the same as that of both Davy and Moreau de Tours: to find artists, poets and men of specialised sensory description to share the experience with. For this he was well-placed: his collaborator John Addington Symonds had just founded *The Savoy* magazine with Aubrey Beardsley, and Ellis had contributed to several of the early issues. Symonds was also a core member of the Rhymers Club, and probably knew all of London's small and esoteric circle of hashish and opium habitués, occultists, paranormal seekers and decadent poets. Symonds took little persuading into a novel and jewelled artificial paradise, but the experiment ran none too smoothly: first the decoction of buttons was too weak, and the second time rather too strong, the onrush of the effects giving him "paroxysmal attacks of pain at the heart and the sense of imminent death". Following this, his trip was coloured by "wild and extraordinary pranks . . . taking place in my body". All his weight seemed to shift into his right knee; then "the back of my head seemed to open and emit streams of bright colour". He heard singing in one ear, felt heat around his eyes; when Ellis passed him a biscuit to help relieve his nausea, "it suddenly streamed out into blue flame . . . for an instant I held the biscuit close to my leg. Immediately my trousers caught alight . . . it was a sight of the most wonderful beauty . . . as I placed the biscuit in my mouth it burst out again into the same coloured fire and illuminated the interior of my mouth, casting a blue reflection on the roof". This fantasia persisted for several hours before ending with an abruptness which seems, for Symonds, to have been as remarkable as anything which had gone before. Having his body back under his control only reinforced the memory of how "my body had become in a manner a stranger to my reason . . . henceforth I should be more or less conscious of the interdependence of body and brain".

The next experimental subject was a poet "interested in mystical matters, an excellent subject for visions, and very

familiar with various vision-producing drugs and processes", who we can safely assume to be W.B.Yeats. Unfortunately, his rather weak heart found him out under mescaline: his breathing became shallow and faint, and he concluded that he personally "much prefers hasheesh, though recognising that its effects are much more difficult to obtain". Another poet, perhaps Yeats' friend Edward Martyn, who also had rooms in the Temple, had a more successful time of it, with a series of exhilarating dragon visions and a late-night stroll out onto the Embankment where he "was absolutely fascinated by an advertisement of 'Bovril', which came and went in letters of light on the other side of the river . . . I can not tell you the intense pleasure this moving light gave me and how dazzling it seemed to me". Ellis himself also went on to become, as far as we know, the first Westerner to take a full dose of mescaline more than once, and continued to write about it in *The Lancet* and elsewhere. He remained curious about its effects on music, and took his second dose with a friend playing the piano and testing his reaction to various themes and pieces. He found that some were much more effective than others in generating visions which synchronised with them and enhanced them both: Schumann and 'Scheherazade' were exceptionally transporting.

Ellis' final verdict on mescaline was more sanguine than Mitchell's. While he also felt that the widespread and continued use of it would be "gravely injurious", he felt that it had certain attributes which would make the profligate or casual abuse of it unlikely. The unpleasantness of its physical effects – compared, say, to opiates – made it of all drugs "the most purely intellectual in its appeal . . . on this ground it is not probable that its use will develop easily into a habit". It also seemed to him that it was a powerful medicine which demanded a strong constitution: unlike morphine or cocaine, whose dangers lay in their ability to cover up physical or nervous weakness while quietly making it worse, with mescaline "robust health is required to obtain any real enjoyment from its visionary gifts". "For a healthy person to be once or twice admitted to the rites of mescal", he concluded, "is not

only an unforgettable delight, but an educational experience of no mean value".

<p>℘ ℘ ℘</p>

So the nineteenth century may not have known LSD or ecstasy but, by the time it came to a close, one of the most potent psychedelics known to man or nature had been identified, analysed and isolated and was being dispensed in pills, powders and crystals to anyone who was interested in sampling it. But volunteers were few. Even more than hashish, with which it shared a similar user profile, it was seen as an obscure, primitive and toxic substance of interest only to Red Indians, medical specialists or bohemian *poseurs*. Its low-level medical use never found the killer application which would have allowed it to penetrate into the clinical mainstream, and none of the Rhymers or Golden Dawn members seem to have studied it as seriously as Havelock Ellis – with the exception of Aleister Crowley, one of Parke Davis' few customers for it in the early twentieth century who, probably on one of his visits to the States, added their 'anhalonium' to his *smorgasbord* of magical substances which already included cocaine, morphine, hashish, ether and chloroform. He took it in Italy in 1907, where he saw "a faery flush of yellow and red over Venice on closing eyes", and proceeded to develop a series of magical rites around its use.

But one mescaline session from the early twentieth century is worth recording, not least because it illustrates how, even in bohemian circles, a 'recreational' peyote trip was profoundly beyond the limits of manageable experience. It was held in 1914 at the Greenwich Village home of society hostess and *salonneuse* Mabel Dodge Luhan, whose parties in New York and Florence were attended by the likes of D.H.Lawrence and Gertrude Stein, and she recounts it in her memoirs as a chaotic and terrifying night entirely unlike anything she ever hosted before or since.

Mabel's house guests for that spring evening included her friend Andrew and his cousin, an excitable young lady called Genevieve, who had just returned from China with a newly-

acquired and rather shallow fascination for Eastern philosophy; a penniless but intense and poetic young anarchist called Terry; a couple of old friends called the Hapgoods, and their cousin Raymond Harrington, an ethnologist who happened to have been researching the peyote religion in Oklahoma. When asked about peyote, he told them that the peyotists were "the most sober and industrious of all" Indians, and that they seemed to have been able to recover ancient beadwork patterns and techniques through using it; when pressed further, he admitted that he had some buttons with him. Mabel and her friends begged him to share them with the assembled company. "Of course I said we must all try it . . . but he was grave and said that it was not a thing to play with." But eventually he agreed to set up a ceremony: "we were all thrilled!". Raymond collected a few props – an eagle feather, an arrow whittled from green wood, a folded white sheet running east-west across the living room – and assembled them round a token 'fire' of a light bulb on the floor covered with a red cloth. He made the guests promise to remain seated around the 'fire' and to continue singing until the morning star rose. Everyone fasted for the day, dressed in their best and assembled for the evening.

Raymond chewed the buttons, and the others followed his example. Mabel ate one – "But it was bitter! Oh, how it was bitter!" – and then secreted the rest in her palm. Soon the mood of the gathering turned strange and inward; some of the guests left without a word, and Mabel found the solemnity gave her an irresistible urge to laugh. Terry the anarchist was frozen, staring at the end of his cigarette with frightening intensity; Raymond and Genevieve, too, seemed lost to the outside world. The scene became "monotonous and outlandish", and Mabel eventually broke the ritual vow and went to bed. Lying awake, she was seized with convulsive anger at the thought that "something was going on *in my house* that I could not stop even if I wanted to". Eventually she heard Andrew lumbering and stomping around, and returned to the living room to find a dimly-lit scene from hell. Andrew was trampling furiously all over the ritual

paraphernalia; Genevieve greeted Mabel with a ghastly expression and a cry – "Oh, Mabel! It is *terrible!*", before running out. Raymond broke out of his trance in horror, repeating again and again to Andrew: "Stop man! That is terribly dangerous!", while Andrew repeated back, "I *had* to break it up!" Terry the anarchist remained motionless; the other guests, with Mabel and Andrew, went in search of Genevieve and found her sobbing under the window. The session devolved into black coffee-drinking, with Genevieve gibbering, eyes rolling, impossible to reach, until they decided to send a telegram to her father and summon a discreet East Side Jewish doctor. Paranoia about the police seized them, and Mabel had nightmare premonitions of "dope party" headlines in the scandal sheets. Terry finally moved, for the first time since the ritual had started. "I have seen the Universe", he proclaimed, "and Man! it is wonderful". He took his hat, walked out and none of them ever saw him again. Suddenly everyone realised that Genevieve, who had been left alone in a bedroom, was no longer there. In a panic, Mabel called some straight and influential friends, who organised a search for her. The evening had turned into a "disagreeable scrape", with police, doctors, journalists, detectives and fathers all rushing around in a melee of damage limitation.

Mabel has no recollection of who found Genevieve or how, but she never saw her again either: she received an incomprehensible note from her a while later from Chicago covered with hieroglyphs and symbols, and gathered from mutual friends that Genevieve's family had developed "a horror of me, filled with blame and the darkest suspicions". Nor did she ever see Raymond Harrington again, although his peyote regalia collection at the Heye Museum in New York was famous as the world's finest. And of the rest, she recalled twenty years on that "I know that every one of the others who had been at the apartment that night talked about it *for years*, and even still continue to do so".

℘ ℘ ℘

Throughout the first half of the twentieth century mescaline remained legally available from pharmacists, and was occasionally experimented with by scientists, artists and philosophers. Walter Benjamin participated in clinical sessions with it in Germany in the 1920s; the French experimental artist and poet Henri Michaux painted and wrote under its influence; most famously, Aldous Huxley wrote his celebrated essays on its effects, *Doors of Perception* and *Heaven and Hell*, in the 1950s. By this time it had been joined by its synthetic cousin, LSD, born in Albert Hofmann's laboratory in Switzerland during the Second World War and already in the throes of its convulsive early progress through medicine, psychiatry, secret biological warfare and increasingly public consciousness expansion. Mescaline, along with LSD, was eventually put under legal controls in the 1960s.

But the discovery of LSD was also the catalyst for the belated emergence of the secret ingredient inside the magic mushroom. Gordon Wasson's pioneering ethnobotany located a surviving Mexican mushroom cult in the 1950s, and delivered specimens to Hofmann's lab where its alkaloids, the psilocybin family, were finally isolated and found to bear a family relationship to both LSD and mescaline. It was laboratory psilocybin which furnished Timothy Leary's first trip before he became the guru of LSD; and, as the drug counterculture spread, so did the knowledge that psilocybin-containing 'magic mushrooms' grew plentifully across Britain, Europe and North America.

The effect of this new psychedelic climate has effectively been to turn the nineteenth-century *status quo* on its head. Mescaline, freely available a century ago, is now a rare substance indeed: most of its clinical uses have been prohibited, and its illicit presence is negligible compared to LSD, which is active at microdose level and vastly cheaper to make. By contrast magic mushrooms, known only by vague repute and second-hand folklore a hundred years ago, carpet the fields and flood the drug scenes of the West every autumn. Although pure psilocybin is controlled, the natural growth of fungi is in itself not an arrestable offence, and thus their

gathering and consumption occupies a legal grey area which, along with their easy availability, has made them one of the commonest illicit drugs.

But while everything else has turned upside down, one tradition has remained constant: the use of peyote by the Native American Church, which is still widespread and little altered from the ceremony described by James Mooney in 1891. Legal harassment of peyotists has continued ever since, with the increased control of peyote under successive federal and state drug laws, but the exemption of NAC members on religious grounds has finally become a robust legal principle. Today, Native American members are even permitted to hold their ceremonies while serving in the armed forces. Peyotism is now, apart from powwow meetings, the most common pan-Indian practice in the United States, with an estimated two hundred thousand adherents; in fact, its greatest danger is now its own success, as supplies of the slow-growing cactus are gradually depleted from their Southern desert habitats.

7

Ardent Spirits

Temperance and Prohibition

From Humphry Davy's first nitrous oxide revelation to Havelock Ellis' New Artificial Paradise a century later, the majority of the nineteenth century's recorded drug experimenters felt they were engaged in a project with its roots essentially in the Enlightenment: a scientific mapping of the unexplored realms of the mind whose future outcome would be a more highly evolved understanding of what it means to be human, a broadening of control over our moods, our abilities, and ultimately our mental health. Most of them would have been astonished to discover that the twentieth century would be characterised by an intense, often fanatical effort to banish these new dimensions of mind from the civilised consensus, and to insist that the use of drugs belonged not to humanity's future but to its primitive and atavistic past.

One of the most striking effects of tracing the origin stories of today's illicit drugs is how huge the gulf seems to be between the largely progressive role which they inhabited in nineteenth-century scientific and bohemian subcultures, and their transformation into the twentieth century's great folk-devils. These origin stories make it abundantly clear that drugs are not without their dangers, and it's not hard to understand how substances like opiates and cocaine should have come under medical scrutiny and statutory regulation – but this happened to thousands of other prescription medicines at the same time without any perceived threat to the fabric of society. And when we examine the cases of, say, cannabis or the psychedelics, the idea that they might constitute a serious social or medical danger is either marginal

or entirely absent from their formative history. To connect the story of drugs in the nineteenth century to that of the twentieth, we need to expand the frame and outline briefly the huge and overarching spectre which looms over not only today's illicit drugs but the nineteenth century in general: the alcohol question and, in America, the 'noble experiment' of prohibition. Only by considering this can we square the circle by understanding how drugs, as the nineteenth century progressed, became flotsam on the tide of opinion about intoxication in general and its role in the civilised societies of the future.

℘ ℘ ℘

It's barely an exaggeration to say that Western civilisation was founded on alcohol. Classical Greece and Rome were both drinking cultures, distinguishing them from many of the barbarians on their borders who retained earlier 'smoking-culture' habits of inhaling hemp and opium from fires and charcoal braziers. Wine and beer were deeply embedded in classical notions of civilisation, used socially, in religious observance, and as a base for sophisticated preparations like perfume and medicine. When Christian Europe emerged, it maintained the centrality of alcohol in Western culture, elevating it to the role of prime sacrament. For centuries, where drinking water was sparse, European children moved directly from mother's milk to beer, wine or cider.

Of course, people got drunk: some records suggest that entire populations must have subsisted in what we would now regard as a permanent alcoholic haze. But even the egregious drunkard – Falstaff, for instance – is not a social problem, or a man with a medical condition, or a sinner. He's a 'sot' rather than an 'alcoholic': if he drinks too much, it's because his character is flawed, not because he's a victim of a nervous instability or chemical dependency.

The story changes with the introduction of distilled alcohol – 'ardent spirits' – to Europe in the seventeenth and eighteenth centuries. Combined with the dense shanty-towns and urban sprawls of the early industrial revolution, this pro-

duced mass public drunkenness on a scale never seen before. Dr. Johnson's London, for example, small enough to cross on foot in a couple of hours, contained thousands of gin stalls, their cry of "Drunk for a penny, dead drunk for twopence" heard on every corner. Alcohol the Social Problem was born.

Thus the colonial expansion into America took place in an era driven by cheap distilled spirits. Puritans apart, most of the early settlers were hard drinkers even by European standards. In sparsely-populated pioneer America, whisky and rum were often more important and useful than money. Most rural communities had their own stills, and even in Puritan settlements drinking wasn't prohibited, merely public drunkenness. Habitual drunkards would be pilloried, or made to wear hair shirts with a large 'D' on them.

But the early Americans had one alcohol problem to deal with which the Europeans didn't: the 'drunken Indian'. Ever since Captain Cook's voyages – and even before – Westerners had been aware that alcohol, introduced carelessly into a culture which had no experience of it, could destroy centuries of tradition and social organisation in a few short years. Right across the New World, the Pacific, Australia, culture after culture had been destroyed by alcohol. But, unlike Europeans, Americans had to live cheek by jowl with alcohol's new victims. Benjamin Franklin, for example, records sealing a treaty with the Indians in Pennsylvania in 1753 with a gift of rum, and being terrified by the drunken party which followed: "They were all drunk Men and Women, quarrelling and fighting. Their dark-colour'd Bodies, half-naked, seen only by the gloomy Light of the Bonfire, running after and beating one another with Firebrands, accompanied by their horrid Yellings, form'd a Scene the most resembling our Ideas of Hell that could well be imagin'd".

Here was a new set of problems. Indians, unused to alcohol, were unequipped to deal with its effects; most specifically, the new dispensation in America was predicated on rules about the different status of whites and Indians which drunken Indians were liable to forget. Furthermore, the Indians didn't distill alcohol themselves, but were dependent on the white

man for it: hence a policy needed to be decided upon, and rules of Temperance could in theory be enforced. Religious voices began to preach of the immorality of allowing Indians to destroy themselves with liquor, and to insist on the paradoxical truth that alcohol could be "The Good Creature of God" for settlers but an agent of Satan for natives.

In theory, the American settlers might have been able to exercise a paternalistic control of alcohol for the natives' own good, but in practice their use of alcohol to make Indians economically dependent on them held up a mirror to the uglier profile of the new arrivals. Initially, many native tribes were uninterested in alcohol, but there were always trappers or traders on hand to help them acquire the taste, and the Western custom of sealing a deal with a shot or two of spirits soon devolved into the vision of Hell witnessed by Benjamin Franklin. Although organisations like the Hudson's Bay Company stipulated that Indian goods should never be bartered for liquor, enforcement in pioneer territory was non-existent and trading with alcohol – ten otter pelts for a bottle of whisky – was immeasurably cheaper for the traders than the real cash price. Warrior tribes already defeated in battle plunged into the bottle with terminal fatalism, and many were eliminated either by drink alone or by suicidal rounds of drunken vendettas and reprisals.

The role of alcohol in the extinction of so many of the native peoples may have been little discussed at the time, but in retrospect it can be seen to have informed many aspects of the move to control other drugs along with alcohol at the end of the nineteenth century. First, it gave legitimacy and precedent to the notion of racial exclusions: some substances should be prohibited to minority ethnic groups for their own good. Thus to ban Chinese immigrants in San Francisco from using opium, while allowing the rest of the population access to it, not only seemed logical but carried a sense of nobility of purpose, even of righting historical wrongs. Second, the idea that some societies could be destroyed by one drug – alcohol – made it plausible that other societies could be destroyed by another. The Opium Wars propaganda which conjured a

China sickening unto death from the 'opium plague' had, as we've seen, little validation in fact, but it had the strong and often overt resonance of the destruction of the Indians by alcohol. In fact, the lesson of history was unambiguous: that dozens, maybe hundreds of societies had been destroyed by alcohol, but it was hard to point to any plausible example of a society being destroyed by any other drug. But despite the regular and rhetorical insistence by medical authorities that alcohol was more dangerous than any other substance – including ether and even heroin – the unexamined suspicion clung on that Western society had been tested by no substance other than alcohol, and that one or all of these foreign intoxicants might have the potential to send the modern West the way of the Indian.

On both sides of the Atlantic the nineteenth century witnessed the formation of a powerful coalition to challenge the central role of alcohol in Western culture for the first time. The various forces involved had their own motives for seeking to control or abolish alcohol use, but their combined strength had the effect of making the opposition to intoxication seem almost unanimous. This coalition was effectively the same as the one which united in the early twentieth century to prohibit the use of drugs for pleasure, and which still strives to maintain the consensus that the use of these drugs places the subject outside the mainstream of society. It can perhaps be considered under four broad headings: politics, religion, medicine and mothers.

℘　℘　℘

Throughout nineteenth-century Britain and Europe, the control of alcohol evolved through a popular Temperance movement into a far-reaching public health programme without ever becoming a defining political issue; by contrast, in American politics, prohibition became (once slavery was settled) perhaps the single most important issue of the century. The roots of this distinction lie in the sharp difference between their overall political landscapes: while the small population of nineteenth-century America was

expanding into its pristine teritory and evolving its sense of nationhood, Europe was being torn apart with wars and revolutions, radical communist and militarist movements. To begin with, alcohol was a concern in Britain and Europe mostly insofar as it had an inflammatory impact on public order in a time of revolutionary mobs and riots, but mobs and riots were also a deterrent to stricter alcohol controls. In gin-soaked mid-eighteenth-century Britain, various attempts to control sales by increasing taxes had met with riots; better results had eventually been achieved by dropping the price of beer to encourage a move away from the ardent spirits. Subsequently, the destructive effects of alcohol had been most effectively diminished not by politics but by the evolving Victorian middle class, its 'sober' culture gradually marginalising the feckless working classes and organising itself to promote charitable and philanthropic initiatives against the excesses of drink. A gap opened up between the aspirational culture, where alcohol was disapproved, and the unreconstructed proletarian culture where getting blind drunk was part of life. We have many more recent examples of this kind of demographic change being exploited – smoking and high-fat diets, for example, being abandoned predominantly by middle class opinion-formers – and we can perhaps extrapolate from today's pervasive cultural prejudice against cigarettes and fried food, increasingly validated in news reports and 'new health findings', to a sense of how alcohol intoxication became an issue on which the socially conscious repositioned themselves on the side of sobriety.

In America, by contrast, alcohol intoxication and its control was a resolutely political issue from the first. The twin features of almost every small town were a church and a saloon, and local politics was more often than not configured around two groups: the founding church-folk and landowners, and the *arriviste* publicans, industrialists and tradesmen. People met in the church or in the saloon – often the same people in both – and it was here that votes were canvassed and blocks formed. The church represented the 'uptown' moral high ground of

Sunday morning, and the saloon the 'downtown' *realpolitik* of business and Saturday night.

Tensions between these two poles of smalltown society was exacerbated throughout the nineteenth century as the demographic balance began to swing in favour of the saloon culture. Millions of immigrants arrived, mostly from traditional drinking cultures like Germany, Italy and Ireland; brewery business, mostly German-owned, began to dominate the industrial landscape. Downtown became an increasingly alcohol-fuelled culture in which the churchgoing founders were less than comfortable, sometimes less than welcome. When it came to voting, there were frequent accusations that publicans standing for office would trade free drinks for votes, turning polling days into drunken farces. As the vacant territory of America began to fill, those who felt their culture being crowded out had ever fewer pristine spaces in which to start anew. The 'sober' culture of the new middle classes, rather than exerting social and cultural pressures for reform, found that, county by county and state by state, they were pitched directly against their opponents at the ballot-box. 'Dry' counties sprang up, and the 'dry' vote, rather like the anti-abortion vote today, became more than merely a call for the control of alcohol but the defining issue in a much larger set of concerns, a flag around which traditional voices of racial nationalism and Old Time Religion could rally.

Thus it was in America that the prohibition of alcohol became a major political issue, just as it was in America that, half a century later, calls for the outright prohibition of drugs would override the moderate voices who merely called for their professional regulation and control. Whereas in Europe the same dynamics – a popular Temperance movement, revised medical opinion, the opposition of the church – led to a new culture of regulation, taxation and licensing laws, in America the 'dry' coalition scented the possibility of a far more overwhelming victory. Although Abraham Lincoln had originally focused the mainstream alcohol debate around taxation and licensing, insisting in 1840 that "prohibition will work great injury to the cause of temperance", prohibition

nevertheless came to occupy a moral high ground whereby anyone who opposed it seemed to be speaking in defence of the worst excesses of drunkenness and alcohol abuse. The main 'wet' lobby, the brewers, responded by becoming increasingly prepared to prohibit spirits but leave beer alone: predominantly German, the culture they wished to protect was the German-American beer-drinkers of mid-west industrial towns like Chicago, Milwaukee and Pittsburgh, which expressed itself in jovial public gatherings to the accompaniment of oom-pah music and Strauss waltzes and fuelled by the German-style beers which still dominate America today – Budweiser, Michelob, Schlitz and the rest (although some Germans were also distillers – the all-American Jim Beam was actually produced by a Jacob Boehm). But the powerful identification of this moderate position with Germans – many brewers' association meetings were addressed in German rather than American – became a major weakness during the First World War when, although the vast majority of Germans stood firmly behind the American flag, the 'wet' lobby was all too easily caricatured as a fifth column of the Kaiser, and the prohibition campaign was ever more clearly cast as a struggle for patriotic identity and racial purity.

There are many parallels here with the prohibition of opium, where the moderate position of control and regulation was also swept away by the prohibition lobby, primarily for the reason that they could. Just as prohibitionist America knew that it had a chance of a final victory, so the medical-religious coalition against opium knew that the rights of casual opium smokers had little public force or representation. Opium, as a medicine, was a predominantly medical issue, and the choice for the medical profession was between a world where their super-strength modern preparations like morphine would compete against public self-medication with weaker opium preparations, or one where the Queen of Medicines would be in their hands alone. A further parallel, which we now recognise with hindsight, is in the counter-productive effects of prohibition: in both cases it delivered the drug in the form which the prohibitionists most feared. Even

among prohibitionists there was little anxiety about beer-drinking compared to the ardent spirits, but illicit supply during prohibition naturally gravitated towards the form of alcohol which was most compact, expensive and cost-effective to smuggle: whisky. Similarly, the prohibition of opium led to its virtual disappearance from the black market in comparison with the more cost-effective, potent and dangerous heroin.

By the end of the nineteenth century, the majority of American politicians had little to lose and much to gain from identifying themselves with the far-reaching 'noble experiment' of prohibition, and talking up a bright new century where the scourge of alcohol would be swept from the civilised world. Nor did the prohibitionist lobby – by now largely concentrated in the powerful and well-funded Anti-Saloon League – have anything to gain from pointing out that many of these politicians were themselves heavy drinkers with no intention of taking the pledge, and accusations of hypocrisy and posturing were largely confined to the East Coast intelligentsia and their satirists like H.L.Mencken. The difficult questions, in the political and public mind, had already been answered by 'expert' religious and scientific opinion.

℘ ℘ ℘

Christianity in Europe had always tended to relegate teetotalism to its more ascetic margins: wine, after all, is not only prominent throughout both Old and New Testaments but is the church's central sacrament. But over the course of the nineteenth century, the religious lobby in Europe and particularly America became a major part of the anti-spirits coalition, adding a weighty moral force to the argument for prohibition. (When it arrived, however, communion wine was exempted from the 18th Amendment – which turned out to be yet another useful loophole for the bootleggers.)

The force of religion was most evident in America, where Temperance and the church shared many goals. In the prevailing Puritan climate, alcohol as a producer of pleasure was an agent of danger, opposed to the virtues of hard work, thrift

and modesty. Alcohol tempted men to live for today, while the church instructed them to think of the morrow. The church's notion of patriotism involved millions of hard-working families becoming prosperous and strong together; alcohol threatened to rupture this communal effort and dissipate its energies in wasteful enjoyment, leading to poverty and dependency. The constituency of the church found the core of its opposition in the constituency of the saloon, and from the 1830s onwards travelling Temperance preachers were guaranteed an enthusiastic hearing in the churches of small town America.

The Puritan tradition had historically found great potency in 'signs' which distinguished them from the people they felt to be beneath them – abstinence and Lent practices, for example, or the maintenance of pre-settlement dress codes – and 'taking the pledge' proved a hugely successful focus for the Temperance crusade, with its echoes of born-again baptism and the promise of entry into a powerful and mighty elite simply by giving up alcohol. If, as it also implied, 'we' can show the world that we can manage perfectly well without alcohol, then why should we be expected to tolerate breweries, saloons and drinkers in 'our' country?

By mid-century, the evils of alcohol had become one of the major religious themes the length and breadth of America. Like the politics of prohibition, the religion of prohibition had the rhetorical advantage over its opposition. If a Presbyterian minister preached that "the saloon is the most fiendish, corrupt, hell-soaked institution that ever crawled out of the slime of the eternal pit", then to attempt to put a milder view was to take the side of the most reprehensible drunkard imaginable. However, once assertions like this had become the common currency, the idea of compromising or reaching consensus with the saloon lobby, or with your 'wet' representative in Congress, became unthinkable, even sinful. Only after the collapse of prohibition would the credibility of this type of rhetoric be weakened by ridicule and the ebbing away of public support; but even by this stage it could still be applied credibly and effectively to more foreign and sinister-sounding drugs.

By the end of the nineteenth century, the equation was clearly laid out and accepted by the vast majority of religious opinion: abstinence meant salvation, drunkenness damnation. To take the 'pledge' was to book your ticket to heaven, and to take a drink was to steep your soul in the corruption of hell. This corruption, too, was more than a metaphor: as the Rev.Justin Edwards claimed in his influential *Temperance Manual*, alcohol destroys the body because neither distillation nor even fermentation are part of God's Plan. Distillation, clearly, is a human perversion of nature and therefore a sin, but fermentation is almost worse: no more than "poisonous miasma" produced by the destruction of healthy fruit: "it is as different as poison is from food, sickness from health, drunkenness from sobriety".

This type of assertion about the physical effects of alcohol may seem to represent the far fringes of fundamentalism, but in fact it was oddly close to the medical mainstream. The scientific understanding of alcohol evolved rapidly through the nineteenth century, dragging the understanding of other drugs like opium and cocaine rather haphazardly behind it; but it, too, became drawn into the current of Temperance spirit, eventually becoming one of its most powerful propagandists.

℘　℘　℘

Alcohol had become a medical concern during the 'gin craze' in eighteenth-century Britain, when doctors like Thomas Trotter and Erasmus Darwin, Charles' grandfather, had begun to connect all manner of diseases – gout, dropsy, epilepsy – with excessive consumption of ardent spirits. Darwin thought that drinking spirits was "taking fire into one's bosom", a practice that inflamed the liver; Trotter's view was that drunkenness was a pathological condition which provided the breeding-ground for a huge range of diseases. But both were postulating organic causes for alcohol-related diseases: inflammations and eruptions caused by the presence of strong spirits in the body. During the nineteenth century a new idea took hold that the relation between alcohol and disease was far deeper, hidden in the hereditary process itself.

P. T. O

231

The first extended formulation of this view came with Morel's *Treatise on Degenerations* in 1857 which, as we've seen, came to be highly influential on medical views of alcohol, hashish and opium alike. According to Morel, alcohol and other drugs were "environmental poisons" which set in motion a progressive degeneration which would be inherited by future generations, eventually culminating in sub-human forms such as cretinism. A drunken father or mother would produce children with an inherited tendency to various forms of moral weakness, including of course alcoholism; the degenerative effect would snowball through the generations, 'nervous' children producing mentally disturbed grand-children and great-grandchildren little more than idiots. Morel's theories became influential across a broad spectrum of medical science, but they dovetailed especially well with the alcohol debate. Morel, himself a devout Catholic, clearly identified health and sanity with God's grace and degener-ation with the Fall and damnation; as sobriety came to equate with salvation and drunkenness with perdition, so medical opinion became skewed towards the view that alcohol set the deep mechanisms of the human organism on the slippery slope to a ruin which would extend even unto the children's children.

During the middle of the nineteenth century, there was some vigorous opposition to this view. The Swedish doctor Magnus Huss, for example, attempted to reverse the arrow of causation by claiming that chronic alcoholism was an environmental problem, not a hereditary one, and that the solution lay in a public health programme which addressed the underlying causes of alcohol abuse and offered alternatives to ardent spirits – state-supplied beverages to supplant the illegal stills, for example. But, as with illicit drugs today, it was easier for doctors and governments alike to insist that alcohol abuse caused social problems like poverty, poor hygiene and overcrowding than to open the can of worms which alcohol both concealed and revealed. Alcohol was presented as the root of an ever-increasing taxonomy of pathological condi-tions: medical specialists in alcoholism tended more and more

to be devout Temperance campaigners, and specialist publications like the *Journal of Inebriety* shaded science into anti-alcohol propaganda, much like today's publicly-funded research into cannabis or ecstasy. Sea-urchin embryos were doused in alcohol and their hereditary degeneracy soberly recorded; the intelligence of children born to Swiss peasants after a bumper wine harvest was found, more in sorrow than anger, to be seriously defective. As a mountain of evidence accumulated for the disastrous effects of alcohol on the human organism, few doctors had the pro-alcoholic zeal to develop the case against, and an eager publicity machine awaited only the findings which seemed to add to the conclusiveness of the proposition. Medical science, by a gradual and systemic process, accepted principles like 'blastopthoric degeneration' and 'alcoholic diathesis', and added its weight to the view that alcohol, as an atavistic and dangerous substance, should be prohibited by civilised society. As other intoxicating drugs like cocaine and chloroform entered the medical arena, their use was naturally seen as an extension of the alcoholic pathology: terms like "opium inebriate", coined by the Temperance doctor Norman Kerr, implied without examination that desire for intoxication by any substance was *prima facie* a form of mental illness.

℘ ℘ ℘

The force which, added to all the above, was perhaps most responsible for making prohibition inevitable was the women's movement. Unlike the others, it was entirely new: the first mass non-violent protest movement in the West, the first time women had ever organised themselves into a lobbying block (the suffrage movement was to develop out of the women's Temperance leagues). Moreover, it was essentially a progressive call for reform which, combined with the conservative voices of religion and patriotism, produced what seemed like an unassailable pincer movement against alcohol: prohibition was the choice both of traditional and modern America.

The National Women's Christian Temperance Union

(WCTU) was founded in 1874 and became, along with the Anti-Saloon League, the most important non-party-political prohibition lobby in the States. Although it included some fundamentalist firebrands like Carry Nation, who achieved brief tabloid celebrity by attacking saloons with hatchets and destroying their bottles and kegs, the vast majority of its members were wives of the new American middle class: doctors, teachers, grocers. Their marches were concentrated on the working-class downtown saloon districts, and the picture they painted of the evils of drink was of the working-class household reduced to misery: mother and children meekly saying grace before supper, with the empty chair a constant reminder that father was in the saloon spending all their money. Temperance actually commanded little support among the working people at whom its message was aimed, but was nevertheless extremely successful in co-opting institutions like schools and hospitals to spread its message about the evils of alcohol – which, as in Britain and Europe, was absorbed in tandem with another message, unintended but nevertheless received loud and clear, that anyone who aspired to its members' social status as pillars of the community must take the pledge as the price of admission.

The WCTU ran a coordinated education campaign among schools and Sunday schools to send the message – derived in equal part from religion and medicine – that alcohol was a wicked and poisonous substance. Young children were taught to sing songs about how God made fruit and water for us to eat and drink when we were thirsty; a common demonstration was to place a fresh pink piece of cow's brain in a jar, then pour some alcohol into it and watch it turn grey – "and that, children, is what would happen to *your* little brains". It's a tradition which is still alive and well in drug education, with particularly close parallels in today's US government-sponsored anti-drug TV campaigns.

Perhaps the keynote of the women's Temperance movement was purity – hygiene, cleanliness and the dangers of dirt. The WCTU wore white ribbons to symbolise this, and their songs – like "Lips that touch liquor shall never touch mine" –

stressed the importance of purity by example. This message was a seamless fusion of traditional religious values and the 'modern', up-to-date discoveries of medicine, and naturally extended their activities into a broader range of hygiene concerns, such as prostitution and racial mixing. It also reflexively extended to other drugs: the medical language of 'plague' and 'contagion' which doctors were applying to opiate addiction identified not just opium, morphine and heroin but all drugs as enemies of moral purity and public hygiene.

But, ironically, one of the salient effects of prohibition when it finally arrived was to make alcohol-drinking much more popular among women. Most of the saloons of the later nineteenth century were men-only institutions, but the prohibition speakeasies were mixed; cocktails were invented during the prohibition era to cater for the new female clientele. Again, there are parallels with the prohibition of drugs: at the beginning of the twentieth century illicit drug use had a predominantly male profile, whereas now 'party drugs' like cocaine and ecstasy are used as much by women as by men. And by the time the end of alcohol prohibition finally came in the early 1930s, one of the groups who had been agitating most vigorously against it were mothers who had had enough of the havoc being wreaked by organised crime and bootlegging in families and communities across the country.

℘ ℘ ℘

Prohibition finally became American law in 1920, with the Volstead Act bringing in an 18th Amendment to the constitution which had been drafted in large part by the Anti-Saloon League. But, within days, public sympathies began to swing sharply against the 'noble experiment'. While it had been supported by vocal lobby groups from across the social spectrum, 'big government' in Washington had been seen as a conspiracy of fat cats taking kickbacks from the vulgar *arriviste* German brewers to thwart the will of the people. Once 'big government' was behind prohibition, all the hypocrisy and humbug which had thus far been ignored was suddenly

presented to public view. The emperor was naked: politicians were all drinkers on the sly, standing up in public to spout sanctimonious claptrap about the evils of drink, impotent against the glamorous bootleggers, Robin Hood figures who came up with ever more spectacular scams to give the people what they wanted.

Civil disobedience was rife from the beginning, partly abetted by the wording of the Volstead Act which forbade buying and selling alcohol but not actually drinking it or being drunk. It could be drunk at home, or if the drinker had a medical prescription for it, or if it had been blessed by a priest or rabbi, all of which allowed for endless loopholes – 'private' parties, doctors supplementing their income, fake synagogue letterheads, as well as the huge quantities of contraband which haemorrhaged across the borders from Canada, Mexico and the Caribbean. A night on the town became an adventure, speakeasy crowds bonded by their shared recognition that the law was an ass, fostering a counterculture spirit like an ecstasy-fuelled warehouse party. Cops turned a blind eye, winked, even joined in.

But it wasn't long before it became clear that prohibition also had a serious downside. Within two years the bootleggers and racketeers had cleared over a billion dollars, and were rapidly becoming a kind of shadow government radiating out of big cities like Chicago. They diversified into numbers rackets, gambling, protection and prostitution, buying police and politicians at the highest level. Free from regulation, alcohol was sold in the most adulterated form and for the highest price that the market would bear. Hundreds of thousands of gallons of denatured methanol was liberated from industrial suppliers which, when not properly detoxified, frequently led to blindness or death. The Robin Hoods of the early 1920s' boomtime had become a massive criminal underground, enforcing their monopolies with violence. It was common knowledge that speakeasy owners and bootleggers were above the law, while the courts punished the small-fry with vindictive and draconian sentences, like the mother of ten from Michigan sentenced to life for possession of a pint of

gin. Politicians blustered, blaming the bootleggers and the drinking public, while police sergeants patrolled their beat in chauffeur-driven sedans.

Throughout the 1920s politicians treated the repeal of prohibition as the issue that dare not speak its name, but eventually a few Democrats raised their heads above the parapet. The New York Congressman Fiorella la Guardia, motivated in part by the harm that gangsterism was doing to the image of his Italian-American community, began to speak the unspeakable: "people are being poisoned, bootleggers are being enriched, and government officials are being corrupted". "There is also a 14th Amendment to the constitution", he observed. "It deals with human rights and liberties and it is dead as a doornail in certain sections of the country". The upcoming Democrat star Frankin D.Roosevelt began to speak about how much tax revenue could be accrued from legal alcohol, but the issue was rarely raised in his 1932 election campaign against Hoover which was dominated by the economic calamity of the Depression. When Roosevelt won and launched his New Deal, the 18th Amendment was voided quickly and without much public discussion. Beer was legalised first, followed a few months later by spirits.

℘ ℘ ℘

In the optimistic, forward-looking era of expansion which followed, few were interested in picking over the bones of prohibition and the reasons for its failure: it was tacitly regarded as a benighted era of American history which was best forgotten. But this blankness was also evidence of the unwillingness to examine the idea that the rackets and mobs born of prohibition might not have died simply by virtue of the 18th Amendment's repeal. The truth, of course, was that the power of the mob wasn't dying but consolidating itself in other territories like gambling, construction, transport – and drugs.

Opiates and cocaine had of course been illegal since the early years of the century but their use had been minor, mostly restricted to small ethnic groups and invalid war

veterans, and had failed to constitute a credible public menace in comparison with illegal alcohol. But the first post-prohibition drug scare came from a new source: the Mexican habit of smoking hemp. During the boom of the twenties, many Mexicans had arrived in the Southwest as economic migrants; now, in the Depression, they were unemployed and unwelcome, their foreign habits causing local anxiety. The recently-formed Narcotics Bureau duly identified 'marijuana' – hemp smoked by Mexicans – as a habit-forming narcotic and began a campaign against it which reapplied much of the discredited alcohol rhetoric to the new 'plague'; the press found that tales of perdition, insanity and murder still played to a public unfamiliar with cannabis-smoking and prepared to believe that it might indeed be the slippery slope to Hell which had been claimed of alcohol a generation before. In 1937, the federal control of marijuana traffic was secured without opposition.

The escalation of anti-drug measures after alcohol prohibition seems to have had an oddly therapeutic function for an America which wanted to believe that it was in recovery. Prohibition had opened ugly racial rifts in the population, claims and counter-claims about who were the 'true' Americans; but one thing on which Puritans and Germans, Italians and Irish could all agree was that Chinese opium-smokers, 'cocaine niggers' and marijuana-smoking Mexicans were undoubtedly less American than the white, Christian majority. Scapegoating the foreign substances of racial minorities healed the scars of alcohol prohibition more quickly and painlessly than a thorough examination of its actual causes.

Furthermore, America was still vigorously taking the lead in the international control and prohibition of narcotics, pushing through more and more anti-drug legislation at League of Nations summits and Geneva Conferences. The rest of the civilised world had been unwilling to follow America into its 'noble experiment', having evolved its own relationship with alcohol over centuries, but it had little experience with other drugs and little to fear from angry mobs and riots if these obscure substances were further controlled. Thus America's

vigorous prosecution of the war on drugs not only confirmed its status as a rising power on the world stage; it also forced the rest of the world to accept that the principle of prohibition was in itself not an unreasonable one, thus perhaps allowing America to feel that its own experiment with alcohol prohibition hadn't, after all, been an irrational aberration which could only have been committed by a young and immature country under the sway of fanatical religious impulses and an intolerant zeal for racial purity.

Other interest groups also had much to gain by switching the focus from alcohol to drugs. The US Narcotics Bureau needed to shake off the stigma which attached to the Alcohol Bureau by showing that their quarry was a genuine enemy, far more dangerous than alcohol, and that this time their goal was one which every citizen should support and respect. Medical opinion, too, was keen to backtrack from the worst excesses of their anti-alcohol collaborations and reverse the nineteenth-century consensus by insisting that substances such as cannabis were, in fact, far more dangerous than alcohol. The press and other media, too, found their readers and viewers eager to accept that the civilised world was being threatened by a plague of sinister foreign drugs, despite the fact that actual levels of problematic drug use were far lower than they'd been a few decades before – a state of affairs which had been achieved not by prohibiting drugs but by a culture of public information which had highlighted their dangers. Today's War on Drugs is predicated on the belief that the abuse of drugs is simply a function of their availability, but the fact remains that the period at the end of the nineteenth century shows both the highest levels of availability and the lowest levels of abuse.

℘ ℘ ℘

Alcohol prohibition may in theory have been a 'noble experiment', but in practice its flaws became apparent almost immediately, and there are few now (outside the mafia) who regard it as anything other than one of the great public policy disasters of the twentieth century. The prohibition of drugs in

its wake may have seemed like a different proposition at the time, when the substances in question were largely confined to marginalised ethnic minorities. Today, though, the drug policy which we've inherited from the fallout of alcohol prohibition is exacting a staggering price, on a scale which could barely have been imagined even in the Chicago of 1930. The story of drugs in the nineteenth century doesn't demonstrate that their widespread use is entirely without its problems and dangers – far from it – but it does enable us to focus with more clarity on the problems and dangers which only emerged after the supply and possession of drugs were criminalised.

At the end of the nineteenth century, when drugs were available under various levels of statutory control, it would have been impossible to extrapolate today's world where the black market in drugs constitutes, according to Interpol, eight per cent of global international trade – along with oil and arms the world's largest business, and one controlled mostly by organised crime. Given this scale, it's not surprising that the knock-on effects of the illicit drugs trade should be as dramatic as they are. Across the drug-producing areas of the Middle East, Central and South-East Asia and Latin America, civil war after civil war has been funded by the only strategy available to rebels and counter-revolutionaries alike – mass-producing their traditional drugs for sale to the global market. In the cities of both the West and the developing world, it's obvious to millions that selling illegal drugs is by far the most financially rewarding path open to them: being poor doesn't make you stupid, and while we may regard drug dealing as morally reprehensible it's hardly surprising that it remains a rational choice for so many. This vast shadow economy has continued to grow despite the untold billions of government funding – now almost impossible even to estimate – spent on enforcing possession laws which would only really be workable in totalitarian police states, imprisoning drug users in their millions and funding civil wars in countries thousands of miles away from the streets where drug traficking continues undisturbed.

To an increasing number of people, this is no longer news. Opinion polls in Britain and Europe over the last decade have shown sharp rises in support for policies of decriminalisation, and whenever the American people have been offered a chance to vote on the issue – as in the state propositions on medical marijuana – they have regularly rejected the US federal policy. At the same time, particularly in Britain and Europe, many have recognised the benefits of rolling back the criminal justice system to allow the problems associated with drugs themselves to be tackled by public health initiatives. Study after study has demonstrated that treating dependent drug users is many times more cost-effective than arresting and imprisoning them; police force after police force has tacitly – even openly – accepted that detecting and prosecuting casual drug users is an unsustainable drain on their limited resources, and one which has no impact on the broader spectrum of crime control. Projects in Britain, Holland and Switzerland have all demonstrated that prescribing drugs like heroin to habitual users is dramatically effective in reducing health problems, deaths and particularly levels of acquisitive crime: not only does it obviate the addicts' own need to steal, but it takes them out of the pyramid selling chain by which addictive drugs are spread. As initiatives like these have gradually proliferated so, like Fiorella la Guardia, increasingly high-profile political figures such as the European Commissioner Emma Bonino and the Prime Minister of Portugal Antonio Guterres have begun to raise their heads above the parapet and suggest openly that the prohibition of drugs is far more damaging than drugs themselves.

But if international drug policy was responsive to this kind of evidence it would have been dismantled long ago. Too many of the central assumptions of today's political and public institutions continue to make sense only as long as we maintain the belief that drugs are the enemy within, a clear and present threat to the progress of civilisation – even, as successive US politicians have called them, "the greatest danger we face". The War on Drugs remains in many ways the vanguard of American foreign policy, and by extension the UN

consensus: 'allies' in the war are rewarded with levels of foreign aid which are otherwise increasingly hard to come by, and 'enemies' become pariah states, their international aid withdrawn and their trade embargoed. Within medicine, the international consensus – as represented by slow-moving bureaucratic giants like the World Health Organisation and the United Nations Drugs Control Programme – has the eradication of all illegal drugs as its stated policy, its colours nailed even more firmly to the mast than they were to the cause of alcohol prohibition. Massive levels of scientific funding, to bodies like the National Institute of Mental Health, are dedicated to elaborating the dangers of drugs, while research into their potential benefits is virtually unfundable. International development programmes aimed at reducing drug supply from around the globe engender not a reduction in supply but more research and costly – thus, for the agencies involved, lucrative – crop substitution programmes. Particularly in America, law enforcement and prison building are among the largest state-funded industries, a powerful lobby for whom even half-way measures like ending custodial sentencing for simple drug possession would represent a collapse of their entire sector. All these state sectors depend on maintaining the current policy and are still almost unanimously supported in the arena of public politics, where the old nineteenth-century spectre of "luxurious use among the working classes" – the fact that problematic drug use is perceived as most prevalent in areas of poverty and social deprivation – makes it perennially popular for politicians to blame drugs for the persistence of these conditions, and to offer to protect their upright citizens from the 'plagues' emanating from marginalised communities where voting is, as they know all too well, more an eccentricity than a civic duty.

Within this context, the trouble with formulating any alternative to the current policy is that all the various options skirt around a single and still alarming word – legalisation. Since the sale and possession of drugs are currently criminalised, any substantive change in policy must involve changing their legal status; but we have only to look at the range of

controls we already have to deal with other substances like alcohol, tobacco and pharmaceuticals to see that there are many options for the regulated distribution of currently illegal drugs. Mind-altering drugs of different strengths and types are already sold through licensed outlets with statutory obligations for the retailer, over pharmacy counters with professional controls, with prescriptions by doctors to named patients, in designated and supervised environments. Our current policymakers encourage us to equate legalisation with heroin available on supermarket shelves in brightly coloured packets; but the onus should surely be on them to explain why it is that the criminal underground is seen as a preferable means of distribution to any or all of the above. Nor should the idea of legalisation be taken to imply the view that drugs are beneficial or even safe: again, the question should be that, granted that drugs can be dangerous and harmful, would we prefer their supply to be controlled by public health agencies or organised crime cartels? Given this choice, it is those who are most concerned about the dangers of drugs who should be agitating hardest for their effective regulation.

The drugs we discovered in the sixteenth century – potentially toxic and addictive substances like caffeine and nicotine – eventually permeated into the fabric of society in mild, legal and easily-assimilated forms; the demon alcohol has been contained with a range of statutory and legal tools like licensing, sales and advertising regulation and state-funded education and treatment. These and other models offer plausible frameworks for the drugs which we discovered in the nineteenth century, but our policy towards them remains based on the fantasy that a society without drugs used to exist, and can somehow be returned to – a fantasy which is anything but harmless. In this light, we can only speculate on the verdict of the historians of a hundred years' time on our own 'noble experiment'.

℘ ℘ ℘

But even if politicians lack the courage or the will to throw the juggernaut of drug prohibition into reverse, the discovery

of drugs which began in the nineteenth century continues regardless. Drug policy may be an immovable object, but drug culture has become an irresistible force which shows every sign of becoming an enduring passion of the Western mind. Just as the pioneering journeys of nineteenth-century explorers have become today's popular travel destinations, so the inner worlds first colonised in the nineteenth century are now visited by more people than ever before.

The overall prevalence of drug use in the West has tripled since 1970, becoming broadly socialised across a wide range of cultures, and in the process the traditional explanations for it – addiction, peer pressure, 'pushers' forcing drugs on the unwilling or ignorant – have become ever less plausible. In their place we can perhaps now begin to discern a new set of explanations, many of which lead us back to our nineteenth-century pioneers. The contradictions between a public culture of anti-drug messages and the personal experience of those who have tried them seems to have produced a generation who are neither easily fooled nor easily scared, and for whom, as for Moreau de Tours, "personal experience is the criterion of truth". The dire but vague warnings of the medical profession have been superseded by a grapevine of street-level drug information to the point where many users now have a better understanding of the technical details of dosages, combinations and effects of their drugs of choice than most doctors. The traditional drug use of ethnic minorities has – the great nineteenth-century fear – indeed spread across an increasingly globalised culture, but has done so along with music, food and a broader complex of cultural appreciation. And as a pervasive consumer culture encourages us to be ever more adventurous in our choice of food, clothes, holidays – and bombards us with messages intended to identify our self-worth with the boldness of these choices – it becomes ever more anomalous that we're asked to accept on faith, and against much of the evidence, that alcohol is the only intoxicant in which we should be interested. Such explanations locate drug culture not as a deviant and retrograde plague but as one manifestation among many of the

naturally curious, increasingly well-informed, multicultural consumer culture which our societies are (in every other context) so keen to foster.

For these and many other reasons, it becomes ever less credible that the next stage in this story will be the United Nations' stated goal of "a drug-free world". A more plausible outcome is perhaps, through processes which are already under way, the evolution of a culture where drug use is more broadly understood and socialised and the problematic use of drugs, when it occurs, is neither a secret shame nor a criminal act but a condition for which impartial information and specialist treatment are available. The prohibition of drugs takes its legitimacy from the idea that drugs are an obstacle which must be overcome on the way to a civilised society, but perhaps it's now the prohibition of drugs which is the greater obstacle. A better criterion of a civilised society might be one which has learnt to contain a range of drug cultures within its pluralist framework, and which shows an informed tolerance equally to those who choose to take drugs and those who choose not to.

Appendix

Selected Texts

Nitrous Oxide

Researches Chemical and Philosophical, Chiefly Concerning Nitrous Oxide or Dephlogisticated Nitrous Air, and its Respiration
Humphry Davy, 1800

Having previously closed my nostrils and exhausted my lungs, I breathed four quarts of nitrous oxide from and into a silk bag. The first feelings were similar to those produced in the last experiment; but in less than half a minute, the respiration being continued, they diminished gradually and were succeeded by a sensation analogous to gentle pressure on all muscles, attended by a highly pleasurable thrilling in the chest and extremities. The objects around me became dazzling and my hearing more acute.

[. . .] I now had a great disposition to laugh, luminous points seemed frequently to pass before my eyes, my hearing was certainly more acute and I felt a pleasant lightness and power of exertion in my muscles.

[. . .] I felt a sense of tangible extension highly pleasurable in every limb; my visible impressions were dazzling and apparently magnified, I heard every distinct sound in the room and was perfectly aware of my situation. By degrees as the pleasurable sensations increased, I lost all connection with external things; trains of vivid visible images rapidly passed through my mind and were connected with words in such a manner, as to produce perceptions perfectly novel. I existed in a world of newly connected and newly modified ideas. I theorised; I

imagined I made discoveries. When I was awakened from this semi-delirious trance by Dr.Kinglake, who took the bag from my mouth, indignation and pride were the first feelings produced by the sight of persons about me. My emotions were enthusiastic and sublime; and for a minute I walked round the room perfectly regardless of what was said to me. As I recovered my former state of mind, I felt an inclination to communicate the discoveries I had made during the experiment. I endeavoured to recall the ideas, they were feeble and indistinct; one collection of terms, however, presented itself; and with the most intense belief and prophetic manner, I exclaimed to Dr.Kinglake "Nothing exists but thoughts! The Universe is composed of impressions, ideas, pleasures and pains!"

[. . .] The next morning the recollections of the effects of the gas were indistinct, and had not remarks written immediately after the experiment recalled them to my mind, I should even have doubted their reality.

Tennyson's Trances and the Anesthetic Revelation
Benjamin Paul Blood, 1902

The Anesthetic Revelation is the Initiation of Man into the Immemorial Mystery of the Open Secret of Being, revealed as the Inevitable Vortex of Continuity. Inevitable is the word. Its motive is inherent – it is what has to be. It is not for any love or hate, not for joy or sorrow, nor good or ill. End, beginning, or purpose, it knows not of.

[. . .] This has been my moral sustenance since I have known of it. In my first printed mention of it I declared: 'The world is no more the alien terror that was taught me. Spurning the cloud-grimed and still sultry battlements whence so lately Jehovan thunders boomed, my gray gull lifts her wing against the nightfall, and takes the dim leagues with a fearless eye.' And now, after twenty-seven years of this experience, the wing is grayer, but the eye is fearless still, while I renew and double emphasise that declaration. I know – as having

known – the meaning of Existence: the same centre of the universe – at once the wonder and the assurance of the soul – for which the speech of reason has as yet no name but the Anesthetic Revelation.

The Varieties of Religious Experience
William James, 1902

Nitrous oxide and ether, especially nitrous oxide, when sufficiently diluted with air, stimulate the mystical consciousness in an extraordinary degree. Depth beyond depth of truth seems revealed to the inhaler. This truth fades out, however, or escapes, at the moment of coming to; and if any words remain over in which it seemed to clothe itself, they prove to be the veriest nonsense. Nevertheless, the sense of a profound meaning having been there persists; and I know more than one person who is persuaded that in the nitrous oxide trance we have a genuine metaphysical revelation.

Some years ago I myself made some observations on this aspect of nitrous oxide intoxication, and reported them in print. One conclusion was forced upon my mind at that time, and my impression of its truth has ever since remained unshaken. It is that our normal waking consciousness, rational consciousness as we call it, is but one special type of consciousness, whilst all about it, parted from it by the filmiest of screens, there lie potential forms of consciousness entirely different.

Opium

The Pains of Sleep
Samuel Taylor Coleridge, 1803

But yester-night I prayed aloud
In anguish and in agony

Up-starting from the fiendish crowd
Of shapes and thoughts that tortured me:
A lurid light, a trampling throng,
Sense of intolerable wrong,
And whom I scorned, those only strong!
Thirst of revenge, the powerless will
Still baffled, and yet burning still!
Desire with loathing strangely mixed
On wild or hateful objects fixed.
Fantastic passions! Maddening brawl!
And shame and terror over all!
Deeds to be hid which were not hid,
Which all confused I could not know
Whether I suffered, or I did:
For all seemed guilt, remorse or woe,
My own or others still the same
Life-stifling fear, soul-stifling shame.

Confessions of an English Opium Eater
Thomas de Quincey, 1821

O just, subtle and all-conquering opium! that, to the hearts of
rich and poor alike, for the wounds that will never heal, and
for the pangs of grief that "tempt the spirit to rebel", bringest
an assuaging balm; – eloquent opium! that with thy potent
rhetoric stealest away purposes of wrath, pleadest effectually
for relenting pity, and through one night's heavenly sleep call-
est back to the guilty man the visions of his infancy, and hands
washed pure from blood: – O just and righteous opium! that
to the chancery of dreams summonest, for the triumphs of
despairing innocence, false witnesses; and confoundest per-
jury; and dost reverse the sentences of unrighteous judges; –
thou buildest upon the bosom of darkness, out of the fantastic
imagery of the brain, cities and temples beyond the art of
Phidias and Praxiteles – beyond the splendours of Babylon
and Hekatompylos; and "from the anarchy of dreaming sleep"
callest into sunny light the faces of long-buried beauties, and

the blessed household countenances, cleansed from the "dis-honours of the grave". Thou only givest these gifts to man; and thou hast the keys of Paradise, O just, subtle, and mighty opium!

The Mystery of Edwin Drood
Charles Dickens, 1870

Shaking from head to foot, the man whose scattered con-sciousness has thus fantastically pieced itself together, at length rises, supports his trembling frame upon his arms, and looks around. He is in the meanest and closest of small rooms. Through the ragged window-curtain, the light of early day steals in from a miserable court. He lies, dressed, across a large, unseemly bed, upon a bed that has indeed given way under the weight upon it. Lying, also dressed and also across the bed, not longwise, are a Chinaman, a Lascar, and a haggard woman. The two first are in a sleep or stupor; the last is blowing at a kind of pipe, to kindle it. And as she blows, shading it with her lean hand, concentrates its red spark of light, it serves in the dim morning as a lamp to show him what he sees of her.

"Another?" says this woman in a querulous, rattling whisper. "Have another?"

He looks about him, with his hand to his forehead.

"Ye've smoked as many as five since ye come in at mid-night", the woman goes on, as she chronically complains. "Poor me, poor me, my head is so bad. Them two come in after ye. Ah, poor me, the business is slack, is slack! Few Chinamen about the docks, and fewer Lascars, and no ships coming in, these say! Here's another ready for ye, deary. Ye'll remember like a good soul, won't ye, that the market price is dreffly high just now?"

The Man with the Twisted Lip
Arthur Conan Doyle, 1889

Through the gloom one could dimly catch a glimpse of bodies lying in strange fantastic poses, bowed shoulders, bent knees, heads thrown back and chins pointing upwards, with here and there a dark, lack-lustre eye turned upon the new-comer. Out of the black shadows there glimmered little red circles of light, now bright, now faint, as the burning poison waxed or waned in the bowls of the metal pipes. The most lay silent, but some muttered to themselves, and others talked together in a strange, low, monotonous voice, their conversation coming in gushes, and then suddenly tailing off into silence, each mumbling out his own thoughts, and paying little heed to the words of his neighbour. At the further end was a small brazier of burning charcoal, beside which on a three-legged stool there sat a tall, thin old man with his jaw resting upon his two fists, and his elbows upon his knees, staring into the fire.

As I entered, a sallow Malay attendant had hurried up with a pipe for me and a supply of the drug, beckoning me to an empty berth.

The Picture of Dorian Gray
Oscar Wilde, 1891

At the end of the hall hung a tattered green curtain that swayed and shook in the gusty wind which had followed him in from the street. He dragged it aside and entered a long, low room which looked as if it had once been a third-rate dancing saloon. Shrill flaring gas-jets, dulled and distorted in the fly-blown mirrors which faced them, were ranged round the walls. Greasy reflectors of ribbed tin backed them, making quivering disks of light. The floor was covered with ochre-coloured sawdust, trampled here and there into mud, and stained with dark rings of spilt liquor. Some Malays were crouching by a little charcoal stove playing with bone counters, and showing their white teeth as they chattered.

[. . .] At the end of the room there was a little staircase, leading to a darkened chamber. As Dorian hurried up its three rickety steps, the heavy odour of opium met him. He heaved a deep breath, and his nostrils quivered with pleasure. When he entered, a young man with smooth yellow hair, who was bending over a lamp, lighting a long thin pipe, looked up at him, and nodded in a hesitating manner.

"You here, Adrian?" muttered Dorian.

"Where else should I be?" he answered listlessly. "None of the chaps will speak to me now."

Cannabis

The Travels of Marco Polo the Venetian
Marco Polo, c.1300

Mention shall now be made of the Old Man of the Mountain [. . .] at certain times he caused opium *(sic)* to be administered to ten or a dozen of the youths; and when half dead with sleep he had them conveyed to the several apartments of the palaces in the garden. Upon awakening from the state of lethargy, their senses were struck with all the delightful objects that have been described, and each perceived himself to be surrounded by lovely damsels, singing, playing and attracting his regards by the most fascinating caresses, serving him also with delicate viands and exquisite wines; until intoxicated with excess of enjoyment amidst actual rivulets of milk and wine, he believed himself assuredly in Paradise, and felt an unwillingness to relinquish its delights. When four or five days had thus been passed, they were thrown once more into a state of somnolency, and carried out of the garden. Upon their being introduced to his presence, and questioned by him as to where they had been, their answer was: "In Paradise, through the favour of your highness": and then before the whole court, who listened to them with eager curiosity and astonishment, they gave a circumstantial account of the scenes to

which they had been witnesses. The chief thereupon addressing them, said: "We have the assurances of our Prophet that he who defends his lord shall inherit Paradise, and if you show yourselves devoted to the obedience of my orders, that happy lot awaits you". Animated to enthusiasm by words of this nature, all deemed themselves happy to receive the commands of their master, and·were forward to die in his service.

The Artificial Paradises
Charles Baudelaire, 1860

Thus let the sophisticates and novices who are curious to taste these exceptional delights take heed; they will find nothing miraculous in hashish, nothing but the excessively natural. The brain and body governed by hashish will yield nothing but their ordinary, individual phenomena, augmented, it is true, in number and energy, but always faithful to their origins. Man will not escape the destiny of his physical and moral temperament: for man's impressions and intimate thoughts, hashish will act as a magnifying mirror, but a pure mirror none the less.

Here is the drug we have before us: a morsel of green paste, the size of a nut, the smell of which is so potent that it gives rise to a certain repulsion and bouts of nausea, as will, for that matter, any fine and even appealing scent when carried to its maximum concentration and density, as it were. I might mention in passing that this proposition can be reversed, so that the vilest, most repugnant odour might perhaps become pleasurable were it reduced to its minimum of quantity and expansion. Here, then, is happiness! – it can be contained within an ordinary teaspoon! – happiness with all of its rapture, childishness and folly! Swallow it without fear; you will not die of it. Your inner organs will suffer no harm. Later, perhaps, a too frequent invocation of the spell will diminish your power of resolve, perhaps you will be less a man than you are today, but the punishment is yet so distant and the future disaster of a nature so difficult to define! Where is the risk?

The Hasheesh Eater: being passages from the Life of a Pythagorean
Fitz Hugh Ludlow, 1857

Slowly I floated down to earth again. There Oriental gardens waited to receive me. From fountain to fountain I danced in graceful mazes with inimitable houris, whose foreheads were bound with fillets of jasmine. I pelted with figs the rare exotic birds, whose gold and crimson wings went flashing from branch to branch, or wheedled them to me with Arabic phrases of endearment. Through avenues of palm I walked arm in arm with Hafiz, and heard the hours flow singing through the channels of his matchless poetry. In gay kiosques I quaffed my sherbet, and in the luxury of lawlessness kissed away by drops that other juice which is contraband unto the faithful. And now beneath citron shadows I laid me down to sleep.

[. . .] I rose that I might test my reinstated powers, and see if the restoration was complete. Yes, I felt not one trace of bodily weariness or mental depression. Every function had returned to its normal state, with the one exception: memory could not efface the traces of my having passed through a great mystery. I recalled the events of the past night, and was pleased to think that I had betrayed myself to no-one but Dr. H. I was satisfied with my experiment.

Ah! would that I had been satisfied! Yet history must go on.

A Hashish-House in New York
H.H.Kane, 1888

"You will probably be greatly surprised at many things you will see tonight", he said, "just as I was when I was first introduced into the place by a friend. I have travelled over most of Europe, and have smoked opium in every joint in America, but never saw anything so curious as this, nor experienced any intoxication so fascinating yet so terrible as that of hashish."

"Are the habitués of this place of the same class as those who frequent the opium-smoking dives?"

"By no means. They are about evenly divided between Americans and foreigners; indeed, the place is kept by a Greek, who has invested a great deal of money in it. All the visitors, both male and female, are of the better classes, and absolute secrecy is the rule. The house has been opened for about two years, I believe, and the number of regular habitués is daily on the increase."

"Are you one of the number?"

"I am, and I find the intoxication far pleasanter and less hurtful than that from opium. Ah! here we are."

[. . .] Wonder, amazement, admiration, but faintly portray my mental condition. Prepared by what I had already seen and experienced for something odd and Oriental, still the magnificence of what now met my gaze far surpassed anything I had ever dreamed of, and brought to my mind the scenes of the *Arabian Nights*, forgotten since boyhood until now. My every sense was irresistibly taken captive, and it was some moments before I could realise that I really was not the victim of some dream, for I seemed to have wholly severed my connection with the world of today, and to have stepped back several centuries into the times of genii, fairies, and fountains – into the very heart of Persia or Arabia.

A Psychical Invasion
Algernon Blackwood, 1910

"Tell me quite frankly, Mr. Pender", he [John Silence] said soothingly, releasing the hand, and with deep attention in his manner, "tell me all the steps that led to the beginning of this invasion. I mean tell me what the particular drug was, and how it affected you – "

"Then you know it began with a drug!" cried the author with undisguised astonishment.

"I know only from what I observe in you, and in its effect upon myself. Certain portions of your atmosphere are vibrating at a far greater rate than others. This is the effect of a drug, but of no ordinary drug. Allow me to finish, please. If the

higher rate of vibrations spreads all over, you will become, of course, permanently cognisant of a much larger world than the one you know normally. If, on the other hand, the rapid portion sinks back to the usual rate, you will lose these occasional increased perceptions you now have."

"You amaze me", replied the author, "for your words exactly describe what I have been feeling -"

"I mention this only in passing, and to give you confidence before you approach the account of your real affliction", continued the doctor. "All perception, as you know, is the result of vibrations; and clairvoyance simply means becoming sensitive to an increased scale of vibrations. The awakening of the inner senses we hear so much about means no more than that. Your partial clairvoyance is easily explained. The only thing that puzzles me is how you managed to procure the drug, for it is not easy to get in pure form, and no adulterated tincture could have given you the terrific impetus I see you have acquired. But please, proceed now and tell me your story in your own way."

"This *Cannabis indica*", the author went on, "came into my possession last autumn while my wife was away. I need not explain how I got it, for that has no importance; but it was the genuine fluid extract, and I could not resist the temptation to make an experiment."

The Trembling of the Veil
W.B. Yeats, 1926

I take hashish with some followers of the 18th-century mystic St. Martin. At one in the morning, while we are talking wildly, and some are dancing, there is a tap at the shuttered window; we open it and three ladies enter, the wife of a man of letters who thought to find no-one but a confederate, and her husband's two young sisters whom she brought secretly to some disreputable dance. She is very confused at seeing us, but as she looks from one to another understands that we have taken some drug and laughs; caught in our dream we know vaguely

that she is scandalous according to our code and to all codes, but smile at her benevolently and laugh.

Ether

Tales of an Ether-Drinker: An Undiscovered Crime
Jean Lorrain, 1895

It was two years ago, when my nervous illness was at its worst; I had been cured of my ether habit, but not of its morbid effects on my hearing and vision, nor of its terrors and nightmares: sulphonal and bromides had reduced these symptoms, but the terrors still held me in their grip. They persisted most tenaciously in the apartment which I had shared with her for a long time, in the Rue Saint-Guillaume, on the other side of the river, where her presence seemed to have impregnated the walls and the draperies. Elsewhere, my sleep was regular, my nights calm, but I could scarcely cross the threshold of this apartment without the indefinable sickness of times past corrupting the very atmosphere; I was frozen with irrational chills which struck at me time and again: troubling shadows seethed malevolently in the corners, dubious folds appeared in the curtains, and the doors were suddenly animated by obscure forces, sinister and without name. By night, these phenomena became unbearable: a horrible and mysterious thing dwelt alongside me in the apartment, an invisible thing. . .

Under the Knife
H.G. Wells, 1897

"Will you hurt me much?" I said in an offhand tone.

"Not a bit", Haddon answered over his shoulder. "We shall chloroform you. Your heart's as sound as a bell." And as he spoke, I had a whiff of the pungent sweetness of the anaesthetic.

They stretched me out, with a convenient exposure of my side, and, almost before I realised what was happening, the chloroform was being administered. It stings the nostrils, and there is a suffocating sensation, at first. I knew I should die – that this was the end of consciousness for me.

[. . .] I was in mid-air. Far below was the West End of London, receding rapidly, – for I seemed to be flying swiftly upward, – and, as it receded, passing westward, like a panorama. I could see, through the faint haze of smoke the innumerable roofs chimney-set, the narrow roadways stippled with people and conveyances, the little specks of squares, and the church steeples like thorns sticking out of the fabric. But it spun away as the earth rotated on its axis, and in a few seconds (as it seemed) I was over the scattered clumps of town about Ealing, the little Thames a thread of blue to the south, and the Chiltern Hills and the North Downs coming up like the rim of a basin, far away and faint with haze. Up I rushed. And at first I had not the faintest conception of what this headlong upward rush could mean.

Diary entry
Aleister Crowley, 1915

I have been sucking up the vapour of Ether for a few moments, all common things are touched with beauty. So, too with opium and cocaine, calm, peace, happiness, without special object, result from a few minutes of those drugs. What clearer proof that all depends on state of mind, that it is foolish to alter externals? A million spent on *objets d'arts* would not have made this room as beautiful as it is just now – and there is not one beautiful thing in it, except myself. Man is only a *little* lower than the angels; one step, and all glory is ours!

Cocaine

Über Coca (On Cocaine)
Sigmund Freud, 1885

The psychic effect of *cocaïnum muiaticum* in doses of 0.05–0.10 g consists of exhilaration and lasting euphoria, which does not differ in any way from the normal euphoria of a healthy person. The feeling of excitement which accompanies stimulus by alcohol is completely lacking; the characteristic urge for immediate activity which alcohol produces is also absent. One senses an increase of self-control and feels more vigorous and more capable of work; on the other hand, if one works, one misses that heightening of the mental powers which alcohol, tea or coffee induce. One is simply normal, and soon finds it difficult to believe that one is under the influence of any drug at all. This gives the impression that the mood induced by coca in such doses is due not so much to direct stimulation as to the disappearance of elements in one's general state of well-being which cause depression. One may perhaps assume that the euphoria resulting from good health is also nothing more than the normal condition of a well-nourished cerebral cortex which 'is not conscious' of the organs of the body to which it belongs.

The Dream of Irma's Injection
Sigmund Freud, 1895

What I saw in her throat: a white patch and turbinal bones with scabs on them. The white patch reminded me of diphtheritis and so of Irma's friend, but also of a serious illness of my eldest daughter's almost two years earlier and of the fright I had had in those anxious days. The scabs on the turbinal bones recalled a worry about my own state of health. I was making frequent use of cocaine at that time to reduce some troublesome nasal swellings, and I had heard a few days earlier that one of my women patients who had followed my example had

developed an extensive necrosis of the nasal mucous membrane. I had been the first to recommend the use of cocaine, in 1885, and this recommendation had brought serious reproaches down on me. The misuse of that drug had hastened the death of a dear friend of mine.

The Strange Case of Dr. Jekyll and Mr. Hyde
Robert Louis Stevenson, 1886

The most racking pains succeeded: a grinding in the bones, deadly nausea, and a horror of the spirit that cannot be succeeded at the hour of birth or death. Then these agonies began swiftly to subside, and I came to myself as if out of a great sickness. There was something strange in my sensations, something indescribably new and, from its very novelty, incredibly sweet. I felt younger, lighter, happier in body; within I was conscious of a heady recklessness, a current of disordered sensual images running like a mill race in my fancy, a solution of the bonds of obligation, an unknown but not an innocent freedom of the soul. I knew myself, at the first breath of this new life, to be more wicked, tenfold more wicked, sold a slave to my original evil; and the thought, in that moment, braced and delighted me like wine. I stretched out my hands, exulting in the freshness of these sensations; and in the act, I was suddenly aware that I had lost in stature.

[. . .] And yet when I looked upon that ugly idol in the glass, I was conscious of no repugnance, rather a leap of welcome. This, too, was myself. It seemed natural and human. In my eyes it bore a livelier image of the spirit, it seemed more express and single, than the imperfect and divided countenance I had been hitherto accustomed to call mine. And in so far I was doubtless right. I have observed that when I wore the semblance of Edward Hyde, none could come near to me at first without a visible misgiving of the flesh. This, as I take it, was because all human beings, as we meet them, are commingled out of good and evil: and Edward Hyde, alone, in the ranks of mankind, was pure evil.

The Sign of Four
Arthur Conan Doyle, 1889

Sherlock Holmes took his bottle from the corner of the mantelpiece, and his hypodermic syringe from its neat morocco case. With his long, white, nervous fingers he adjusted the delicate needle, and rolled back his left shirt-cuff. For some little time his eyes rested thoughtfully upon the sinewy forearm and wrist, all dotted and scarred with innumerable puncture-marks. Finally, he thrust the sharp point home, pressed down the tiny piston, and sank back into the velvet-lined armchair with a long sigh of satisfaction.

[. . .] "Which is it today", I asked, "morphine or cocaine?"

He raised his eyes languidly from the old black-letter volume which he had opened.

"It is cocaine", he said, "a seven-per-cent solution. Would you care to try it?"

"No, indeed", I answered brusquely. "My constitution has not got over the Afghan campaign yet. I cannot afford to throw any extra strain upon it."

He smiled at my vehemence. "Perhaps you are right, Watson", he said. "I suppose that its influence is physically a bad one. I find it, however, so transcendentally stimulating and clarifying to the mind that its secondary action is a matter of small moment."

Mescaline

The Golden Ass
Apuleius, c.200

At twilight, she led me on tip-toe, very quietly up to the loft, where she signed to me to peep through a chink in the door. I obeyed, and watched Pamphile first undress completely, and then open a small cabinet containing several little boxes, one of which she opened. It contained an ointment which she

worked about with her fingers and then smeared all over her body from the soles of her feet to the crown of her head. After this she muttered a long charm to her lamp, and shook herself; her limbs vibrated gently and became gradually fledged with feathers, her arms changed into sturdy wings, her nose grew crooked and horny, her nails turned into talons, and Pamphile had become an owl. She gave a querulous hoot and made a few little hopping flights until she was sure enough of her wings to glide off, away over the roof-tops.

Inebriantia
Linnaeus, 1762

Intoxicants are commonly said to be those stimulants which affect the nervous system in such a way that there is a change not only in its motor but in its sensory functions. These agents are extremely subtle and light particles like those which rise from plants, as if by exhalation, or by means of chemical fermentation, are highly subtilised and are called spirituous.

[. . .] Almost no nations are without intoxicants, by means of which the weary, the exhausted, the dispirited, the faint-hearted often console their minds and refresh their bodies. These intoxicants restore now physical, now mental power, quickly – something which foods do more slowly and not without delay, and not even then sufficiently. For as soon as some intoxicant is taken, the strength increases on the spot, the heart beats excitedly, weariness vanishes, the body grows warm, the mind becomes more expansive and eager to carry on its activities.

We Europeans use fermented intoxicants such as Beer, Wine and distilled Spirits, primarily as an accompaniment in our daily food, when by a drug of that sort we desire to assure a pleasing taste. Other nations however, especially the Orientals who are much enslaved to intoxicants, care less about the accompanying food.

The First Men in the Moon
H.G.Wells, 1901

The stuff was not unlike a terrestrial mushroom, only it was much laxer in texture, and, as one swallowed it, it warmed the throat. At first we experienced a mere mechanical satisfaction in eating; then our blood began to run warmer, and we tingled at the lips and fingers, and then new and slightly irrelevant ideas came bubbling up in our minds.

"It's good", said I, "Infernally good! What a home for our surplus population! Our poor surplus population", and I broke off another large portion.

[. . .] Cavor replied to my third repetition of my "surplus population" remark with similar words of approval. I felt that my head swam, but I put this down to the stimulating effect of food after a long fast. "Ess'tent discov'ry yours, Cavor", said I. "Se'nd on'y to the 'tato."

"Whajer mean?", asked Cavor. "'scovery of the moon – se'nd on'y to the 'tato?"

I looked at him, shocked at his suddenly hoarse voice, and by the badness of his articulation. It occurred to me in a flash that he was intoxicated, possibly by the fungus.

The Lotos-Eaters
Alfred, Lord Tennyson, 1832

The charmed sunset linger'd low adown
In the red West: thro' mountain clefts the dale
Was seen far inland, and the yellow down
Border'd with palm, and many a winding vale
And Meadow, set with slender galingale;
A land where all things always seem'd the same!
And round about the keel with faces pale,
Dark faces pale against that rosy flame,
The mild-eyed melancholy Lotos-eaters came.

Branches they bore of that enchanted stem,

Laden with flower and fruit, whereof they gave
To each, but whoso did receive of them,
And taste, to him the gushing of the wave
Far far away did seem to mourn and rave
On alien shores; and if his fellow spake,
His voice was thin, as voices from the grave;
And deep-asleep he seem'd, yet all awake,
And music in his ears his beating heart did make.

Mescal: A New Artificial Paradise
Havelock Ellis, 1898

This moment was, perhaps, the most delightful of the experi-
ence, for at the same time the air around me seemed to be
flushed with vague perfume – producing with the visions a
delicious effect – and all discomfort had vanished, except a
slight faintness and tremor of the hands, which, later on, made
it almost impossible to guide a pen as I made notes of the
experiment; it was, however, with an effort, always possible to
write with a pencil. The visions never resembled familiar
objects; they were extremely definite, but yet always novel;
they were constantly approaching, and yet constantly eluding,
the semblance of known things. I would see thick, glorious
fields of jewels, solitary or clustered, sometimes brilliant and
sparkling, sometimes with a dull, rich glow. Then they would
spring up into flower-like shapes beneath my gaze, and then
seem to turn into gorgeous butterfly forms or endless folds of
glistening, iridescent, fibrous wings of wonderful insects;
while sometimes I seemed to be gazing into a vast hollow
revolving vessel, on whose polished concave mother-of-pearl
surface the hues were swiftly changing. I was surprised, not
only by the profusion of the imagery presented to my gaze,
but still more by its variety. Perpetually some totally new kind
of effect would appear in the field of vision; sometimes there
was swift movement, sometimes dull, somber richness of col-
our, sometimes glitter and sparkle, once a startling rain of gold,
which seemed to approach me. Most usually there was a

combination of rich, sober colour, with jewel-like points of brilliant hue. Every colour and tone conceivable to me appeared at some time or another.

Select bibliography

Nitrous Oxide

Cartwright, F.F.: *The English Pioneers of Anaesthesia* (John Wright & Sons, Bristol 1952)

Davy, Humphry: *Researches, Chemical and Philosophical, chiefly concerning Nitrous Oxide, or Dephlogisticated Nitrous Air, and its Respiration* (J.Johnson, London 1800)

Ellis, E.S.: *Ancient Anodynes: Primitive Anaesthesia and Allied Conditions* (Wm.Heinemann 1946)

Forgan, Sophie (ed): *Science and the Sons of Genius: Studies on Humphry Davy* (Science Reviews 1980)

Golinski, Jan: *Science as Public Culture: Chemistry and Enlightenment in Britain 1760–1820* (Cambridge U.P. 1992)

Grayson, Ellen Hickey: *Social Order and Psychological Disorder: Laughing Gas Demonstrations, 1800–1850*, in *Freakery: Cultural Spectacles of the Extraordinary Body*, ed. Rosemarie Garland Thompson (NYU Press 1996)

Hartley, Sir Harold: *Humphry Davy* (S.R.Publishers 1971)

James, William: *The Varieties of Religious Experience* (Penguin 1982)

Keys, Thomas E.: *The History of Surgical Anaesthesia* (Schuman's, NY 1945)

Knight, David: *Humphry Davy: Science and Power* (Blackwell 1992)

Sheldin, Michael and Wallechinsky, David with Salyer, Saunie: *Laughing Gas: Nitrous Oxide* (Ronin Publishing, Berkeley US 1973)

Smith, W.D.A.: *A History of Nitrous Oxide and Oxygen Anaes-*

thesia (British Journal of Anaesthesia, Vol XXXVII, #10, October 1965)

— *Under the Influence: A History of Nitrous Oxide and Oxygen Anaesthesia* (Macmillan 1982)

Treneer, Anne: *The Mercurial Chemist: A Life of Sir Humphry Davy* (Methuen 1963)

Tymoczko, Dmitri: *The Nitrous Oxide Philosopher* (*Atlantic Monthly*, May 1996)

Wright, A.J.: *Early Use of Nitrous Oxide* (in *Educational Synopses in Anesthesiology and Critical Care*, Vol.3 #6, June 1996)

Opium

Berridge, Virginia and Edwards, Griffith: *Opium and the People: Opium Use in Nineteenth-Century England* (Yale University Press 1987)

Burwick, Frederick: *Poetic Madness and the Romantic Imagination* (Pennsylvania State University Press 1996)

Escohotado, Antonio: *A Brief History of Drugs* (Park Street Press, US, 1999)

Hayter, Alethea: *Opium and the Romantic Imagination* (Crucible, 1988)

Kohn, Marek: *Narcomania* (Faber & Faber, 1987)

Lefebure, Molly: *Samuel Taylor Coleridge; A Bondage of Opium* (Gollancz, 1974)

Lindop, Grevel: *The Opium-Eater: A Life of Thomas de Quincey* (Weidenfeld 1993)

Metzger, Th.: *The Birth of Heroin and the Demonisation of the Dope Fiend* (Loompanics Unlimited, 1998)

Milligan, Barry: *Pleasures and Pains: Opium and the Orient in 19th-Century British Culture* (University Press of Virginia, 1995)

Musto, David F.: *The American Disease: Origins of Narcotic Control* (Oxford University Press, 1999)

— *Opium, Cocaine and Marijuana in American History* (Scientific American, July 1991)

Newman, Richard K.: *Opium Smoking in Late Imperial China:*

A Reconsideration (in *Modern Asian Studies, 29, 4* Cambridge University Press, 1995)

Parssinen, Terry: *Secret Passions, Secret Remedies: Narcotic Drugs in British Society 1820–1930* (Manchester University Press, 1983)

de Quincey, Thomas: *Confessions of an English Opium-Eater* (1822)

Cannabis

Baudelaire, Charles: *On Wine and Hashish/Artificial Paradises* (1851–60, repr. Citadel Press 1996, tr. Stacy Diamond)

Blanchard, Sean and Atha, Matthew J.: *Indian Hemp and the Dope Fiends of Old England: A Sociopolitical History of Cannabis and the British Empire* (http://www. druglibrary. org/schaffer/library)

Cooke, Mordecai: *Seven Sisters of Sleep* (1860, repr. Park Street Press 1997)

Dulchinos, Donald P.: *Pioneer of Inner Space: The Life of Fitz Hugh Ludlow, Hasheesh Eater* (Autonomedia 1998)

Daftary, Farhad: *The Assassin Legends: Myths of the Isma'ilis* (I.B. Tauris, 1994)

Haining, Peter (ed.): *The Hashish Club Vol. 1* (Peter Owen, 1975)

von Hammer-Purgstall, Joseph: *History of the Assassins* (tr. O.C. Wood, London 1835)

Indian Hemp Drugs Commission: *Hemp Drugs Commission Report* (House of Commons Papers 1893–4, LVXI.79)

James, Tony: *Dream, Creativity and Madness in Nineteenth-Century France* (Clarendon Press 1995)

Kane, H.H.: *A Hashish-House in New York* (1883, in *The Drug User* ed. John Strasbaugh and Donald Blaise, Blast Books 1990)

Mickel, Emanuel J.: *The Artificial Paradises in French Literature* (Chapel Hill, University of North Carolina Press 1969)

Moreau de Tours, J.J.: *Hashish and Mental Illness* (1845, repr. Raven Press 1973, introduction by Bo Holmstedt)

O'Shaughnessy, W.B.: *On the Preparations of Indian Hemp* . . .
(Bishops College Press, Calcutta, 1839)

Pichois, Claude and Ziegler, Jean: *Baudelaire* (Vintage 1991)

Reynolds, Sir R.J.: *On the Therapeutic Uses and Toxic Effects of
Cannabis Indica* (*Lancet*, 22/3/1890)

Screech, M.A.: *Rabelais* (Duckworth 1979)

Starkie, Enid: *Baudelaire* (Faber & Faber 1957)

Ether

Booth, Martin: *A Magick Life: A Biography of Aleister Crowley*
(Hodder & Stoughton, 2000)

Cartwright, F.F.: *The English Pioneers of Anaesthesia* (John
Wright & Sons 1952)

Duncum, Barbara M.: *The Development of Inhalation Anaes-
thesia* (Oxford University Press, 1847)

Evans, Thomas J.: *The Unusual History of Ether*
(www.anesthesia-nursing.com/ether.html)

Hart, Ernest: *An Address on Ether-Drinking: Its Prevalence and
Results* (British Medical Association, 1890)

Kerr, Norman: *Ether Inebrity* (Journal of the American Medical
Association, 21st November 1891)

Lee, Thos.: *The Sedative Effects of Vaporous Ether Recognised
Some Forty Years Since* (*Lancet* 13/2/1847)

Lewin, Louis: *Phantastica* (1924, repr. Park Street Press 1998)

Ludovici, L.J.: *Cone of Oblivion: A Vendetta in Science* (Max
Parrish 1961)

Nagle, David R.: *Anesthetic Addiction and Drunkenness: A
Contemporary and Historical Survey* (*International Journal of the
Addictions*, Vol 3 No.1, Spring 1968)

Pagel, Walter: *Paracelsus: An Introduction to Philosophical Medi-
cine in the Era of the Renaissance* (Basle; Karger 1982)

Porter, Roy: *Health For Sale:Quackery in England 1660–1850*
(Manchester University Press 1989)

Rice, Dr. Nathan P.: *Trials of a Public Benefactor as Illustrated
in the Discovery of Etherization* (Pudney & Russell, NY
1859)

Richardson, Dr. BenjaminWard: *Diseases of Modern Life* (Macmillan 1876)

— *On Ether-Drinking and Extra-Alcoholic Intoxication* (*Popular Science Monthly* 1878, Supplement 19:31)

Thompson, C.J.S.: *The Quacks of Old London* (Barnes & Noble 1993)

Wintle, Dr. F.T.: *Letter to The Lancet* (*Lancet* 1847, 1:162)

Wyld, George M.D.: *On Certain Psychological Phenomena Accompanying the Administration of an Anaesthetic* (*Lancet* 23/3/1895)

Cocaine

Andrews, George and Solomon, David (ed.): *The Coca Leaf and Cocaine Papers* (Harcourt Brace Jovanovich 1975)

Brown, Ivor: *The Case of Robert Louis Stevenson* (History of Medicine, Vol 2 No.4, Winter 1989)

Freud, Sigmund: *Cocaine Papers* (ed. Robert Byck, notes by Anna Freud, Stonehill 1974)

Goodman, Jordan: *Excitantia: Or, How Enlightenment Europe took to Soft Drugs*, in *Consuming Habits: Drugs in History and Anthropology*, ed. Jordan Goodman, Paul E.Lovejoy and Andrew Sherratt, Routledge 1995)

Gootenberg, Paul (ed.): *Cocaine: Global Histories* (Routledge 1999)

Henman, Anthony: *Mama Coca* (Hassle Free Press 1978)

Holmstedt, Bo and Fredga, Arne: *Sundry Episodes in the History of Coca and Cocaine* (*Journal of Ethnopharmacology*, Vol.3, 1981)

Inglis, Brian: *The Forbidden Game: A Social History of Drugs* (Hodder & Stoughton 1975)

Mariani, A: *Coca and its Therapeutic Application* (J.N. Jaros 1890)

Martensen, Robert L.: *From Papal Endorsement to Southern Vice: The Cultural Transit of Coca and Cocaine* (Journal of the American Medical Association, Nov 20 1996)

Musto, David F.: *Opium, Cocaine and Marijuana in American History* (Scientific American, July 1991)

— *The American Disease: Origins of Narcotic Control* (Oxford University Press 1999)

Nahas, Gabriel G.: *Cocaine: The Great White Plague* (Paul S. Eriksson 1989)

Pearce, D.N.: *Sherlock Holmes, Conan Doyle and Cocaine* (Journal of the History of the Neurosciences, Vol 3 1994)

Sulloway, Frank J.: *Freud: Biologist of the Mind* (Basic Books 1979)

Thornton, E.M.: *Freud and Cocaine* (Blond & Briggs 1983)

Tracy, Jack with Berkey, Jim: *Subcutaneously, My Dear Watson: Sherlock Holmes and the Cocaine Habit* (James A.Rock & Co, 1978)

Mescaline

Anderson, Edward F.: *Peyote, The Divine Cactus* (University of Arizona Press 1980)

Carmichael, Michael: *Wonderland Revisited* (in *Psychedelia Britannica*, ed. Antonio Melechi, Turnaround Books 1997)

Carroll, Lewis: *Alice's Adventures in Wonderland* (Penguin Classics 1998)

Cooke, Mordecai: *Seven Sisters of Sleep* (1860, repr. Park Street Press 1997)

Ellis, Havelock: *Mescal: A New Artificial Paradise* (in *The Contemporary Review*, January 1898)

Gartz, Jochen: *Magic Mushrooms Around the World* (tr. Claudia Taake, LIS Publications 1996)

Grosskurth, Phyllis: *Havelock Ellis: A Biography* (New York University Press 1985)

Lewin, Louis: *Phantastica* (1924, repr. Park Street Press 1998)

Linnaeus, Carl: *Inebriantia* (Uppsala 1762, repr. in *Linnaeus on Intoxicants*, H.H.Parker, University Microfilms International 1984)

Luhan, Mabel Dodge: *Movers and Shakers* (Curtis Brown 1935)

Martineau, Jane (ed.): *Victorian Fairy Painting* (Royal Academy of Arts/Merrell Holberton 1997)

Mitchell, Dr. S.Weir: *Remarks on the Effects of the Anhalonium Lewinii (the Mescal Button)* (British Medical Journal, Dec 5 1896)

Mooney, James: *The Mescal Plant and Ceremony* (*Therapeutic Gazette*, 12 (11), 1896)

Prentiss, Dr. D.W. and Morgan, Dr. Francis P.: *Anhalonium Lewinii (Mescal Buttons): A Study of the Drug, with Especial Reference to its Physiological Action Upon Man, with Report of Experiments* (*Therapeutic Gazette*, September 16th 1985)

Rolfe, R.T. and Rolfe, F.W.: *The Romance of the Fungus World* (1925; repr. Dover Publications 1974)

Sowerby, James: *Coloured Figures of English Fungi or Mushrooms* (R.Wilks, London 1803)

Stafford, Peter: *Psychedelics Encyclopaedia* (Ronin Publishing 1978, 1992)

Stewart, Omer C.: *Peyote Religion: A History* (University of Oklahoma Press 1987)

Wasson, R.Gordon: *Soma: Divine Mushroom of Immortality* (Harcourt Brace Jovanovich 1978)

Wilson, Peter Lamborn: *Ploughing the Clouds: The Search for Irish Soma* (City Lights 1999)

Alcohol

Behr, Edward: *Prohibition* (Penguin 1997)

Bynum, W.F.: *Alcoholism and Degeneration in 19th Century European Medicine and Psychiatry* (*British Journal of Addiction*, 79, 1994)

Jay, Mike: *Why Do People Take Drugs?* (*International Journal of Drug Policy*, Vol. 10, 1999)

Mancall, Peter: *Deadly Medicine: Indians and Alcohol in Early America* (Cornell University Press 1995)

Sournia, Jean-Charles: *A History of Alcoholism* (Basil Blackwell 1990)

Index of Names

Adelphi Theatre, 40, 124
Anderson, Dr. Winslow, 81
Anglo-Oriental Society for the
 Suppression of the Opium Trade,
 The, 81–2
Anslinger, Harry, 123
Anstie, F.E., 195
Anti-Saloon League, 229, 233, 235
von Anrep, Vassily, 161
Arabian Nights, The, 24, 66, 93, 112
Aschenbrandt, Theodor, 155–6
Assassins, the, 88–96, 106–7, 123
Atlantic Monthly, The, 47, 136

Banks, Sir Joseph, 22
Balzac, Honoré de, 107
Baudelaire, Charles, 91, 107–112,
 253
Bayer Pharmaceuticals, 52, 85–6
Beardsley, Aubrey, 214
Beauvoir, Roger de, 108
Beddoes, Thomas, 14–37, 56, 124,
 128
Beddoes, Thomas Lovell, 24
Benjamin, Walter, 219
Bennett, Allan, 180
Bernays, Martha, 155, 160–1
Blackwood, Algernon, 121, 255–6
Bleriot, Louis, 168
Blood, Benjamin Paul, 44–5, 47, 49,
 247–8
Boissard, Joseph, 107
Bonino, Emma, 241

Brande, Dr. Everard, 185–6
Brent, Bishop, 84
Breuer, Joseph, 165
British Medical Association, 79
British Medical Journal, 176, 177,
 209
Brown, John, 21–2, 56
Burroughs Wellcome, 170
Burroughs, William, 107

Carbonari, 94
Carmichael, Michael, 195
Carpenter, W.B., 195
Carroll, Lewis, 194–6
Charcot, J.M., 158, 162, 165
Charles II, 55
Charles X, 130
Christison, Sir Robert, 153, 176
Clive of India, 68
Club des Haschischins, 105–8,
 112–3, 121
Coca-Cola Company, The, 169,
 180, 184
Coleridge, Samuel Taylor, 24–34,
 37, 56–63, 66, 248–9
Collier's Weekly, 177
Colt, Samuel, 40
Colton, Dr. Gardner Quincy, 41–2,
 44, 134
Conan Doyle, Sir Arthur, 174–7,
 194, 251, 261
Contemporary Review, 212
Cook, Captain James, 188, 223

Cooke, Mordecai, 195–6
Cottle, Joseph, 34
Crichton-Browne, Sir James, 46
Cromwell, Oliver, 55
Crothers, Dr. Thomas, 179
Crowley, Aleister, 142, 179–80, 216, 258
Culpepper, Nicholas, 91

Darwin, Erasmus, 231
Davy, Humphry, 14–37, 40, 59, 104, 118, 127, 130, 141–2, 149, 154–5, 162, 164, 185, 188, 208, 213, 221, 246–7
De Quincey, Thomas, 10, 59–68, 98, 108, 118, 249–50
De Sacy, Silvestre, 88–93, 98
Defence of the Realm Act, 85
Detroit Therapeutic Gazette, 156
Dickens, Charles, 82, 250
Disraeli, Benjamin, 95
Dowdeswell, G.F., 153, 156
Dowson, Ernest, 121
Dumas, Alexandre, 107, 112–3

Edison, Thomas, 168
Edwards, Rev. Justin, 231
Ellis, Havelock, 212–5, 221, 264–5
Emerson, Ralph Waldo, 116–7
Erba, Carlo, 103
Erlenmeyer, Dr. A., 164, 171
Esquirol, J.E., 96–7
Everybody's Magazine, 181

Fitzgerald, John Anster, 193–4
Flaubert, Gustave, 109, 112–3
Fleischl von Marxow, Dr. Ernst, 163–4
France, Anatole, 168
Franklin, Benjamin, 223–4
Freemasons, 94–6
French Revolution, 36, 94
Freud, Sigmund, 104, 154–67, 259–60
Friend of China, The, 81

Gautier, Theophile, 105–7, 109, 121
General Medical Council, 73
Gentleman's Magazine, 149
Ghost Dance, 201–3
Gillray, James, 35
Gladstone, William, 68, 70
Golden Ass, The, 187, 261
Golden Dawn, Order of the, 121, 179, 216
Gonne, Maud, 121
Graham, James, 124–6
Grimm Brothers, 190
la Guardia, Fiorella, 237, 241
Gurney, Edward, 46
Guterres, Antonio, 241
Gysin, Brion, 107

Hahnemann, Samuel, 115
von Hammer-Purgstall, Joseph, 95–6, 107, 109
Hammond, Dr. William, 165, 171
Harper's Magazine, 119
Harrington, Raymond, 217–8
Heffter, Arthur, 206–8
Hegel, Georg, 47–8
Herodotus, 92, 109
Hickman, Henry Hill, 129–131, 133
Hippisley, Sir John, 35
Hofmann, Albert, 189, 218–9
Hollick, Frederick, 115
Holmes, Oliver Wendell, 134, 142–3
Holmes, Sherlock, 83, 173–7, 261
Hudson's Bay Company, 224
Huss, Magnus, 232
Huxley, Aldous, 29, 207, 219

Ibsen, Henrik, 168
Illuminati, 94
Institute of France, 88
Irving, Washington, 116

Jackson, Charles Thomas, 132, 134–6, 161

James, Henry, 47, 212
James, William, 47–50, 118, 142, 211, 248
Jefferson Airplane, 194
Johnson, James, 115
Johnson, Dr. Samuel, 223
Journal of Inebriety, The, 233

Kane, H.H., 121, 254–5
Keats, John, 189
Keightley, Thomas, 190
Kerr, Norman, 140, 233
Kinglake, Dr., 14–17, 23
Koller, Carl, 155, 159–62, 176
Kopéc, Joseph, 192–3
Königstein, Leopold, 159–60

Lancet, The, 46, 119, 137, 145, 153, 162, 215
Lavoisier, A-L, 19
Lawrence, D.H., 216
League of Nations, 122, 238
Leary, Timothy, 219
Levinstein, Dr. Eduard, 76
Lewin, Louis, 78, 144, 166, 205–8
Lincoln, Abraham, 227
Linnaeus, Carl, 188, 262
Lloyd, John Uri, 197–8
London Magazine, 60
Long, Dr. Crawford Williamson, 131, 135–7
Lorrain, Jean, 142, 257
Ludlow, Fitz Hugh, 91, 116–8, 254
Luhan, Mabel Dodge, 216–8
Lusanna, Filippo, 103
Lytton, Bulwer, 197

McKinley, President, 168
Marco Polo, 89–90, 93, 112, 252–3
Mariani, Angelo, 167–9
Martyn, Edward, 215
Mantegazza, Paolo, 149–52, 156
Maupassant, Guy de, 142
Medical and Physical Journal, 186
Medical Society of Bengal, 113

Mencken, H.L., 229
Merck Pharmaceuticals, 156, 162, 167, 171, 175
Michaux, Henri, 219
Mitchell, Dr. S. Weir, 209–211
Mitchill, Samuel Latham, 20, 23
Monardes, Nicholas, 147–8
Monet, Claude, 213
Montesquieu, Baron de, 98
Mooney, James, 203–9, 220
Moreau de Tours, J-J, 96–105, 214, 244
Morel, B.A., 74, 83, 104, 232
Morse, Samuel, 134
Morton, William, 42, 44, 132–6, 140, 143, 161

Napoleon, 88, 111, 122
Narcotics Bureau, U.S., 123, 238–9
Nation, Carry, 234
Nation of Islam, 79
National Institute of Mental Health, 242
National Women's Christian Temperance Union, 233–5
Native American Church, 205, 219–20
de Nerval, Gerard, 107
Niemann, Albert, 152
von Niemeyer, Dr., 77
Nightingale, Florence, 68

Ödman, Samuel, 193
Opium Exclusion Act (1875), 80
Opium Wars, 70–1, 81, 224–5
O'Shaughnessy, Dr. William, 113–5

Palmerston, Lord, 70
Paracelsus, 127
Parke Davis Pharmaceuticals, 162, 167, 169–71, 175, 177, 205–6
Parker, Quanah, 203
Pemberton, John, 169
Pharmacy Act (1868), 73

Philadelphia Gazette, 38
Philadelphia Medical Journal, 178
Piercy, Rev. George, 81
Pneumatic Institution, 14–37, 124
Polli, Giovanni, 103
Prentiss, Dr. D.W., 207–9
Priestley, Joseph, 19
Puttnam's Monthly, 116

Rabelais, François, 92
Ramsay, Prof. William, 46
Revue Contemporain, Le, 109
Revue des Deux Mondes, 105
Reynolds, Dr. J.R., 119
Rhymers Club, The, 121, 214, 216
Richardson, Dr. Benjamin Ward, 138–42, 144, 146
Rimbaud, Arthur, 107
Rodin, Auguste, 168
Roget, Dr. P.M., 29
Rohmer, Sax, 122
Roosevelt, Franklin D., 237
Rousseau, J-J, 62
Rowntree, Joseph, 83
Royal Academy of France, 130, 135
Royal Commission on Opium, 83, 120
Royal Commission on Hemp, 120
Royal Institution, 22, 35–7,
Royal Society, 14

Savoy Magazine, The, 214
Sceptic, The, 35
von Schertzer, Carl, 152
Schoenbein, Dr., 40
Schübeler, Frederik Christian, 193
Shaftesbury, Lord, 70
Shulgin, Alexander and Ann, 26
Simpson, Dr. James Young, 143
Smith, Sydney, 134
Society for Psychical Research, 45–6, 121
Society for the Study and Cure of Inebriety, 138, 140
Southey, Robert, 24–8, 40, 126

Sowerby, James, 188–9
Spanish Inquisition, 201
Stein, Gertrude, 216
Stevenson, Robert Louis, 172–3, 260
Sydenham, Thomas, 55
Symonds, John Addington, 46, 213–4

Taft, Howard, 84
Taylor, Bayard, 116
Templars, 95
Tennyson, Alfred Lord, 189, 210, 263–4
Therapeutic Gazette, The, 203
Thomas, Moses, 38–9
Thompson, James, 27
Thoreau, David, 116
Tobin, J.W., 29
Trocchi, Alex, 107
Trotter, Thomas, 231
Twain, Mark, 119

United Nations Drugs Control Programme, 242, 245
UNESCO, 86

Vanity Fair, 142
Vatican, 94
Verga, Andrea, 103
Verne, Jules, 168
Victoria, Queen, 119
Volstead Act, 235

Warren, Dr. John Collis, 42, 133
Washington, George, 123
Wasson, Gordon, 191, 219
Watchman, The, 24
Watson, Sir Thomas, 128
Watt Brothers, 37
Wedgwood, Thomas, 23, 58–9
Wells, H.G., 145, 168, 198–9, 257–8, 263
Wells, Horace, 42–4, 132, 135–6, 143

Wesley, John, 126
Whitman, Walt, 116–8
Wilberforce, William, 68
Wilde, Oscar, 83, 251–2
Williams, Dr. Edward H., 182
Wöller, Professor F., 152
Wordsworth, William, 24, 59, 213

World Health Organisation,
 242
Wyld, Dr. George, 145

Yeats, W.B., 121, 215, 256–7
'Yellow Peril', 68, 80–83
Yves St.Laurent, 51, 60